December 2004

Happy Holidays

To Our Friends & Clients

from all of us at

The Law Offices of

Manfredi, Levine, Eccles & Miller

3262 E. Thousand Oaks Boulevard, Suite 200
Westlake Village, California 91362
(805) 379-1919 www.mlem.com

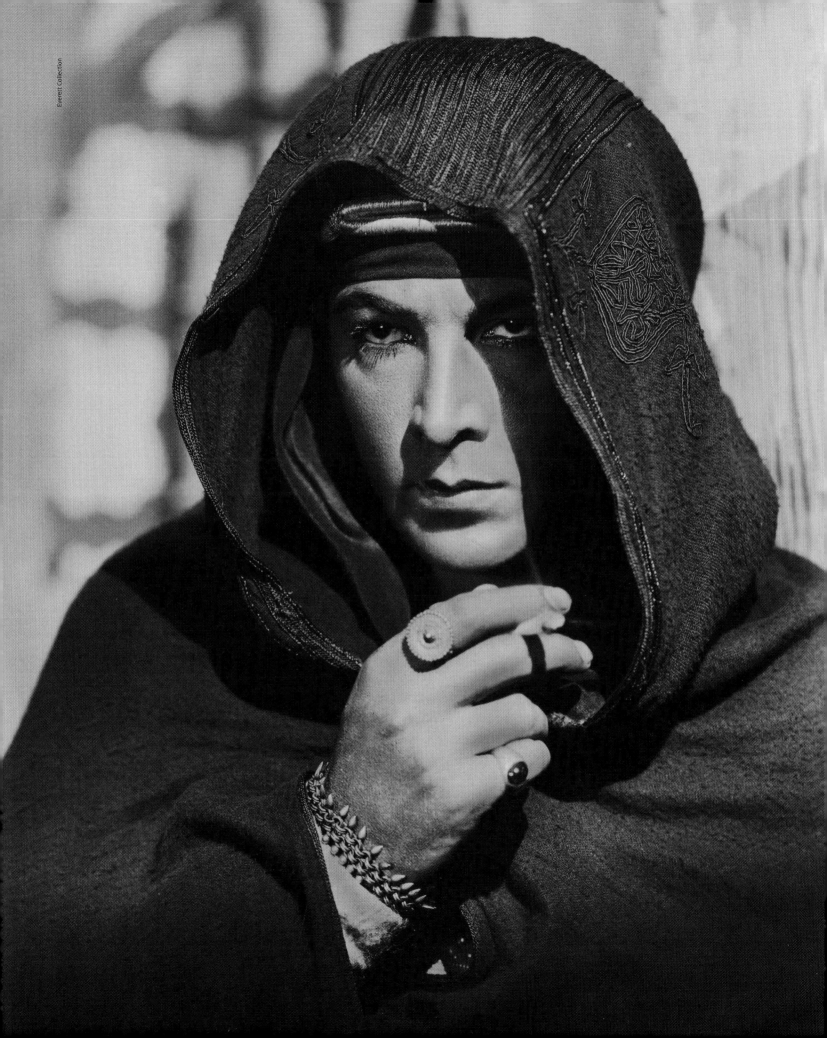

LIFE
In Hollywood

LIFE

Editor Robert Sullivan
Creative Director Ian Denning
Picture Editor Barbara Baker Burrows
Executive Editor Robert Andreas
Associate Picture Editors Christina Lieberman, Vivette Porges
Senior Reporter Hildegard Anderson
Copy J.C. Choi (Chief), Bruce Diamond
Production Manager Michael Roseman
Picture Research Lauren Steel
Photo Assistant Joshua Colow
Consulting Picture Editors
Suzanne Hodgart (London), Tala Skari (Paris)

Publisher Andrew Blau
Director of Business Development Marta Bialek
Finance Director Camille Sanabria
Assistant Finance Manager Karen Tortora

Editorial Operations Richard K. Prue (Director),
Richard Shaffer (Manager), Brian Fellows, Raphael Joa,
Stanley E. Moyse (Supervisors), Keith Aurelio, Gregg Baker,
Charlotte Coco, Scott Dvorin, Kevin Hart, Rosalie Khan,
Po Fung Ng, Barry Pribula, David Spatz, Vaune Trachtman,
Sara Wasilausky, David Weiner

Time Inc. Home Entertainment

President Rob Gursha
Vice President, Branded Businesses David Arfine
Executive Director, Marketing Services Carol Pittard
Director, Retail & Special Sales Tom Mifsud
Director of Finance Tricia Griffin
Marketing Director Kenneth Maehlum
Assistant Marketing Director Ann Marie Doherty
Prepress Manager Emily Rabin
Book Production Manager Jonathan Polsky
Associate Product Manager Jennifer Dowell

Special thanks to Bozena Bannett, Robert Dente,
Gina Di Meglio, Anne-Michelle Gallero, Peter Harper, Suzanne
Janso, Robert Marasco, Natalie McCrea, Jessica McGrath, Mary
Jane Rigoroso, Steven Sandonato, Niki Whelan

Published by

LIFE Books

Time Inc.
1271 Avenue of the Americas,
New York, NY 10020

ISBN: 1-931933-29-4
Library of Congress Number:
2003100210

"LIFE" is a trademark of
Time Inc.

We welcome your comments
and suggestions about LIFE
Books. Please write to us at:
LIFE Books, Attention:
Book Editors, PO Box 11016,
Des Moines, IA 50336-1016

If you would like to order any
of our hardcover Collector's
Edition books, please call us
at 1-800-327-6388 (Monday
through Friday, 7:00 a.m.–
8:00 p.m. or Saturday, 7:00
a.m.–6:00 p.m. Central Time).

Please visit us, and sample
past editions of LIFE, at
www.LIFE.com.

Iconic images from the LIFE Picture Collection are now available
as fine art prints and posters. The prints are reproductions
on archival, resin-coated photographic paper, framed in black
wood, with an acid-free mat. Works by the famous LIFE
photographers—Eisenstaedt, Parks, Bourke-White, Burrows,
among many others—are available. The LIFE poster collection
presents large-format, affordable, suitable-for-framing
images. For more information on the prints, priced at $99 each,
call 888-933-8873 or go to www.purchaseprints.com. The
posters may be viewed and ordered at www.LIFEposters.com.

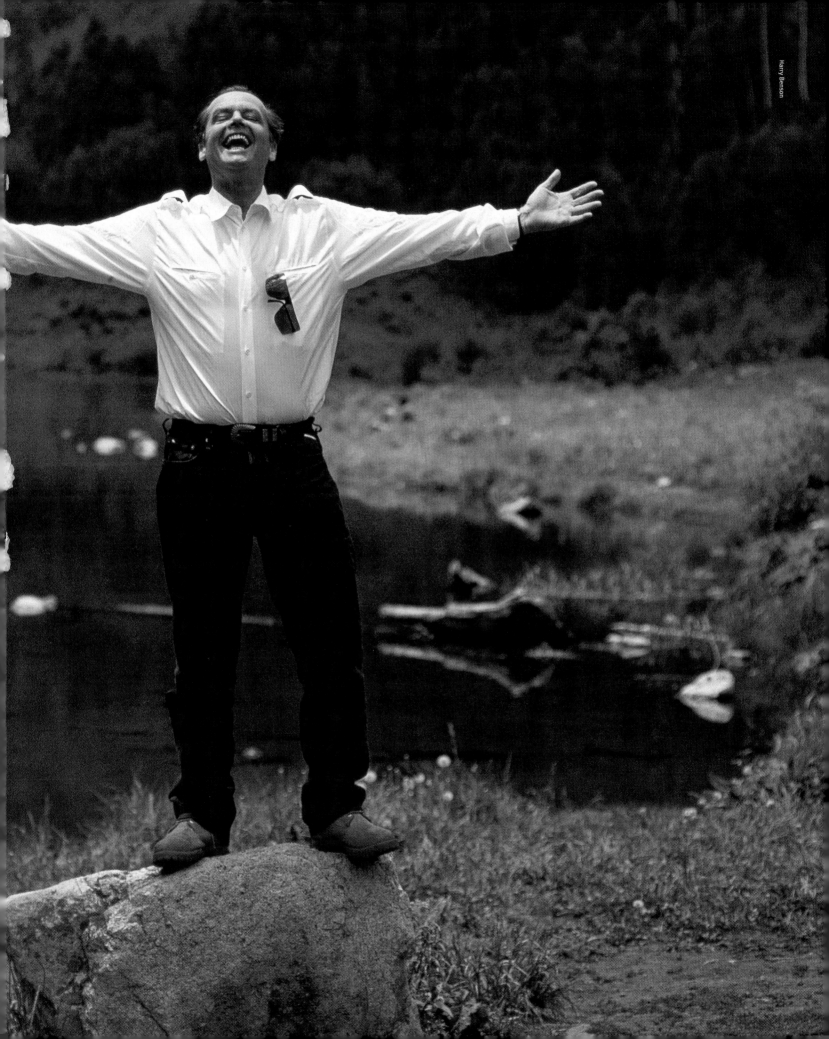

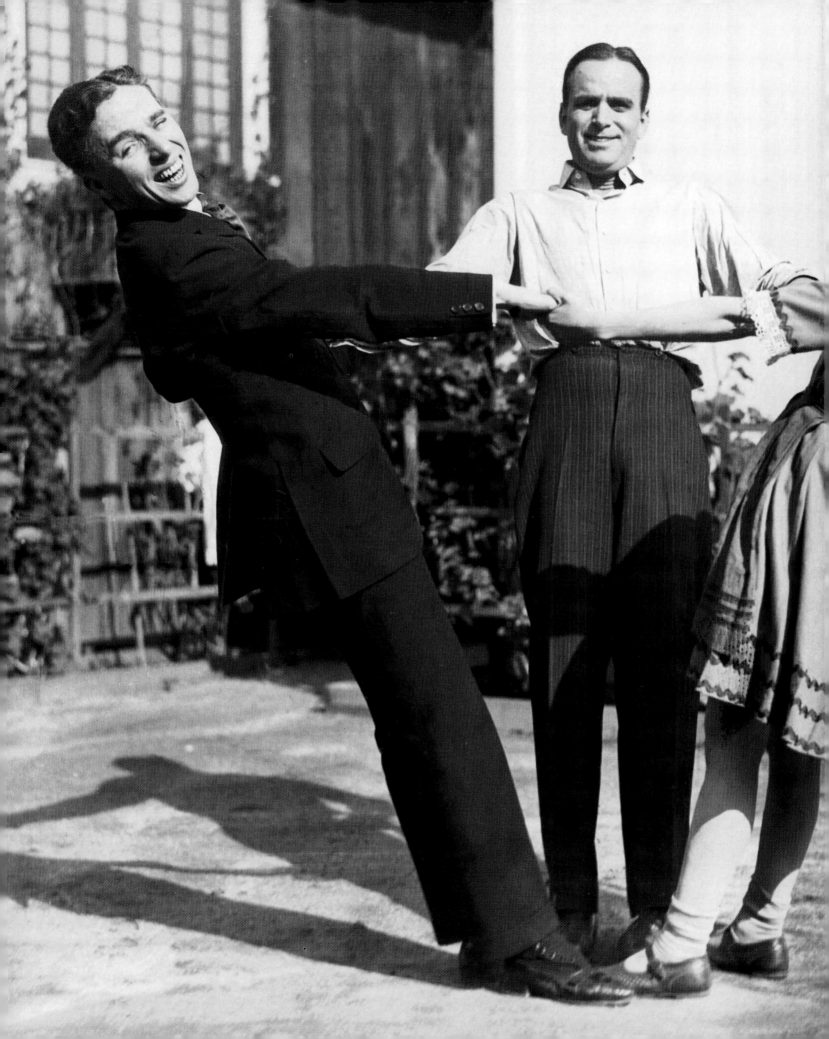

Everett Collection

Hooray For Hollywood!

In the middle of a sun-drenched nowhere, a sober, God-fearing man and woman settled in to create a like-minded community. But the future would be determined by powerful stars and Machiavellian moguls.

Charlie Chaplin, Douglas Fairbanks and Mary Pickford, on top of the world in 1921. And why not? Two years earlier they and top director D.W. Griffith had formed their own studio, United Artists, for one thing because no one else could afford to pay their salaries.

T here is a certain sort of place in America that is often referred to as a "state of mind." *Cape Cod, New Orleans, the Florida Keys.* They are both real and imaginary; they transcend. They exist on the ground and in the head. But however fanciful these other enclaves may be, there is one that surpasses all: *Hollywood.* The word conjures images of soundstage and Sunset Strip, of nightclubs and all sorts of naughtiness, of movie palaces and extraordinary people—stars of the gaudiest illumination.

Yes, there is an actual Hollywood, a segment of Los Angeles. There, beginning a century ago, the American dream burst out bigger than life, ultimately touching everyone, everywhere. The industry that transformed this relatively barren place into a land as mystical and intoxicating as Xanadu or Bali Hai was the motion picture business. Of course, movies were then, and still are, made in locales other than Hollywood, some quite nearby and some far-flung. But nowhere and nothing else frees our fantasies and stirs our hopes and fears, our tears and our eternal romances, like that single incomparable word—*Hollywood.*

When Daeida and Harvey Wilcox (left) arrived from Kansas in the 1880s, they beheld a vista much like the one in this photo taken in 1900. The couple bought a 120-acre spread they would call Hollywood for $18,000. That sum now might get you all gussied up and driven around town on Oscars night.

In the first decade of the 20th century, "movies" were like an irrepressible toddler, lunging in every which direction in France, Italy and England. The young medium was up and about in America, too, as New York City and Chicago hosted a slew of firms that produced fodder for the growing number of nickelodeons (five cents + [mel]odeon, or music hall). By the latter half of the decade there were thousands of these simple showplaces across the land, each of them displaying one- or two-reel films that lasted from a few minutes to a couple dozen. What may now seem a rather rudimentary product created a sensation: Viewers were mesmerized by these pictures that moved.

The short dramas and comedies came from a number of production companies. In 1908, Thomas Edison, irate that others were horning in on "his" movie inventions but aware that compromise was his only option, united the 10 biggest operations as "the Trust." These 10 would control distribution, exhibition, pricing and everything else—in short, a monopoly. But in this wild and woolly time, independent distributors and exhibitors formed their own organization to fight back. Many of these freelancers migrated west to the Los Angeles area. For one thing, it was as far as you could get from New York, and although there were Trust members in California, the muscle was back East. And also, L.A.,

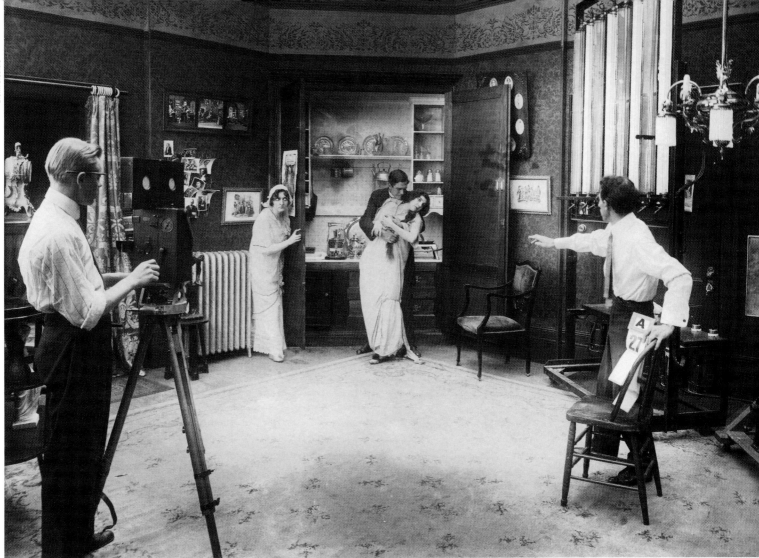

The scene above is being shot in a studio in Manhattan circa 1915 (the director is likely J. Searle Dawley). The different scale possible in a Hollywood production may be seen at right in Cecil B. DeMille's 1923 *The Ten Commandments*. He retold the story in his final film, in 1956.

as it happened, was perfect for filmmaking. A great majority of the early flicks had been shot indoors, to satisfy lighting and temperature requirements. Southern California, with its ready labor market, mild climate and nonstop sunshine, opened the way to outdoor shooting, while providing an unrivaled variety of settings—mountains, deserts, beaches, villages and urban L.A.

Two decades earlier, near Los Angeles, a prohibitionist from Kansas by the name of Harvey Wilcox had bought a patch of land in quiet, nondescript Rancho La Brea. He thought it would be a perfect site for a community that would reflect his conservative beliefs, and he built his house smack in the

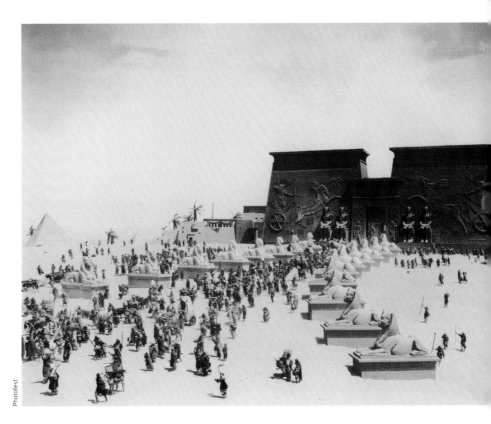

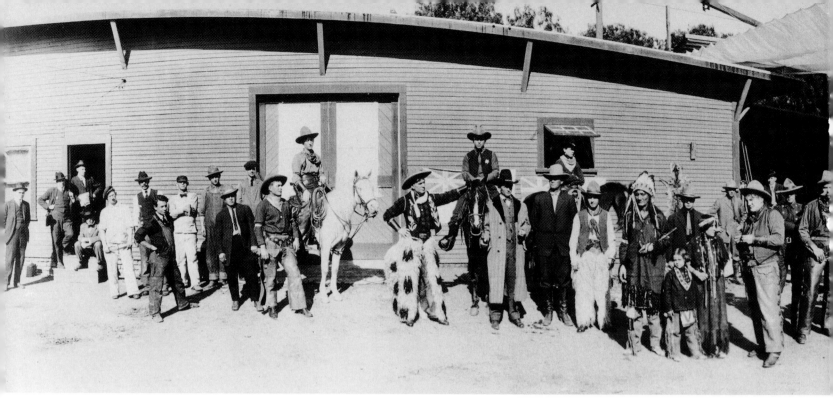

middle of a fig orchard. Shortly thereafter his wife, Daeida, met a woman on a train who spoke of her summer home called Hollywood. Smitten with the name, Mrs. Wilcox decided to borrow it for their 120-acre tract. In 1903 the colony was incorporated as Hollywood, and in 1910, to take advantage of the water supply and sewer system, Hollywood became part of Los Angeles.

In that same year, the Trust suffered a serious blow when German-born Carl Laemmle introduced the star system to movies. Edison and his group

Above, in 1914, the *Squaw Man* set. Its codirector, DeMille, is seen opposite (in gloves) on a later production. Laemmle (bottom left) made Florence Lawrence the first "movie star."

had cloaked their performers in anonymity, rendering them mere cogs in the Trust's smooth operations. But many of the immigrants—mainly from central and eastern Europe—who were finding opportunities in this new, wide-open business had different ways of doing things, and weren't saddled with puritanical constraints that might keep them from using ribald tales and sensationalism to sell tickets. The most sensational idea belonged to Laemmle, who stole Florence Lawrence from Trust-member Biograph and launched a publicity campaign around her. From that moment on, there weren't just movies, there were movie stars, and they would soon attract, and hold, huge followings.

Another piece of the puzzle: In 1911, David Horsley came from New Jersey and purchased the Blondeau Tavern on Sunset Boulevard. There, he hung out the shingle of Hollywood's first studio, the Nestor Film Company. Before the year was out, 15 other firms had set up shop nearby. Three years later, Cecil B. DeMille, Jesse Lasky and Samuel Goldwyn took a giant cinematic step with the release of the first feature-length film, *The Squaw Man*. Made in a barn a block away from what became the corner of Hollywood and Vine, it was a box

Florence Lawrence

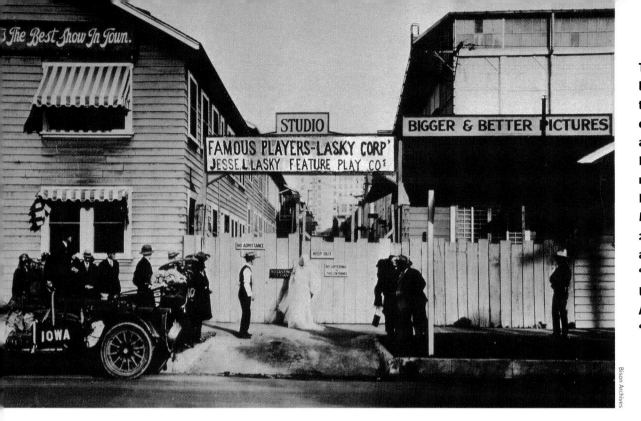

The humble scene at left later gave way to the sort of grandeur one expects from a Hollywood studio. In 1935, Lasky was renamed Paramount Pictures, which, with MGM, Warner Bros., 20th Century Fox and RKO made up the "Big Five." Columbia, Universal and United Artists were the "Little Three."

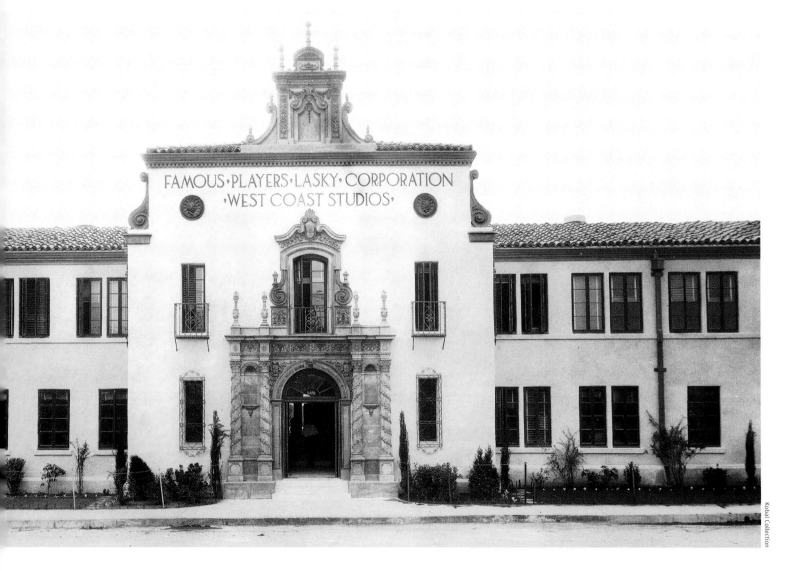

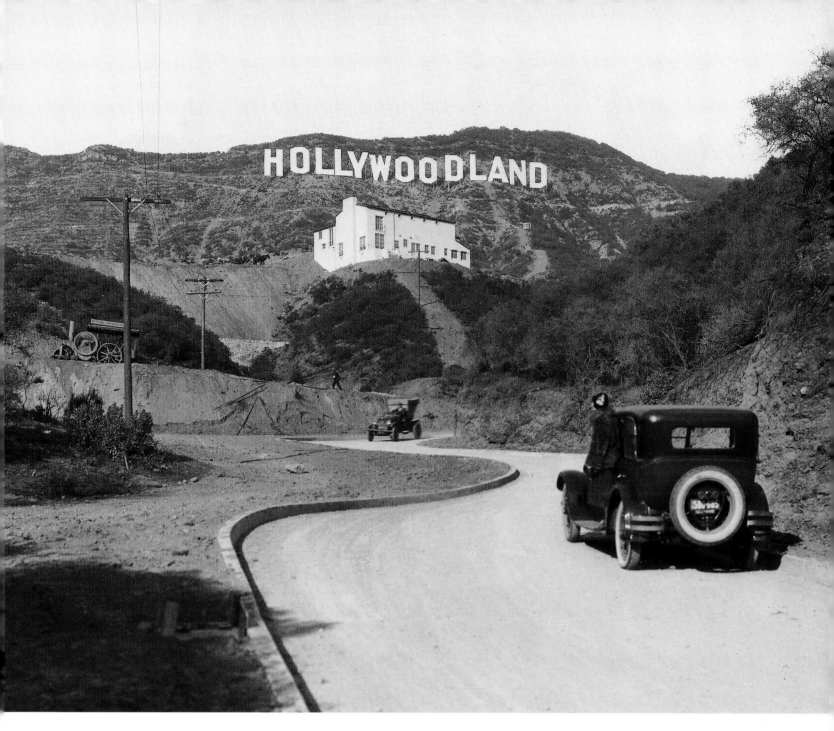

office hit and created a demand for longer movies. (*The Squaw Man* was visionary in a second way: In 1917, *The Squaw Man's Son* took in a good bit of wampum and began a hallowed Hollywood tradition, that of the sequel.) D.W. Griffith raised the bar immeasurably in 1915 with *The Birth of a Nation*, which, its repellent Ku Klux Klan sympathies aside, was the first motion picture piece of art. Weighing in at 190 minutes, it signaled the enormous possibilities of the feature film. Indeed, its very length was important: *Nation* made movies acceptable to a middle class that felt more at ease with a new medium that now provided the familiarity of the-

The famous sign was built in 1923 to lure new buyers to an upscale housing tract. Vandals and time took a toll, and in 1949 the LAND was removed and the other letters renovated. Each is 50 feet tall by 30 wide.

ater-length shows. And these new devotees had higher standards, which meant more money would be sunk into the making of motion pictures.

Movies, said Griffith at the time, will change the world. "The human race will think more rapidly, more intelligently, more comprehensively than it ever did . . . We don't 'talk' about things happening, or describe how a thing 'looks'; we actually show it—vividly, completely, convincingly. It is the ever-present, realistic, actual now that 'gets' the great American public, and nothing ever devised by the mind of man can show it like moving pictures."

Nation was made during World War I, which,

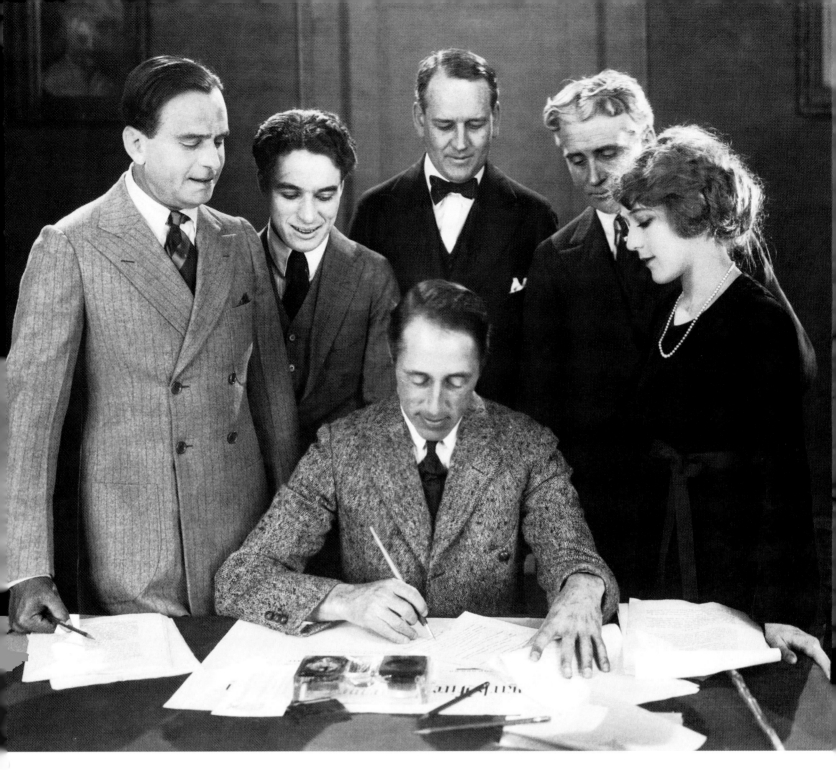

while derailing the European cinema, left American moviemaking as the leader of the pack. Hollywood boasted famous names like Mary Pickford, Douglas Fairbanks and Charles Chaplin, and, as much as anything, the star system defined the American movie. Certainly the great dream factories like MGM, Warners and Fox were the disseminators of the celluloid champagne, but then, as now, people usually chose what they would pay to see by whose name was on the marquee. And then, as now, the cult of celebrity was in full swing. Actors

Griffith signs with the evident approval of his new partners, from left, Fairbanks, Chaplin and, at right, Pickford, in 1919.

lived in fantasy homes in Hollywood (and later Beverly Hills). People were thrilled simply to drive by these castles, hoping beyond hope they might catch sight of a Theda Bara or a Tom Mix. The stars held gala bashes to die for—Harvey Wilcox's dream of a nice temperate village in the fig grove had given way to a pretty good replica of Gomorrah—and wore clothes that were more swell than a bee's knees. There were magazines and books devoted to them, photos of them to cut out and kiss. They were, truly, American royalty.

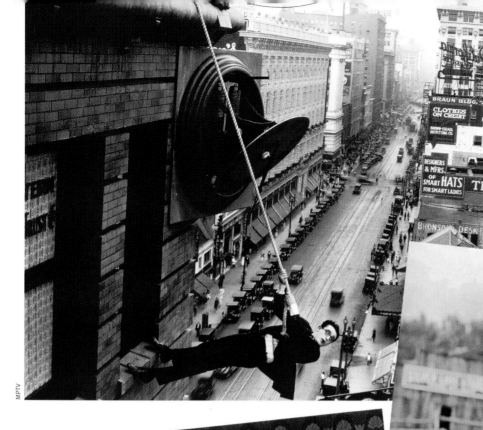

Bettmann/Corbis

MPTV

Culver Pictures

MPTV

Species of star: Harold Lloyd (left) was never more comfortable than when he was scaring audiences out of their wits with aerial artistry. The onscreen character of Tom Mix—honest, good-natured—set the tone for generations of cowpokes to come. Hollywood's first vamp, Theda Bara, dyed her blonde hair black and used her exotic wiles to destroy men from 1915 to 1919.

What we think of as Hollywood quickly became much too colossal to be contained within a section of the City of Angels. It spread across the nation and around the world. Hollywood taught girls and boys, gangsters and decent folk, how to walk and talk and dress. It rescued us from the rigors of the Depression and assured us that we could topple our savage foes in battle. It gave us music and dancing, violence and sex. Movies would later "grow up," but they would always be about laughing and crying, about learning how to live and how to die.

Hollywood can never disappear. We and it are as one.

The Birth of the Oscars

Actually, they weren't yet called Oscars. They were just nice trophies, doled out quickly after dessert, to say, "Well done. Keep up the good work. Now then, let's strike up the band!"

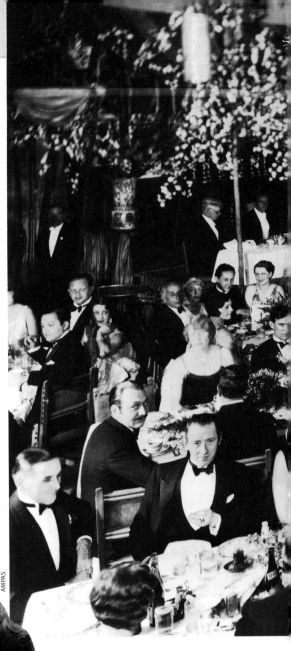

"Give flowers to the living, don't wait until they are dead," said the producer and Academy of Motion Picture Arts and Sciences member Louis B. Mayer on May 16, 1929, in explaining his rationale for these new movie awards that had just been presented. The reception given his words by the 300 glitterati assembled at 36 tables in the Blossom Room of the Roosevelt Hotel was warm, general and certainly heartfelt—Hollywood applauding itself.

While it has ever been thus, it is still safe to say that there has never been an awards ceremony like the first one: The presentation of honors took all of five minutes as Academy president Douglas Fairbanks, who handed out the awards, positively leapt through the proceedings. When the statuettes had been distributed, there were a few self-congratulatory words by such as Mayer and Academy director William C. DeMille, a closing performance by Al Jolson—and that was it.

In the earliest years of the awards, winners were recognized for their work over two seasons, and sometimes for efforts in more than one production. The top 1929 laurels, honoring films from 1927 and 1928, went to *Wings* for Best Production, Emil Jannings (*The Last Command; The Way of All Flesh*) for Best Actor, Janet Gaynor (*Seventh Heaven; Sunrise; Street Angel*) for Best Actress and Frank Borzage, Best Director for *Seventh Heaven.* Said the 21-year-old Gaynor, when asked what had most thrilled her: "Meeting Douglas Fairbanks!"

A postscript: The trophies weren't called Oscars in 1929. Pop legend has it they were nicknamed after the spitting-image uncle of an Academy librarian. Whatever . . . By '34, Walt Disney was thanking the Academy for his "Oscar."

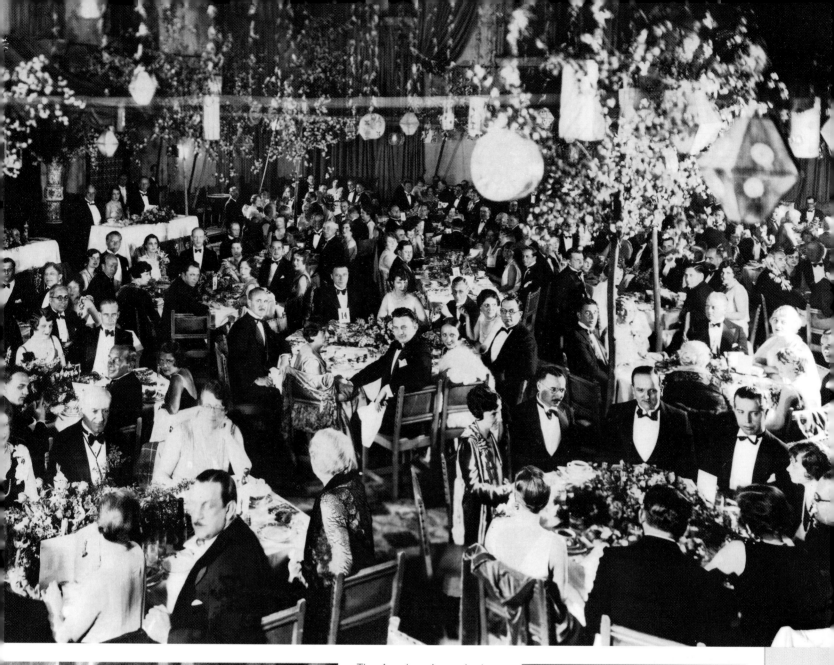

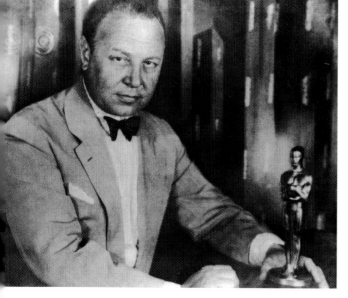

The Academy's opulent second-anniversary banquet at the Hollywood Roosevelt in 1929 was the occasion of the first presentation of Academy Awards. Handing out the trophies that evening was Academy president Fairbanks (opposite), while among the recipients, not all of them present at the dinner, were the blushing Gaynor, the serious Jannings (left) and the positively somber Borzage.

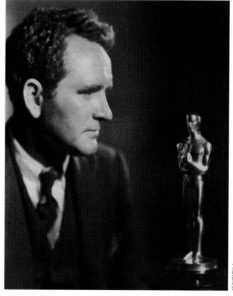

Photofest

A Family Tradition

Politics has its Bushes and Kennedys, baseball its Bondses and Griffeys. And so it is with Hollywood, with its vast cast of Fondas, Hustons and especially Barrymores. It's not easy filling large shoes, but some children do persevere and prevail, making their parents proud.

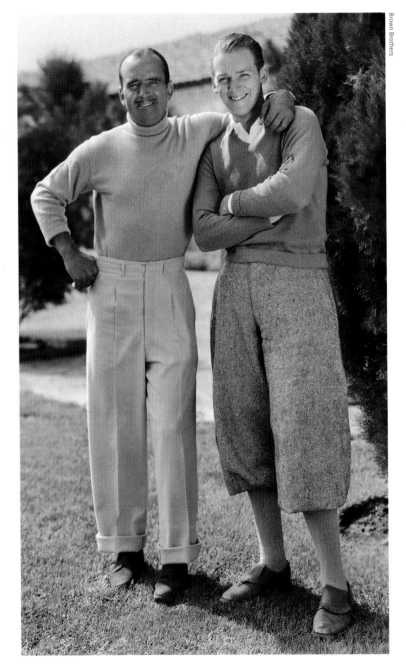

Brown Brothers

Fairbanks
Dad's Legacy: Swashbuckler

Douglas Fairbanks was an immensely popular silent-film star. Born in Colorado to a Jewish father and southern belle who split up early on, he was first the all-American boy, then drew on his athleticism to do his own stunts in thrilling adventures. About the time talkies arrived, his energy flagged and he soon retired. Offscreen, he wed Mary Pickford, but it was with wife Anna Beth that he sired Douglas Jr.—reduced in the shadow of his father, but an affable screen-strutter himself in *Gunga Din* and *Sinbad the Sailor.*

Douglas
Dad's Legacy: Leading Man

Papa Kirk, a master of film noir, westerns and war movies, once noted, "I've made a career of playing sons of bitches." Michael, one of his four sons, has taken some strides in that direction himself. Douglas the younger was a very bad boy as a vicious stockbroker in *Wall Street,* as an errant husband in *Fatal Attraction,* and as a man who battles his wife to the death in *The War of the Roses.* And just like his father, he was riveting in every one of them. These are two of the best actors of the past half century.

Lisa Larsen

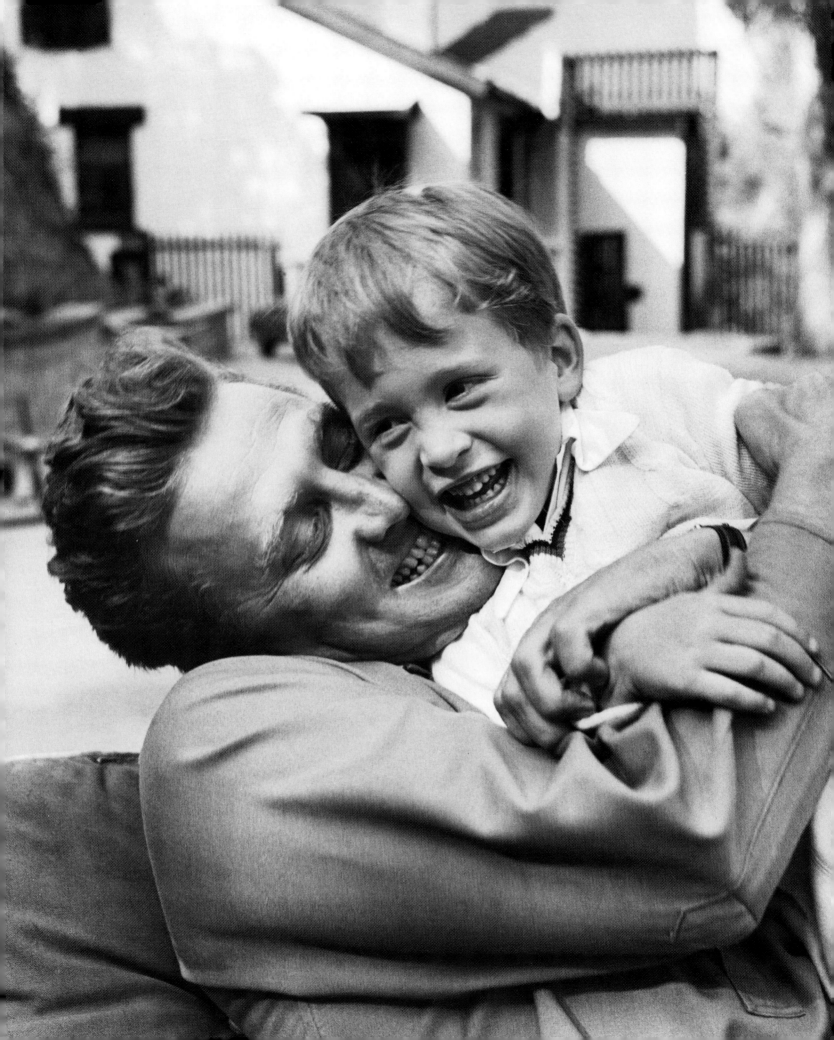

Barrymore Profile of a Dynasty

America's First Family of Acting isn't really the Barrymores, it's the Drews. In the mid-19th century, John and Louisa Drew had three children, and Maurice, John Jr. and sister Georgie took to the stage. An English emigrant to America named Herbert Blythe had a similar hankering, and changed his name to Maurice Barrymore to spare his family the shame of having an actor in the family. Maurice became a stage star, as did all three of the children that he and Georgie had after they met and married. Lionel, Ethel (for whom the term *glamor girl* was coined) and John (the Great Profile) moved the family business from Broadway to Hollywood, where John's son, John Drew, and granddaughter, Drew, kept the torch burning.

Opposite: The mustachioed John Drew Jr. was the brother of Georgiana Emma Drew, who, after marrying Maurice Barrymore (top left), gave birth to Lionel, Ethel and John (with their mother, and above). John's son, John Drew Barrymore (right), is Drew's pa.

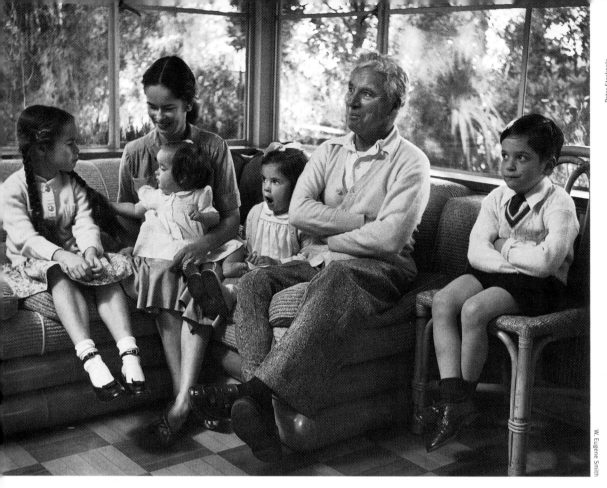

Chaplin The King of Comedy and His Princess

Charlie Chaplin's marriage to Eugene O'Neill's daughter Oona produced eight children; seen here with their parents in 1952 are Geraldine, Victoria, Josephine and Michael. While several of the kids dabbled in the movies, Geraldine distinguished herself. She was discovered by director David Lean at the Royal Ballet School in London and cast in 1965's *Doctor Zhivago.* Her finest performances have been in several Robert Altman films and, eerily, playing Charlie Chaplin's crazed mother—her own grandmother—in Richard Attenborough's 1992 biopic, *Chaplin.*

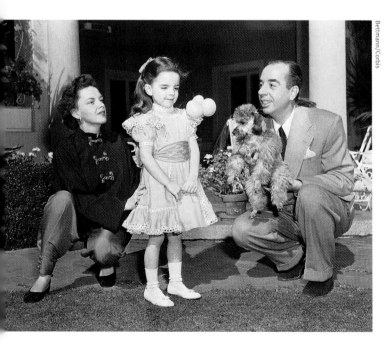

Garland and Minnelli
The Movie Musical's First Family

Judy Garland was the foremost female singer the movies have ever produced, in the likes of *Babes in Arms, The Wizard of Oz* and *A Star Is Born.* But, as Bing Crosby said, "There wasn't a thing that gal couldn't do—except look after herself." Vincente Minnelli, the director of such musical gems as *Gigi* and *Meet Me in St. Louis* (featuring Judy), was also adept with sturdy stuff like *Some Came Running.* Their gifted daughter Liza won an Oscar for *Cabaret.*

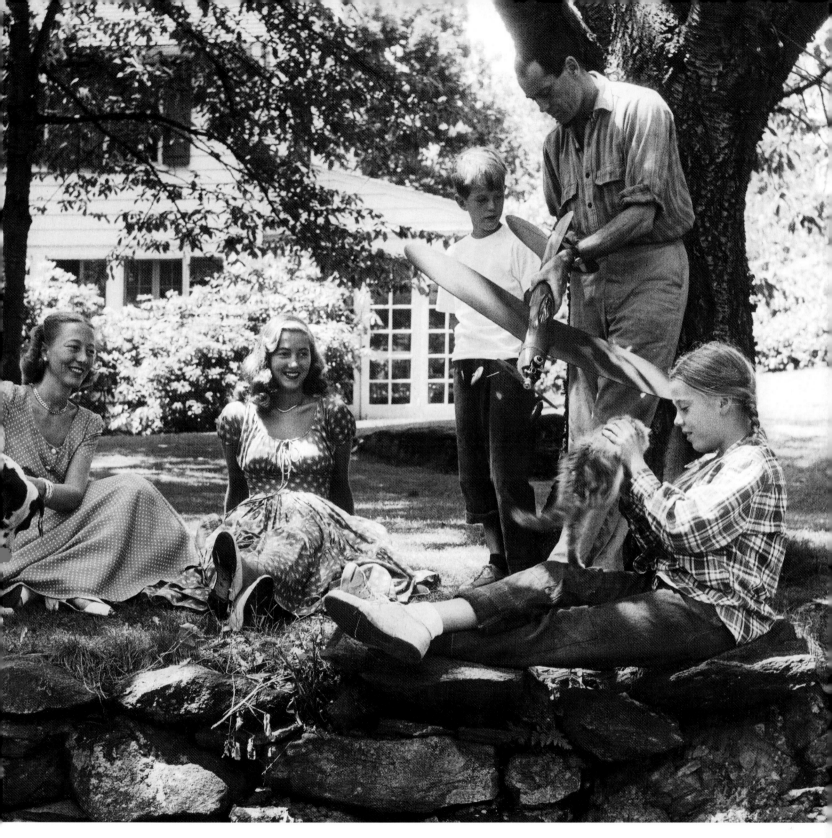

Fonda American Icon, American Rebels

Henry fixes a plane for son Peter in 1948; Peter's mother, Frances, holds the dalmatian as she sits next to her daughter from a previous marriage, Frances Brokaw; Peter's sister, Jane, plays with the cat. The calm of the Connecticut suburbs was distant in the rearview mirror by the time Peter blazed to counterculture stardom in the seminal 1969 film *Easy Rider*. His sister, already famous as an actress, was becoming known as Hanoi Jane for her antiwar politics. Both survived the '60s, and Jane went on to have a triumphant career, while Peter made a comeback in 1997's *Ulee's Gold*. And now it's his daughter Bridget's turn.

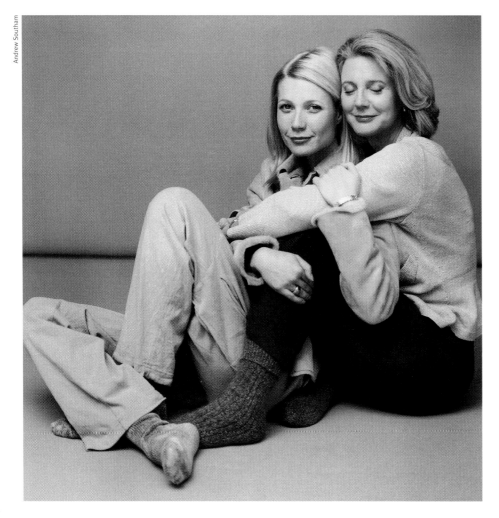

Andrew Southam

Loomis Dean

Paltrow and Danner
Blithe Spirits

In some cases, the child outdoes the parent—and nothing could make the parent happier. Blythe Danner, long esteemed for her work on screen and, especially, stage—she won a Tony in 1970 for *Butterflies Are Free*—moved East with her husband, director Bruce Paltrow, when their daughter, Gwyneth, was 11. The family wanted to be near the Williamstown, Mass., Summer Theater, with which Bruce and Blythe were both affiliated. In Williamstown, Gwyneth learned to act, and appeared alongside her mother in a production of *Picnic*. She was in the movies while still a teenager, and won the Oscar for *Shakespeare in Love* at age 26. In accepting, she thanked her parents—and no one was surprised.

Huston Against the Grain

Their cinematic éclat was begat in 1929 when Walter became the talkies' first notable character lead; intensified with triple-threat son John; and will glow as long as granddaughter Anjelica performs. Walter (né Houghston) delivered countless adult performances. When accepting his Oscar for *The Treasure of the Sierra Madre* (right, on the set, with Pablo, a local orphan whom John would adopt), he said he had told his son, "'If you ever become a writer, try to write a good part for your old man sometime.' Well, by cracky, that's what he did!" John wrote and/or directed scores of such classics as *The Maltese Falcon, Fat City* and *Prizzi's Honor,* in which daughter Anjelica starred, and was a cad for the ages in *Chinatown.* Opposite, dancing in 1966.

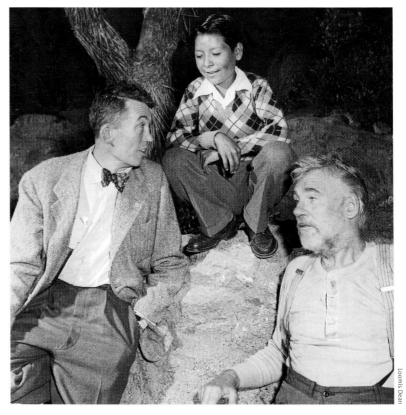

Loomis Dean

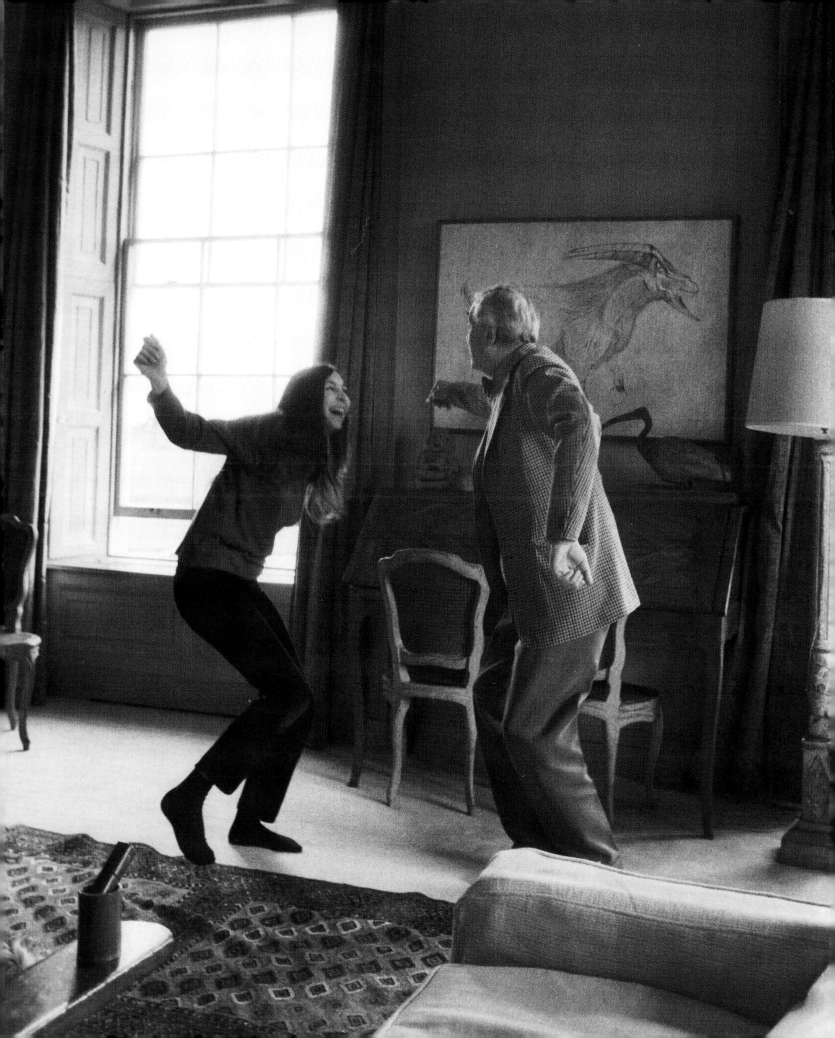

The Man Who Made the Oscar

The Academy wanted a trophy, but not just any trophy. The artist assigned to design it became quite a collector of his own handiwork.

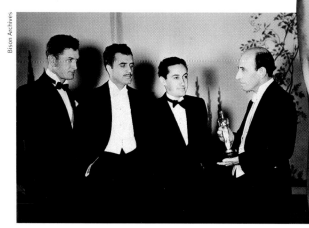

Cedric Gibbons, born in Brooklyn in 1890, inherited the aesthetic sense of his father, a prominent architect. The son even tried his hand at Dad's business, but before long became bored as a draftsman. In 1914 a painter who was creating murals for Thomas Edison's movie company asked Gibbons if he would like a job as an assistant. Gibbons leapt at the chance and in short order had more than 100 movies on his résumé. In 1916, Samuel Goldwyn hired him as art director of his nascent film company, and when Gibbons was discharged from the Navy after World War I, he was told by the boss to go west. The young man did, and in Hollywood embarked on a career that was as successful and influential as any in film history.

When Goldwyn's studio merged with others to form Metro-Goldwyn-Mayer in 1924, Gibbons found himself in charge of a design department that would, during his 32-year tenure, represent the heart and soul of moviemaking's most storied dream factory. He was from the get-go regarded as a master of sumptuous set design, and was an early and well-respected Hollywood insider. When the Academy

Bison Archives

Oscars: AP

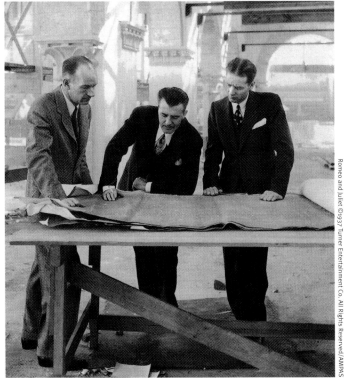

Opposite: Gibbons, second from left, admires his 1928-29 Oscar for *The Bridge of San Luis Rey.* He designed the art deco statuette, as well as the home where he and Del Rio pose by the hearth. Above: Fine-tuning the look of *Romeo and Juliet* in 1936. Below: an Oscar logjam on the bookshelf.

of Motion Picture Arts and Sciences launched its grand awards program in 1929, it had sitting on its board a fitting candidate to design a fitting tribute. The resultant statuette represented the elegant, art deco side of Gibbons. To judge the man's breadth, consider that he designed not only the sultry Garbo classics but also the stylish *Thin Man* films. He went on to win Oscars of his own for the lavish *Pride and Prejudice* and *Little Women;* the atmospheric *Gaslight* and *An American in Paris;* the stark *The Bad and the Beautiful* and *Somebody Up There Likes Me.*

He won 11 in all, having been nominated an astonishing 39 times. With his success, his standing in the industry and a glamorous personal life—he and first wife Dolores Del Rio, one of the town's most exotic women, lived in a deco mansion of his design overlooking the Pacific during the 1930s—Gibbons was a prince of Hollywood's Golden Era. He died in 1960, his legacy secure.

The Men of a Million Faces

If ever a lineage has left its mark on Hollywood, it is the Westmore clan. They have been plying their trade for nearly as long as there have been feature films. They invented the make-up department, and have molded the look of countless stars. And the rouge is still flowing.

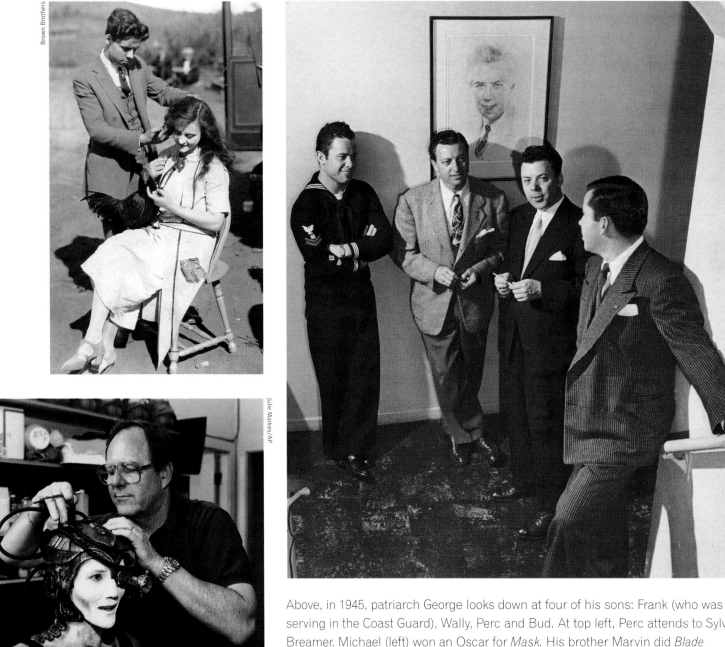

Above, in 1945, patriarch George looks down at four of his sons: Frank (who was serving in the Coast Guard), Wally, Perc and Bud. At top left, Perc attends to Sylvia Breamer. Michael (left) won an Oscar for *Mask*. His brother Marvin did *Blade Runner*. Their father, Monty, was another of George's sons. He died shortly after supervising *Gone with the Wind*. Opposite: Wally assists Claudette Colbert in 1936.

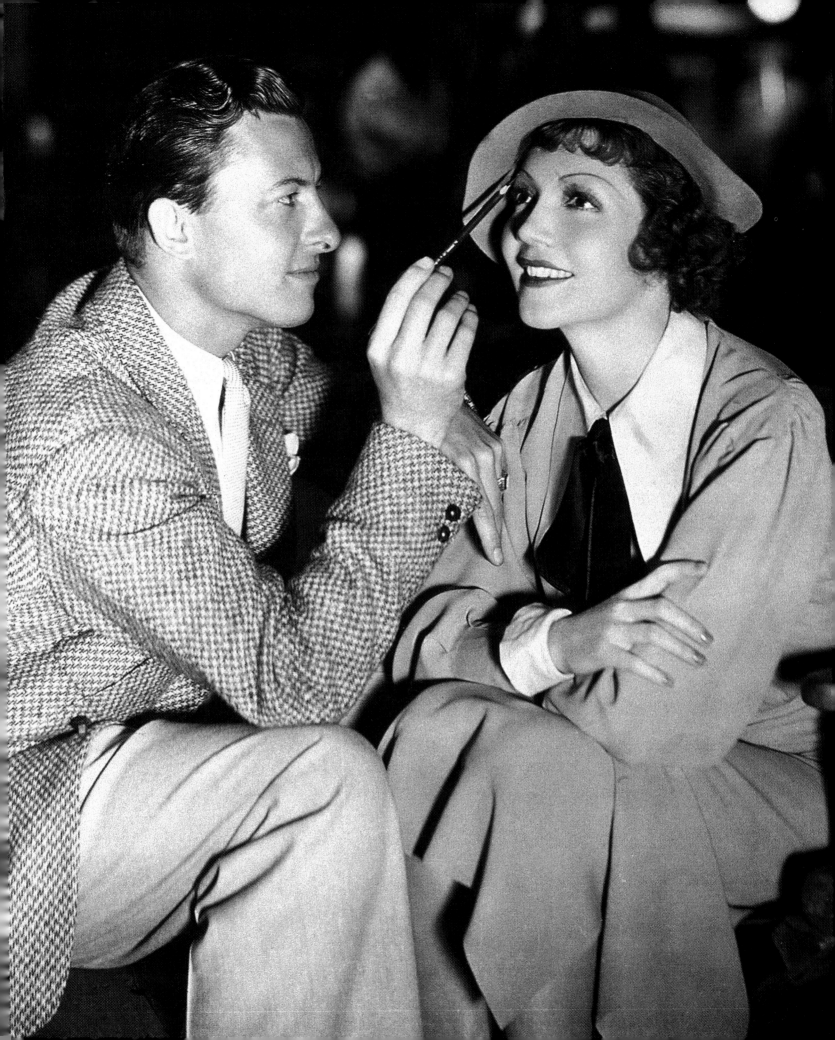

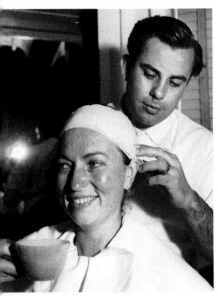

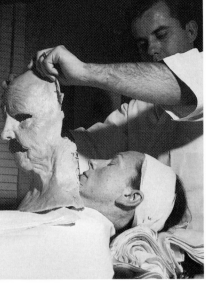

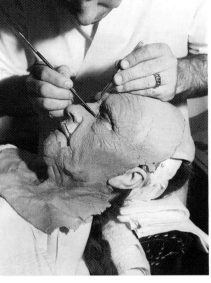

Kobal Collection: AP (2); Bob Landry

For *The Lost Moment*, a 1947 version of Henry James's *The Aspern Papers,* Bud spends five hours daily turning Agnes Moorehead into a 110-year-old woman using liquid adhesive, a rubber mask and rubber grease in which wrinkles are etched. Then the whole business is powdered. The script called for her to age to 105, but Bud thought it would be fun to tack on another five years.

John Dominis

Bob Landry

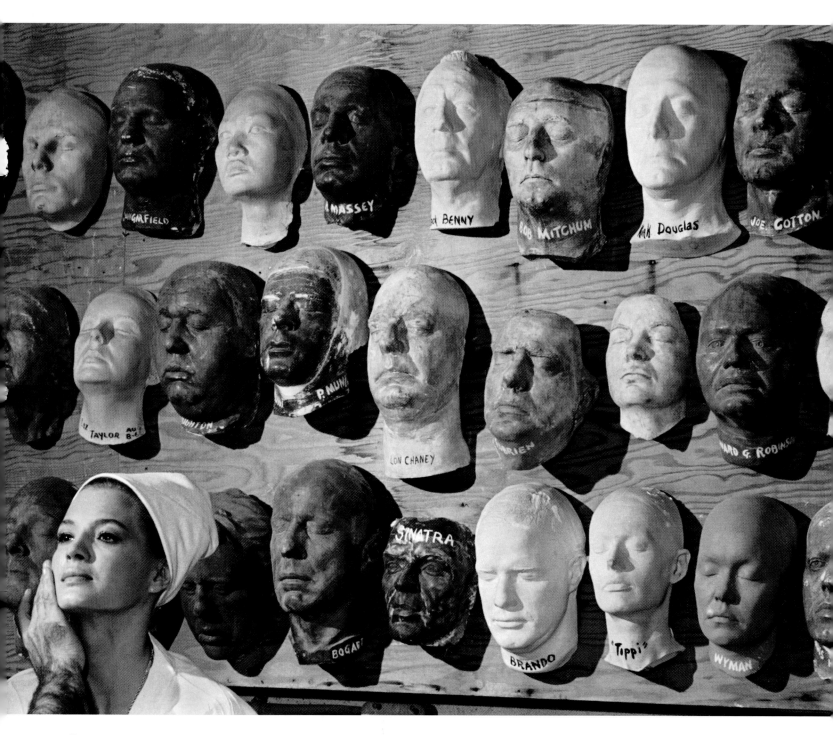

George, a wig-maker born in England, started the whole thing in 1917 when he created the first studio makeup department, at Selig. He would go on to work with Pickford and Fairbanks and the Gish sisters, but his efforts began to pale compared with those of his sons, and events led to his suicide in 1931. In fact, the family was long plagued by bickering and emotional problems, although this didn't keep them from monopolizing the industry. For ages, nearly every major film had a Westmore doing makeup. Monty was at Selznick; Perc headed Warners for 27 years; his twin, Ern, was at RKO and Fox; Wally was makeup chief at Paramount for 41 years; Frank Worked constantly; Bud ran Universal from 1946 to '70 (above, he is making a mask of Angie Dickinson in 1963— the masks are used as models for complicated jobs). For 30 years they also ran an elegant salon on Sunset Boulevard, the House of Westmore. In the '80s a female joined in the act when Marvin's daughter Kandace began working. At the risk of gilding the lily, it should be mentioned that her brother Kevin is, yes, a makeup artist. In recent years, Westmores have also become adept at therapeutic makeup for burn and accident victims.

Alfred Eisenstaedt in Hollywood

By 1936, the former exurban L.A. fig grove had been thoroughly replanted as Tinseltown. In that year, LIFE's master photographer took a tour round town with his Leica camera, capturing a singular, slightly surreal rendering of the American dream.

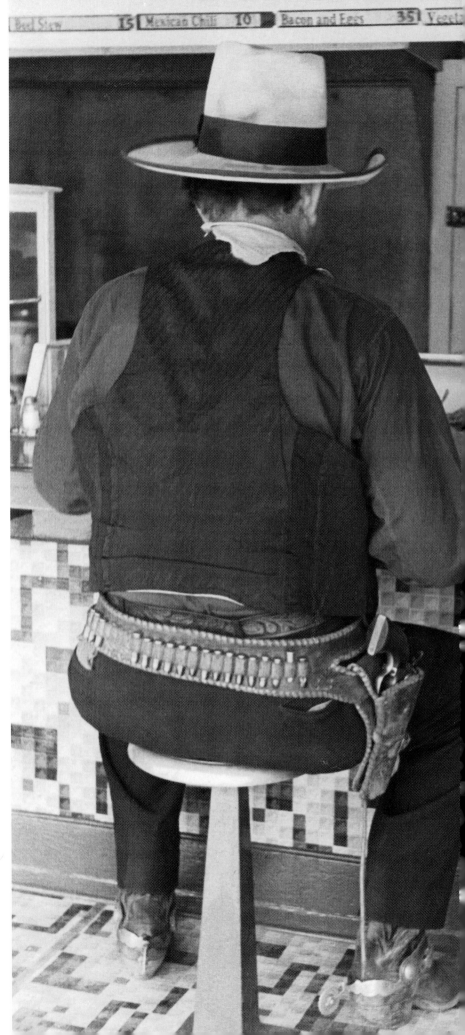

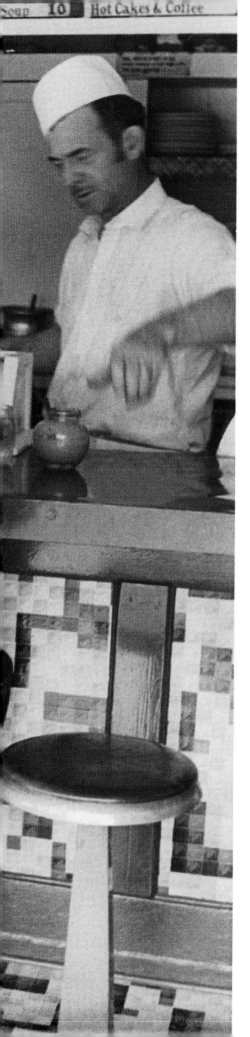

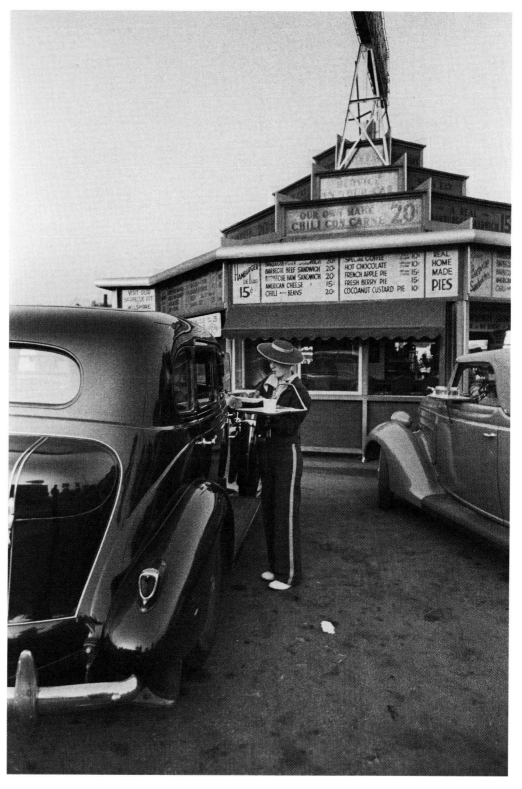

Eisenstaedt, like many LIFE photographers of the era, could do it all: portraiture, photojournalism, the photo essay. His pictures of such stars as Monroe and Loren remain definitive. His sailor-kissing-the-nurse and kids-at-the-puppet-show are signal 20th century images. Sometimes the assignment would be to "bring back the story"—the multipicture narrative that tells what is happening in a particular place at a particular point in time. In Hollywood in '36, what was happening included soda-swilling Indians, lunch-break cowpokes chowing down at the diner, and a fancy for fast food.

Hollywood attracted busload after busload of young movie star wannabes who spent their days sleeping in or hanging out, waiting for The Call. Tourists came too, in a swelling stream, and paid real money even in hard times for just a glimpse of stars who appeared, to them, larger than life.

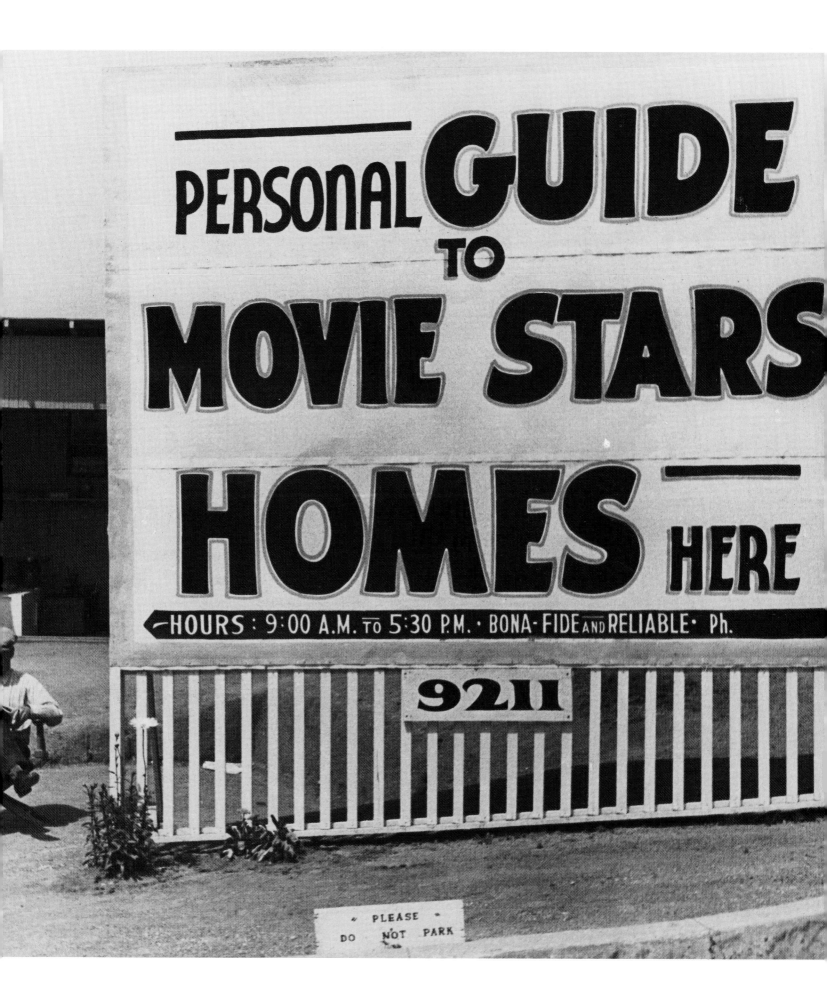

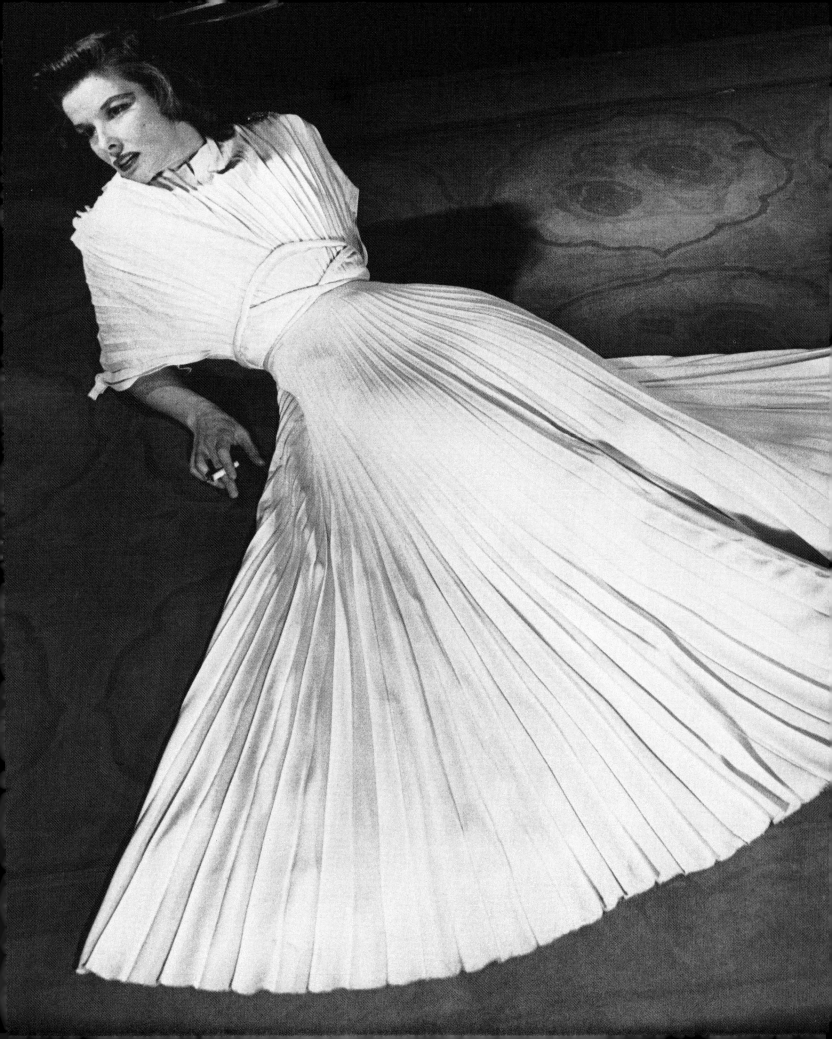

Larger Than Life

This is all about *je ne sais quoi.* It's about an elusive quality, an otherness, that is held in kind by certain stars. A genius acting ability isn't the sole or even principal criterion. While Katharine Hepburn had whatever "it" is, her dear friend Spencer Tracy somehow did not, not quite. Chaplin had it, of course, as did Brando and Garbo and Harlow. The word *charisma* doesn't quite capture it. *Transcendence* comes closer to the mark. Those who possess it have always attracted courtiers in the form of directors and photographers who seek to capture the quicksilver element on film—somehow bottle the magic, preserve it forever. Among the legendary lensmen have been some of LIFE's greatest photographers, as this gallery attests.

Katharine Hepburn *Photograph by Alfred Eisenstaedt*

Assessing how snugly *The Philadelphia Story* fit its star, LIFE wrote, "Its shiny surface reflects perfectly from her gaunt, bony face. Its languid action becomes her lean, rangy body. Its brittle smart talk suits her metallic voice. And when Katharine Hepburn sets out to play Katharine Hepburn, she is a sight to behold. Nobody is then her equal." The 1940 film turned an acclaimed actress into a Hollywood star. She earned a record 12 Oscar nominations and four statuettes.

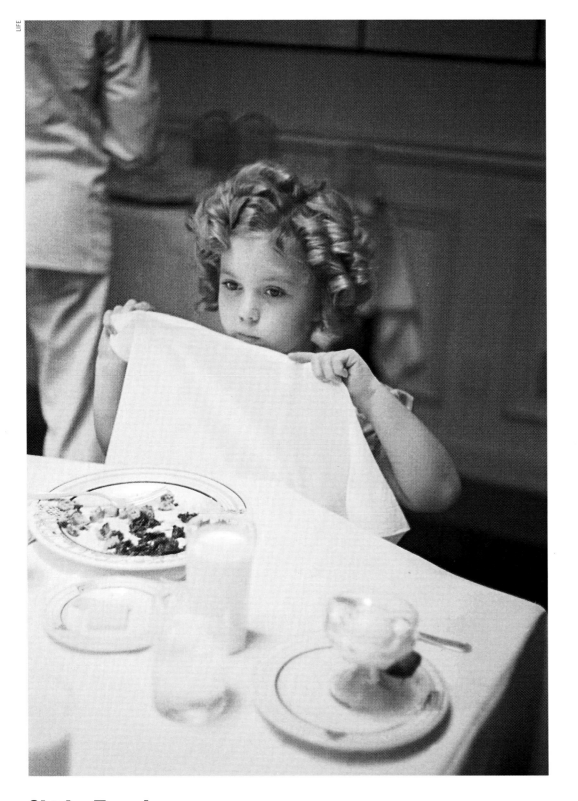

Mary Pickford
Photograph by DeGaston

Born in Toronto in 1892, the girl destined to become America's Sweetheart was onstage by age six. She got into the movies as a sideline in 1909, making pictures with D.W. Griffith's New York–based Biograph film company during downtime on Broadway. The fate of "Our Mary" was sealed when her lovely, silent image captured—or broke—hearts coast to coast. She went west, eventually making 236 pictures, founding United Artists with Charlie Chaplin and others, and holding court at Pickfair. She really did have a sweet heart, fronting for charitable causes and even, during World War II, allowing her estate to be used for USO swimming parties.

Shirley Temple *Photograph by Alfred Eisenstaedt*

Although she enjoyed success in later life, for example as a U.N. delegate, it was impossible for Shirley Temple Black to approach the standards set by Shirley Temple the child star, who was "just like the girl next door—provided, of course, you live in heaven." She was only three when she had her first role in 1932, and for the next eight years films like *Dimples* and *Curly Top* ruled the screen. Saccharine? Yes, but just the pick-me-up the world needed in those gloomy times.

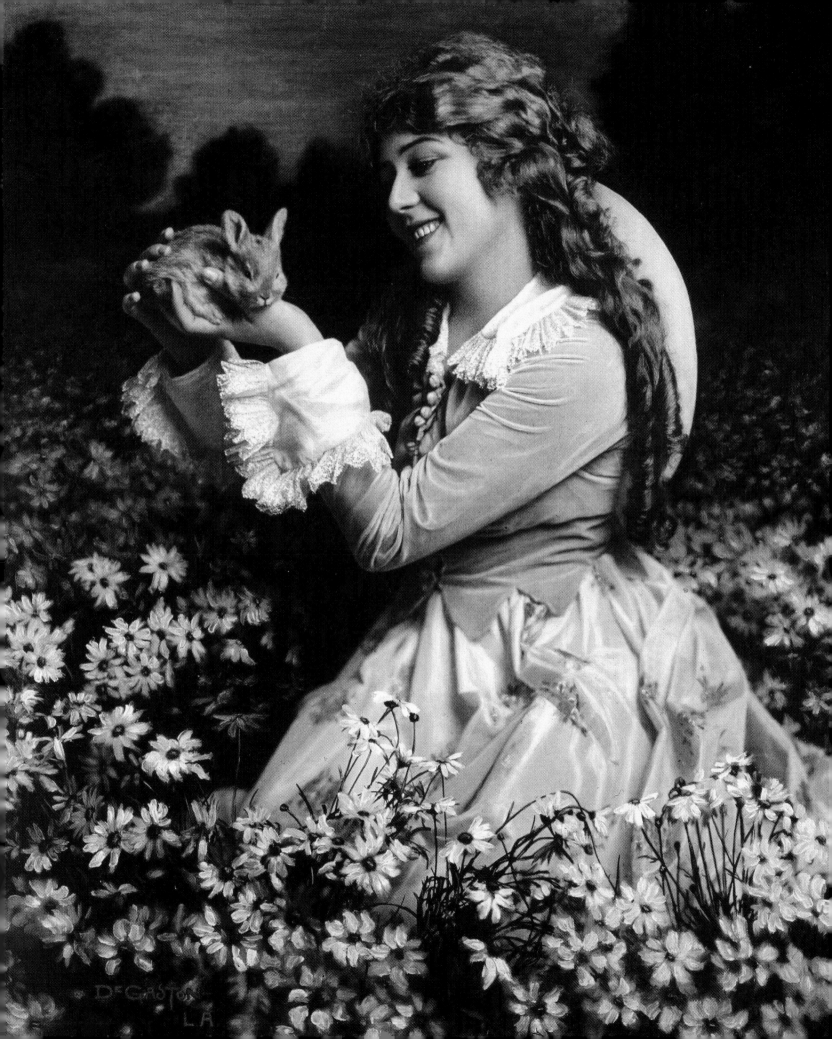

DeGASTON
LA

James Cagney *Photograph from Grand National Studios*

He was the most electrifying performer in the history of motion pictures, entirely original and dead-on serious about his craft. The son of an Irishman and his Norwegian wife, he grew up in New York, and the vitality of the city streets forever colored his work. Stardom arrived with the blistering 1931 gangster film *The Public Enemy.* From there he danced us off our feet in *Yankee Doodle Dandy* and made us laugh, really laugh, in *Blonde Crazy.* Bright, humane, and a genius.

Fred Astaire
*Photograph by
Robert Landry*

Could it be true that he might have slipped through the cracks? That the early assessment, "Can't sing. Can't act. Slightly balding. Can dance a little," might have held sway, and this, the most urbane of actors, loveliest of all dancers, pleasantest yet hardest-working man in the business, might have danced upside-down in obscurity rather than singing sublimely the greatest songs of the century and soaring deliciously and divinely with Ginger Rogers, a cane, a hat tree (!), and the hearts of millions of people drowning in the despair of the Depression? Ladies and gentlemen, Fred Astaire!

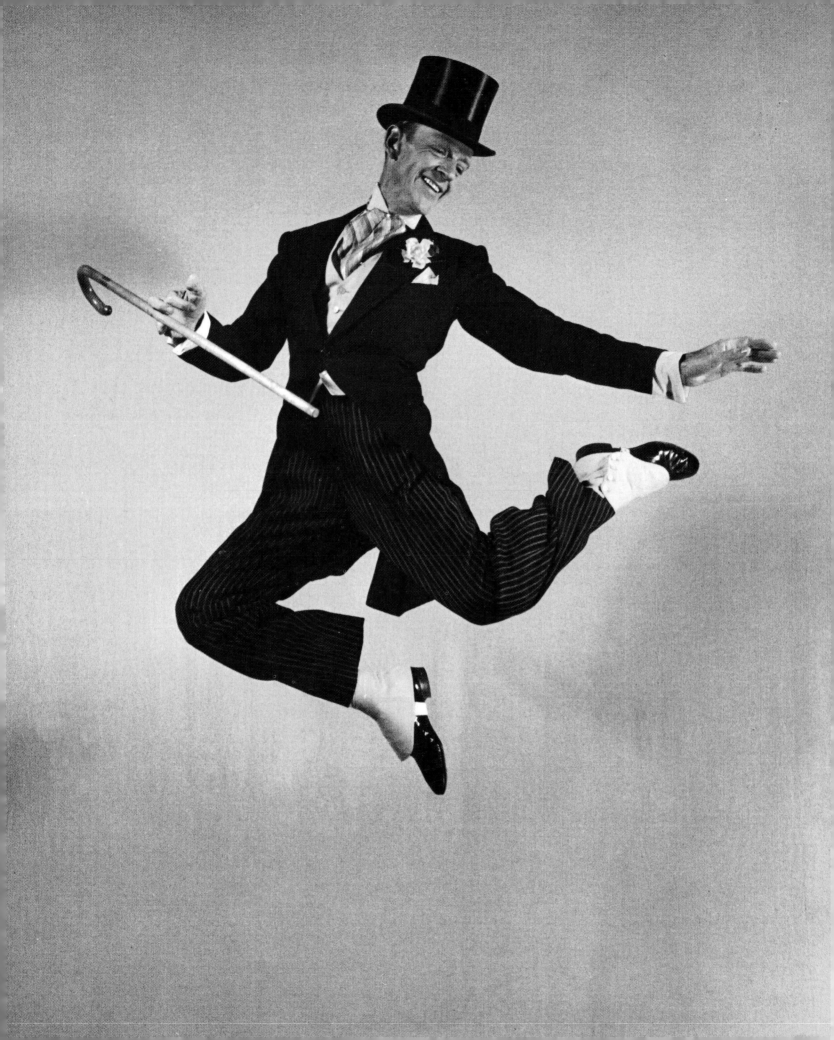

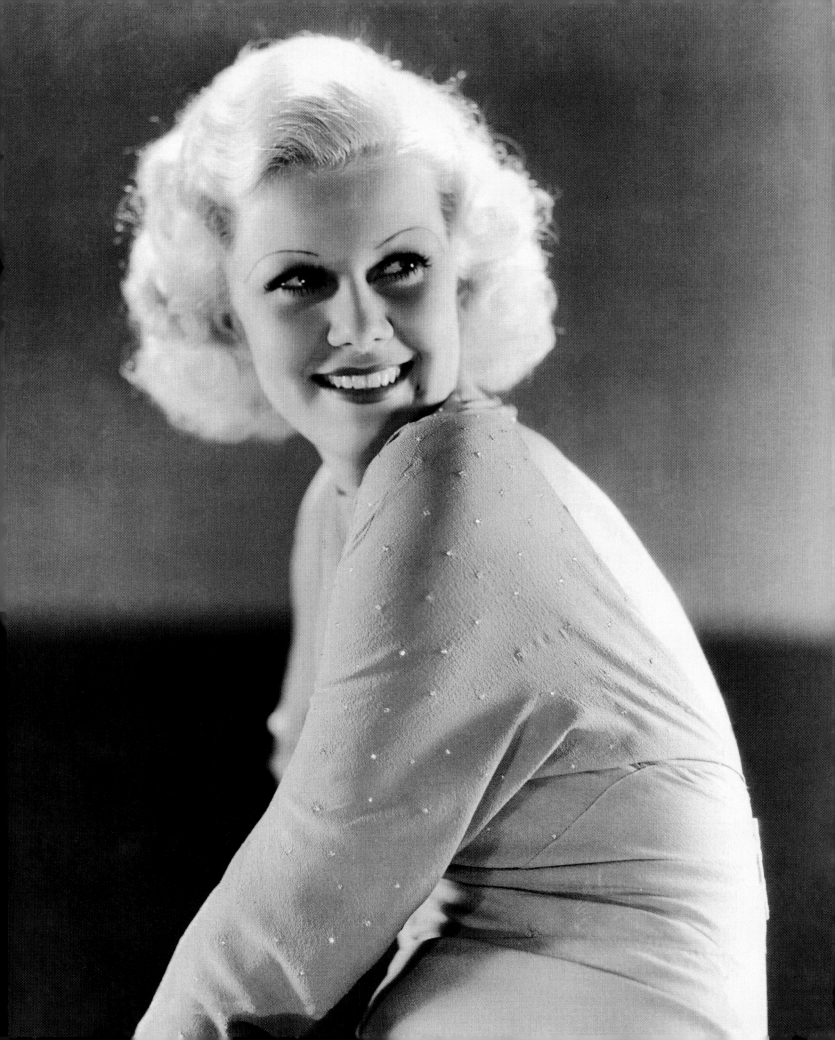

Jean Harlow

Photograph from Metro-Goldwyn-Mayer

With her platinum blonde hair, curves aplenty and disdain for underwear, she became the first sex goddess of the talkies era. In 1930's *Hell's Angels,* she turned up the burners when she asked a suitor, "Would you be shocked if I changed into something more comfortable?" Although audiences loved her, it took the critics a while to realize Harlow wasn't just gorgeous, she was electrifying in comedy or drama. On May 3, 1937, she became the first movie actress to appear on the cover of LIFE; a month later she was gone. *China Seas, Bombshell, Dinner at Eight* . . . How many more would there have been if she hadn't died at age 26 of a kidney ailment?

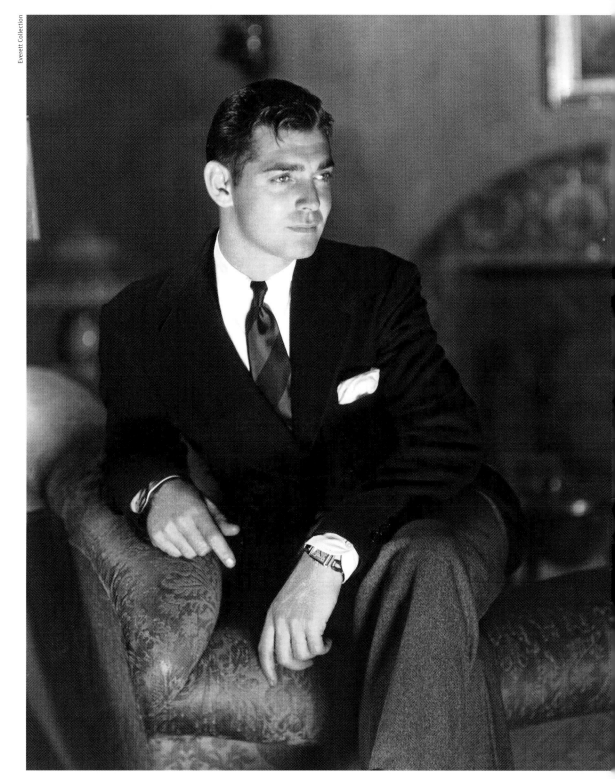

Everett Collection

Clark Gable *Photograph by Clarence Sinclair Bull*

No, he didn't descend from Olympus, but he was, as Joan Crawford said, "the King of an empire called Hollywood." Films like *Red Dust* and *Gone with the Wind* put him on top. Then, in 1942, when his beloved wife Carole Lombard died, the inconsolable Gable famously enlisted in the Army Air Corps, where he served with dignity. Afterward, the hits were there, if fewer, and three decades of stardom ended when this man's man died after completing *The Misfits* in '61.

Bette Davis *Photograph by Alfred Eisenstaedt*

The New Englander made her way west via Broadway, but when she arrived in Hollywood in 1930, a studio rep assigned to pick her up returned alone because no one at the train station had looked like a movie star. After a wheel-spinning start at Universal—"as much sex appeal as Slim Summerville," said one exec—she soared with Warners, winning Oscars for *Dangerous* and *Jezebel*. Compelling, bold, indomitable, Davis was a force: "I will never be below the title."

Joan Crawford
Photograph by George Hurrell

"Movie stars? I don't like the name," said Humphrey Bogart. "The words 'movie stars' are so misused they have no meaning. Any little pinhead who does one picture is a star. Gable is a star, Cooper is a star, Joan Crawford, as much as I dislike the lady, is a star, but I don't think the so-called others are." She was the only star to reign from the silents till the '60s, as nothing— *nothing*—would keep Lucille LeSueur of San Antonio from being Joan Crawford of Hollywood. And because her need was so palpable, you never, ever could take your eyes off her. By the end, Lucille LeSueur had vanished, and there was only Joan Crawford.

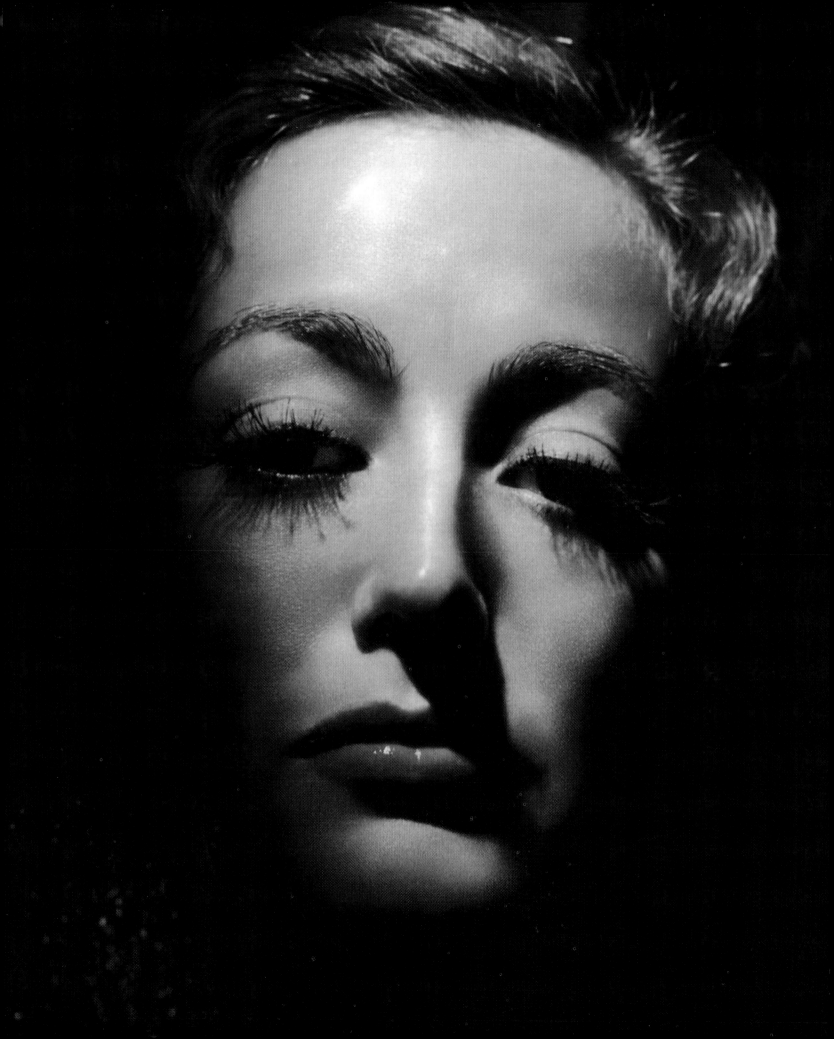

Mickey Mouse *Drawing from Walt Disney*

His range may have been somewhat limited, but no other actor is better known. Mickey debuted in 1928's *Steamboat Willie*. Walt Disney, of course, created him, and provided his voice, although the little mischief-maker was usually drawn by Ub Iwerks. Mickey's impact was such that he brought home an honorary Oscar to Disney as early as 1932, and the likes of *Fantasia* were yet to come. Just take a look at Mickey—nobody has ever made us feel happier.

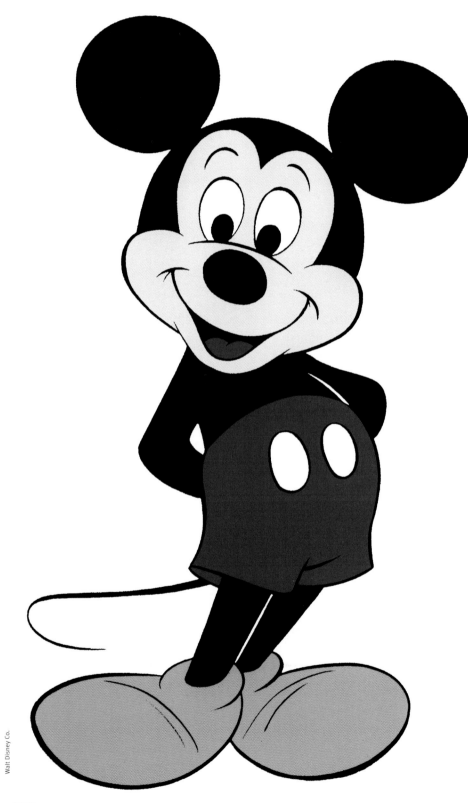

Charlie Chaplin
Photograph by Edward Steichen

Preeminent among all film comedians and one of the cinema's seminal auteurs, Chaplin was born in England in 1889—in the same month and year as Hitler, whom he would savagely impersonate in his 1940 film, *The Great Dictator.* A vaudeville prodigy, he emigrated to the U.S. in 1910 and began making a lengthy series of two-reelers. *The Kid, The Gold Rush, City Lights* and *Modern Times*—all with variations of Chaplin's brilliantly realized Little Tramp—are silent classics, while *Monsieur Verdoux* and *Limelight* are memorable talkies. The incomparable Sir Charles died on Christmas Day, 1977.

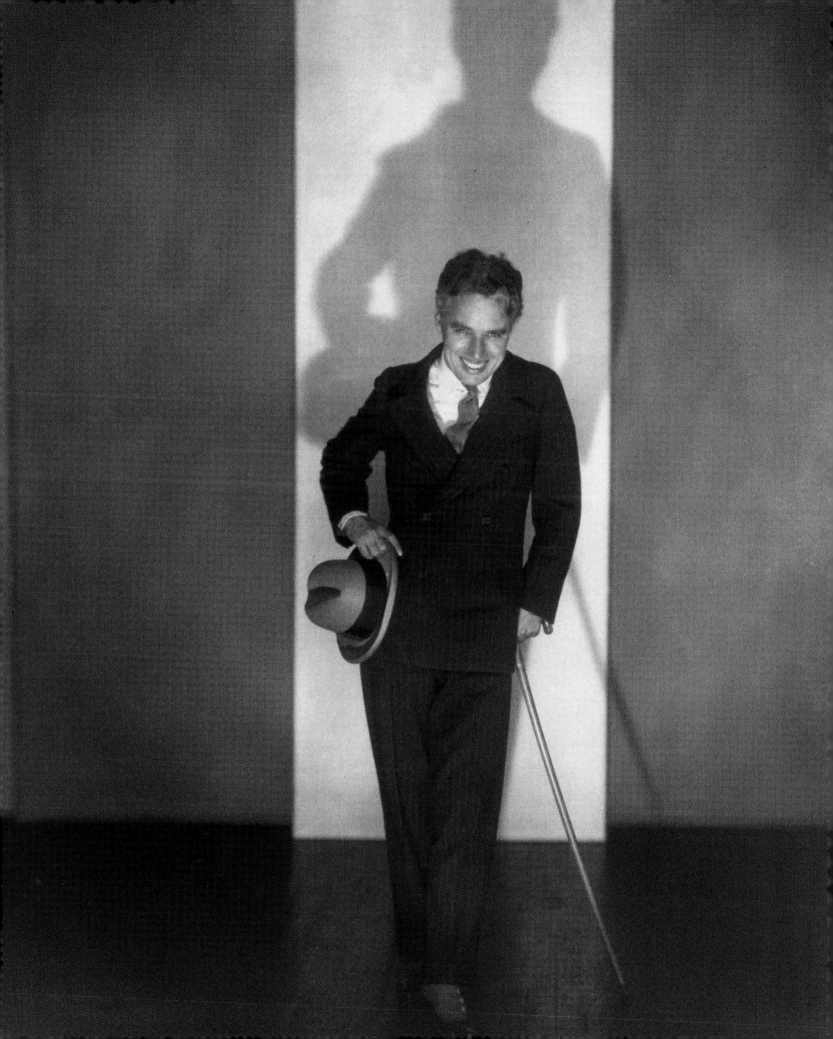

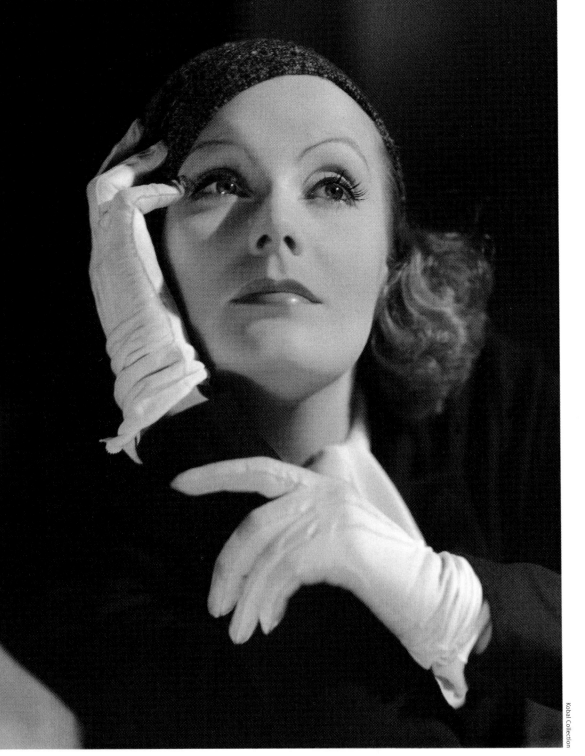

Kobal Collection

Marlene Dietrich
Photograph by
Alfred Eisenstaedt

When *The Blue Angel* and *Morocco* opened in the U.S. in 1930, the sultry Berlin-born singer and actress became a sensation. LIFE said director Josef von Sternberg and his leading lady had created a "magic myth" of a woman. But Dietrich was no myth; she was a woman of substance. Having ignored Hitler's entreaties to return, she went the opposite way, all but forsaking her career to appear 500 times before Allied troops, working as close to the front as she could. She called her war effort "the only important thing I've ever done."

Greta Garbo *Photograph by Clarence Sinclair Bull*

A legend unsurpassed, she was Garbo: immeasurable talent, ethereal beauty, perfection of gesture, and a heart-wrenching solitude that was just beyond repair. She seemed always to be resisting her proper place in a world of manna and nectar, instead remaining tethered to an ungraspable melancholy, even misery. Despite it all, or perhaps because of it, she was—in such as *Anna Christie* and *Camille* —the most unforgettable actress of the 20th century.

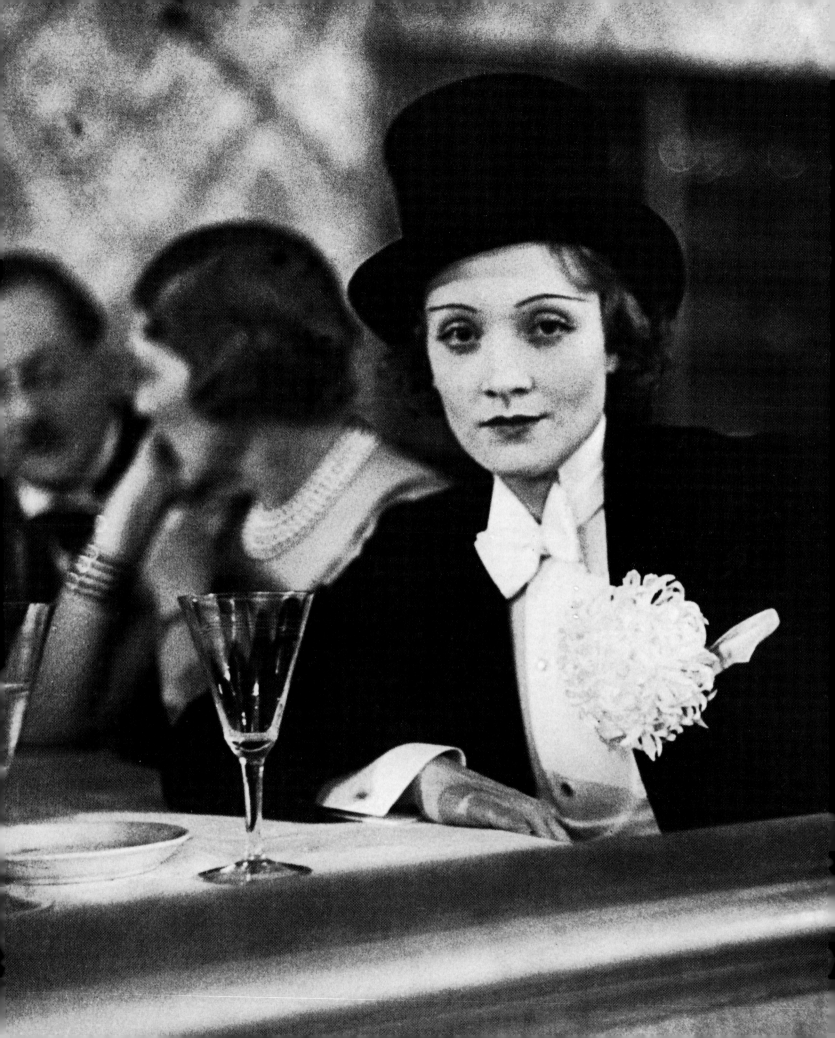

Errol Flynn *Photograph by Peter Stackpole*

The most dashing actor of the sound era had plenty of swash as well as buckle, both on- and offscreen. He was a natural in costume, and no one will equal his thrilling Robin Hood, Captain Blood or General Custer. But Flynn took little seriously except booze, boats (his mother descended from Fletcher Christian), belly laughs and babes. Though acquitted of statutory rape in 1943, the very public trial took something out of him—and the lifestyle stole his beauty.

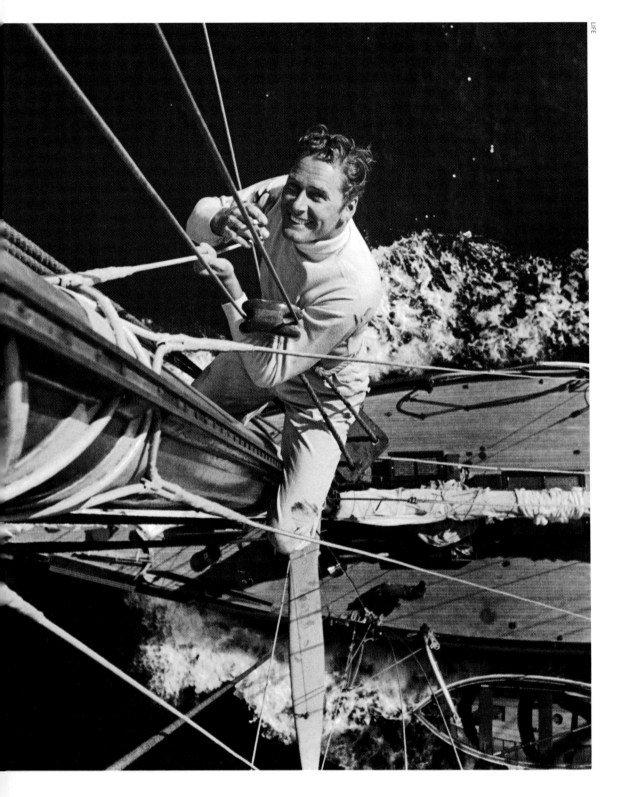

The Marx Brothers

Photograph by Allan Grant

For the French writer Antonin Artaud, the films of the Marx Brothers were "a kind of boiling anarchy, an essential disintegration of the real by poetry." Certainly that stateroom in *A Night at the Opera* suffered a form of disintegration, and that hotel suite in *Room Service* ("Jumping butterballs!") underwent a makeover. And for all this, our world is a much better place. Friendly, anarchistic Harpo, seemingly benign Chico, and the Man of the Century, Groucho, together kicked pretense squarely in the pants while invigorating all else. Hail, hail Freedonia!

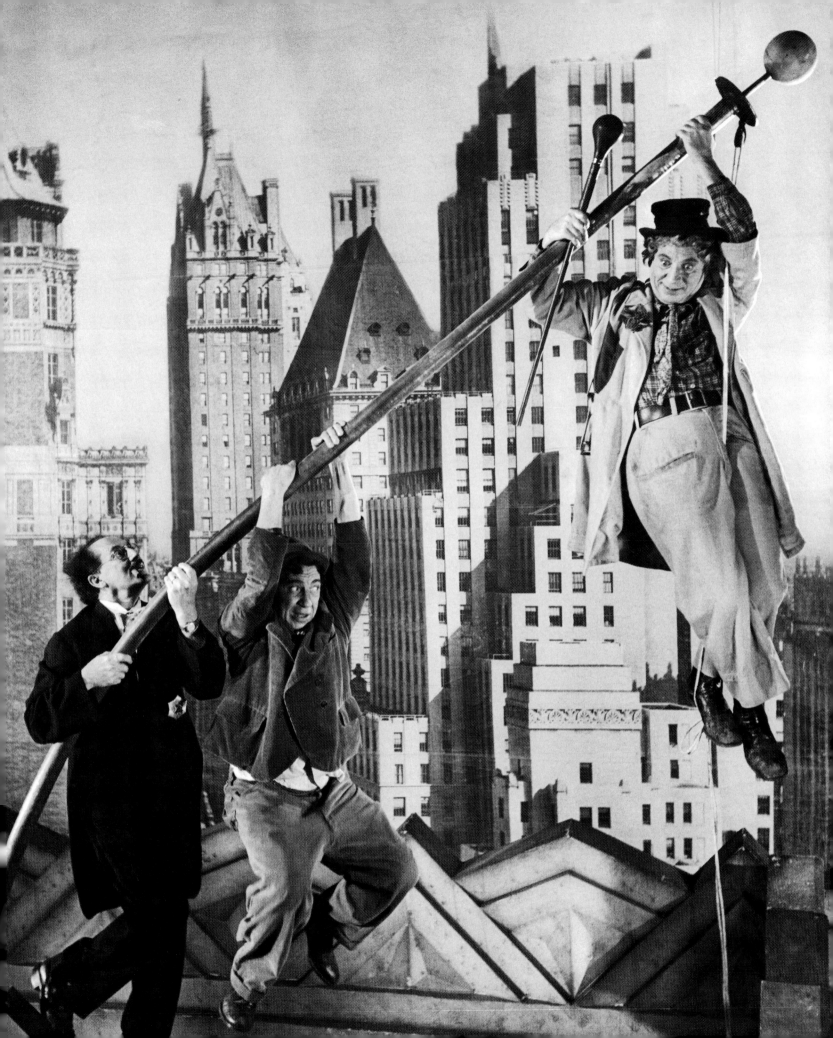

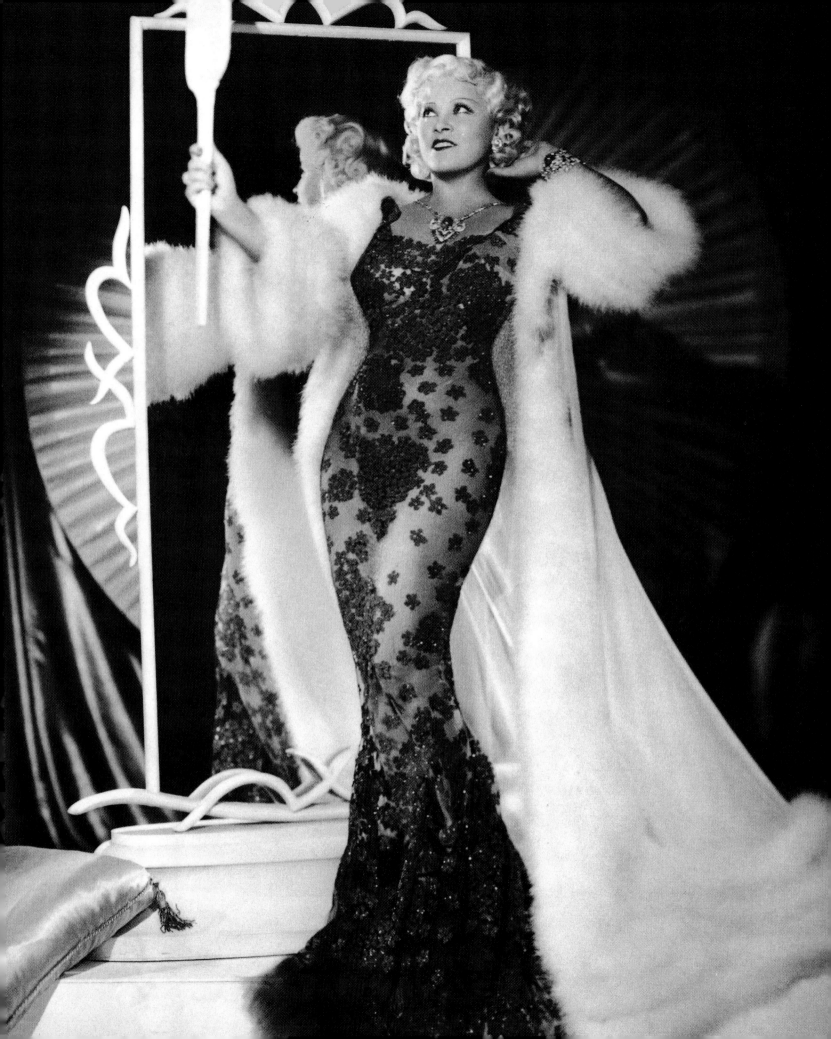

Mae West *Photograph from the Paramount Studio*

Mae West never received an Oscar, but she is instantly recognizable, in photos or words: "When I'm good, I'm very good, but when I'm bad, I'm better . . . Is that a gun in your pocket or are you just glad to see me? . . . When caught between two evils, I generally pick the one I've never tried before." Born in Brooklyn in 1893, she caused a sensation onstage. Once onscreen, her wit, delivery and, oh yes, figure, blended so potently that, as actor George Raft said, "she stole everything but the cameras."

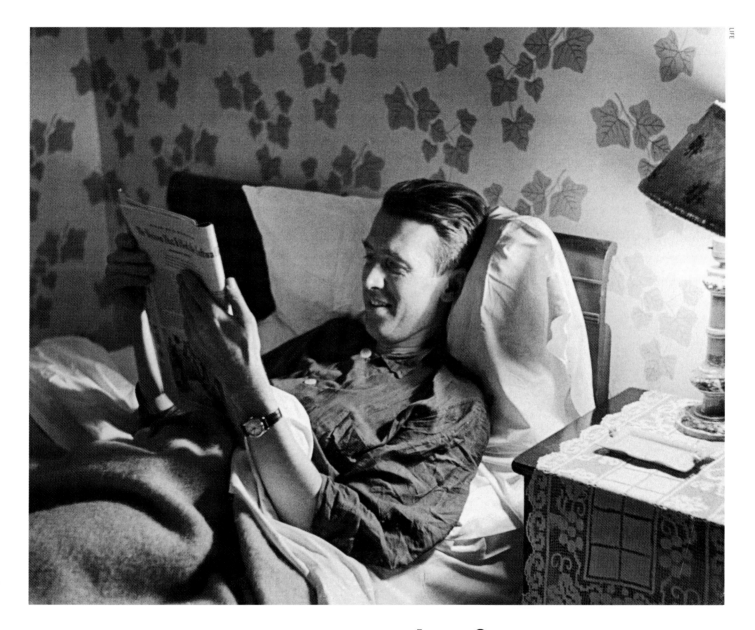

James Stewart *Photograph by Peter Stackpole*

It was his humanity that was always front and center, as he fought through marital troubles (*Made for Each Other*), stood up for the little people (*Mr. Smith Goes to Washington*) and confronted suicide (*It's a Wonderful Life*). It took him a while to get the words out, but you listened to what he said, and cared about it. He was one of the best in the West and was haunting in Hitch's *Vertigo.* When push really came to shove, he flew 20 combat missions in WWII. One of the screen's most beloved stars.

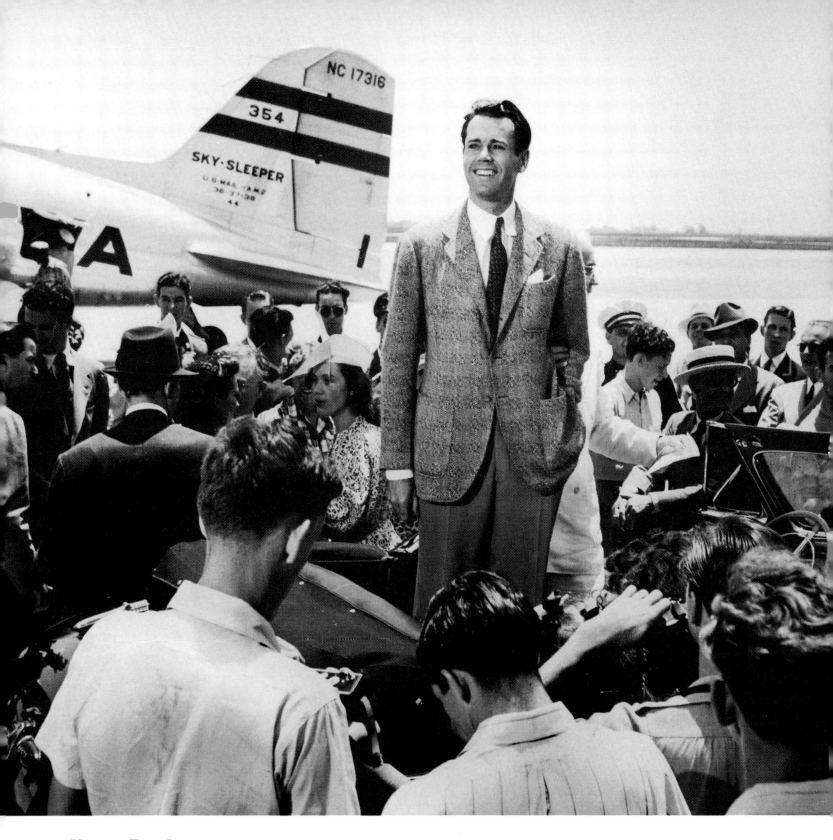

Henry Fonda *Photograph by John Swope*

The gentlest of eyes, shy but quick with a smile, not looking for trouble (but you can't let folks push
you around forever), a fellow who thinks before he talks, one that people naturally cotton to and like
to be around: He was Abe Lincoln, Tom Joad, Mister Roberts. Early on, in 1939, he was heartbreaking
as a colonist in *Drums Along the Mohawk,* the first of his several memorable John Ford films. Said
our Everyman, "I ain't really Henry Fonda! Nobody could be. Nobody could have that much integrity."

Orson Welles *Photograph by W. Eugene Smith*

The native Wisconsinite casts the longest shadow in film history. Already heralded as a boy genius for his work in radio and theater by the time he got to Hollywood in 1940, his first film, *Citizen Kane*, a modern Shakespearean tragedy told through utterly innovative cinematography, remains the most influential—many say the best—movie ever made. Welles was 25, and, while there would be other great films and performances, his crowning work was done: "I started at the top and worked down."

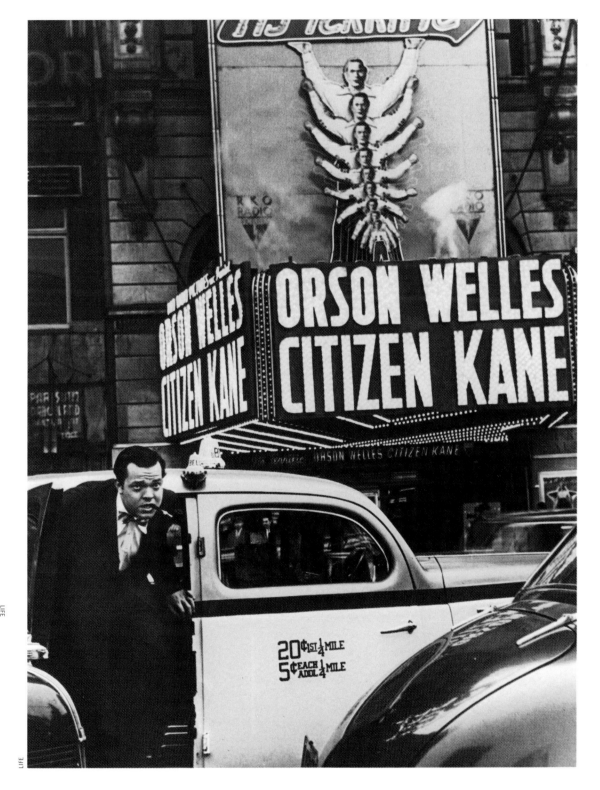

Cary Grant *Photograph by Alan Neeke*

"Everybody wants to be Cary Grant. Even I want to be Cary Grant." This from the man himself. And who wouldn't want to be intergalactically handsome, a person so at home in his own skin, the apotheosis of debonair but equally happy rattling sabers in *Gunga Din*? The intelligence, the smile, the grace, the humor, the whole tanned package. Without his legacy in comedy (*My Favorite Wife*) and drama (Hitchcock's *Notorious*), the silver screen wouldn't be half so bright.

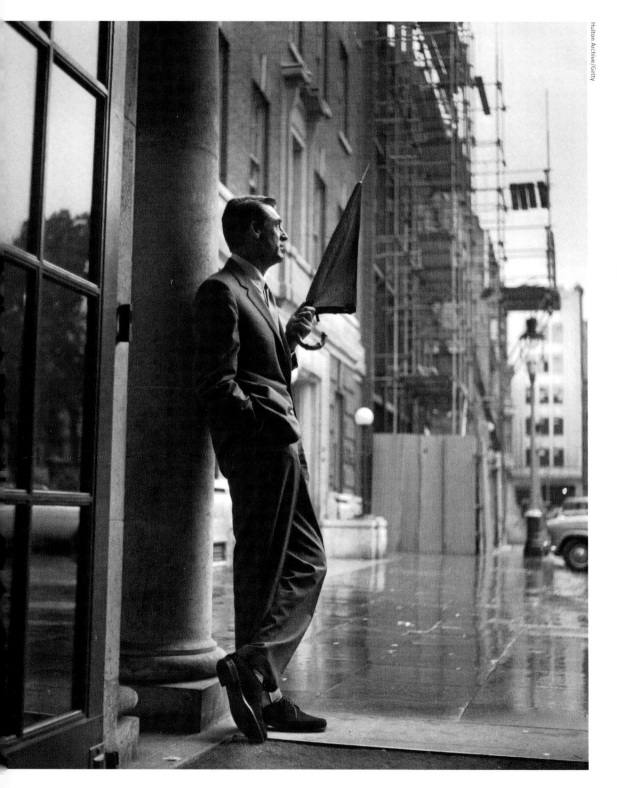

Hulton Archive/Getty

Marilyn Monroe
Photograph by Alfred Eisenstaedt

Her figure was Greek, her life a Greek tragedy. Californian Norma Jean Baker, raised in an orphanage and a dozen foster homes, was precociously voluptuous, and photos that she modeled for as a teen landed her on the cover of several men's magazines in the mid-'40s. Hollywood noticed, and the rechristened Marilyn Monroe began a climb to the pinnacles of fame, fortune and, finally, critical respect. But the goddess had demons that couldn't be conquered, and she died of a sedative overdose in 1962 at age 36.

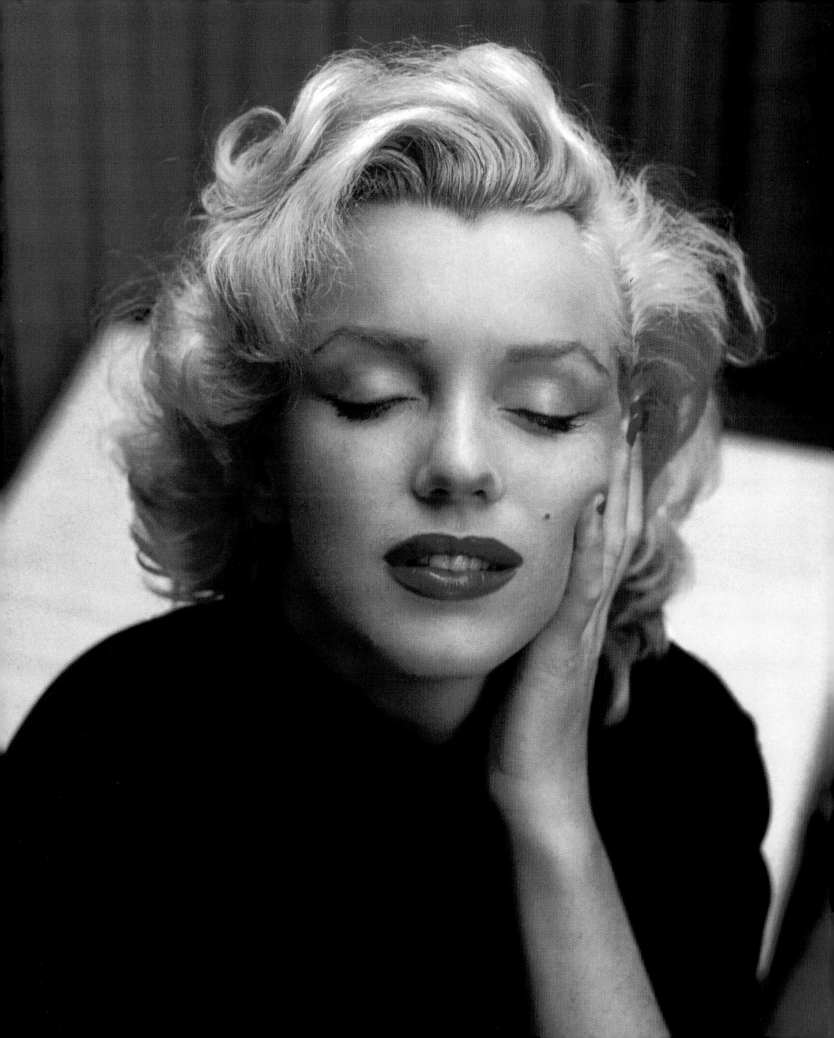

Ingrid Bergman *Photograph by Gordon Parks*

No other actress combined such intelligence, integrity and radiant beauty. Growing up in Stockholm, she was shy, but "I had a lion roaring inside me that wouldn't sit down and shut up." She would win three Oscars, but her career was jolted midstream by an affair with director Roberto Rossellini. Perhaps because, as director Jean Renoir put it, "she will always prefer a scandal to a lie," Bergman survived, decency intact.

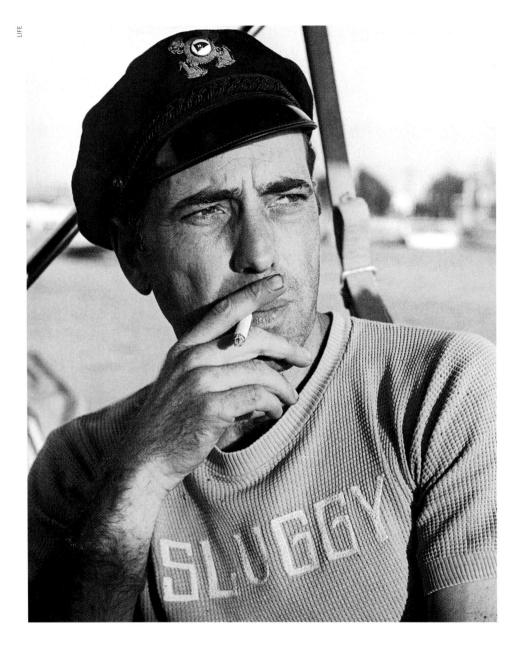

Humphrey Bogart *Photograph by John Florea*

He was a star for many years, in gangster sagas, melodramas and adventures. But it was only after his death in 1957 that we realized he had been the perfect existential hero, his face and body betraying life's injustices and thereby his disillusionment, but also his resolve to somehow make his way. A three-time loser at the altar, he finally met his match when he wed Lauren Bacall. As for us, we'll always have *Casablanca*.

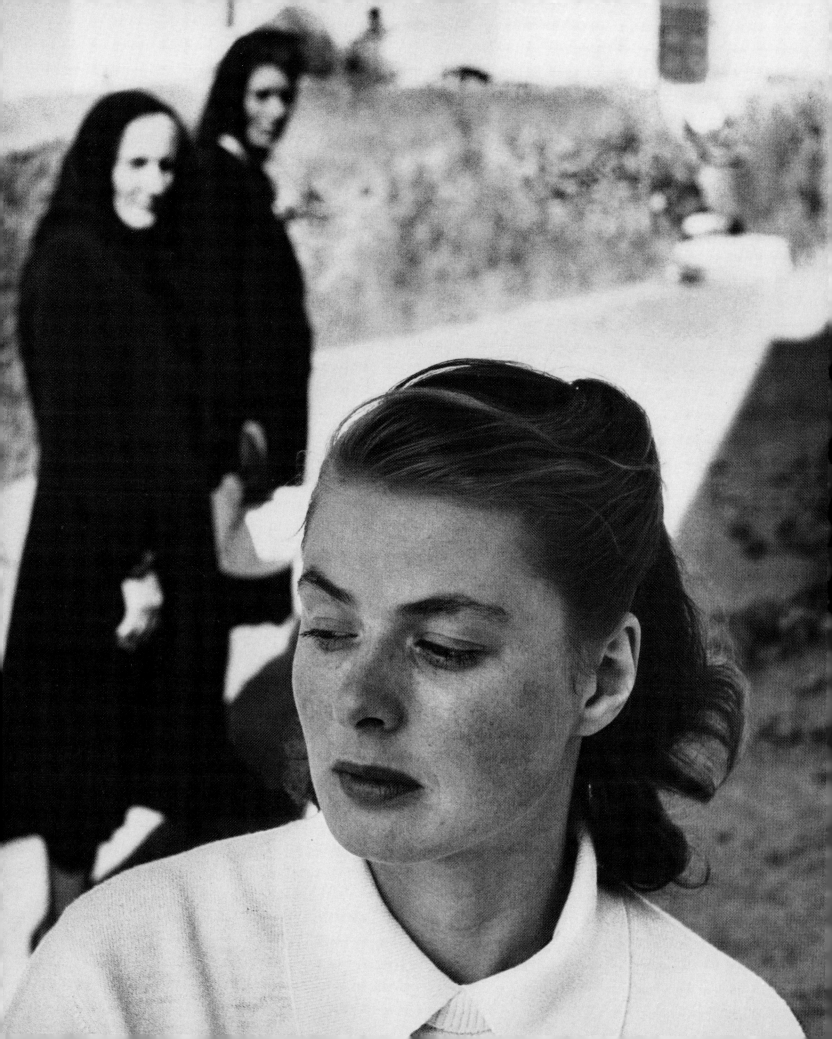

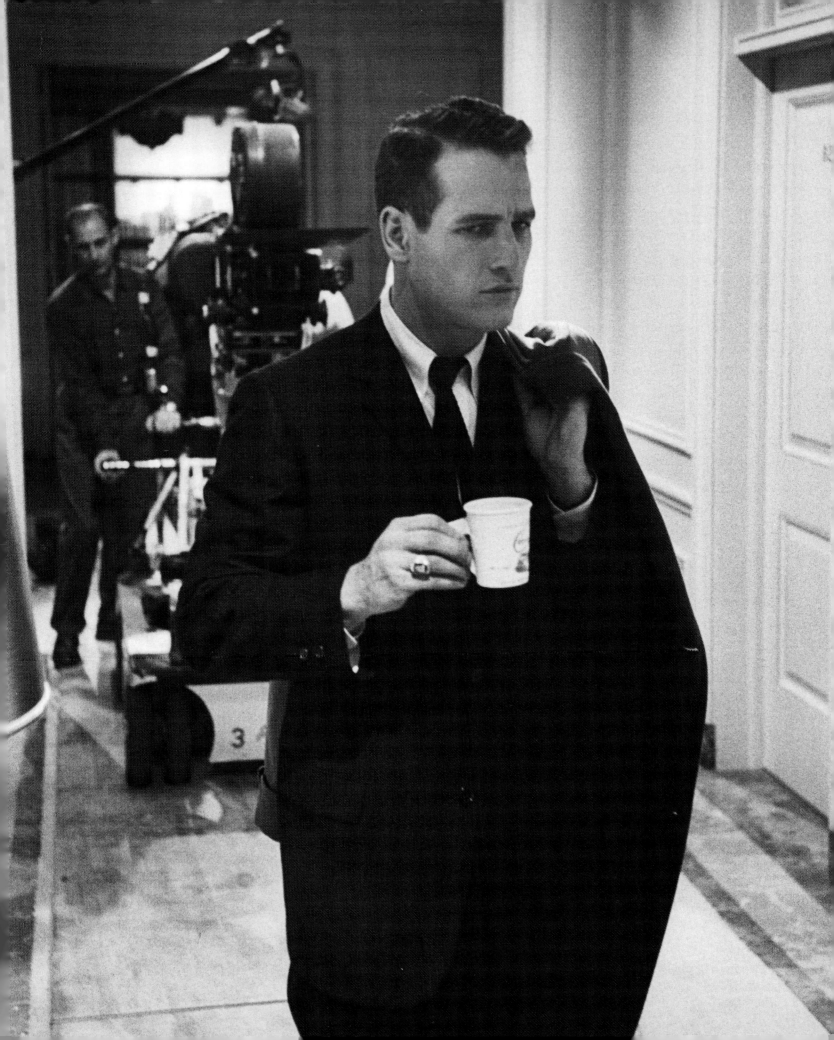

Paul Newman *Photograph by Leonard McCombe*

Gifted, honorable, and displaying two of the most famous eyes in the world, he is, no surprise, among the crème de la crème of actors. His "Lucky H" pictures alone—*The Hustler, Hud, Harper* and *Hombre*—would have secured his fame, but they're just four facets of his bejeweled career, which includes *The Sting* and *The Verdict.* Throw in a great marriage with Joanne Woodward and colossal contributions to charity, and you have, to borrow a phrase from Jimmy Cannon, a credit to his race . . . the human race.

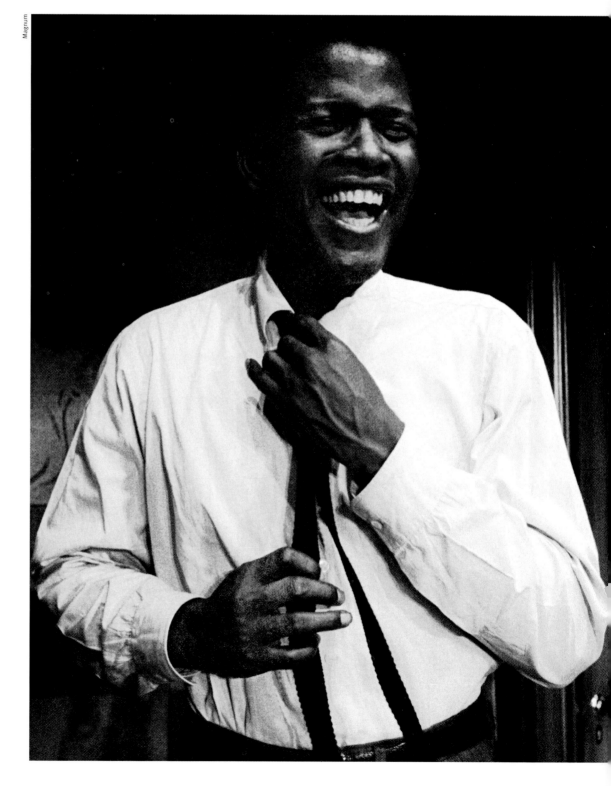

Magnum

Sidney Poitier

*Photograph by
Dennis Stock*

Son of a Bahamian dirt farmer, he was a troubled teenager sent to live with a relative in Miami. He made his way to New York, overcame his accent and found work with the American Negro Theater. After a breakout turn as a high school rebel in 1955's *Blackboard Jungle* came *A Raisin in the Sun, Lilies of the Field*—for which he won the Oscar, first ever for a black actor in a leading role—*Guess Who's Coming to Dinner* and *In the Heat of the Night.* These superb films and performances make the pioneering Poitier, also an accomplished director and influential social activist, one of the most important actors of the 20th century.

LIFE

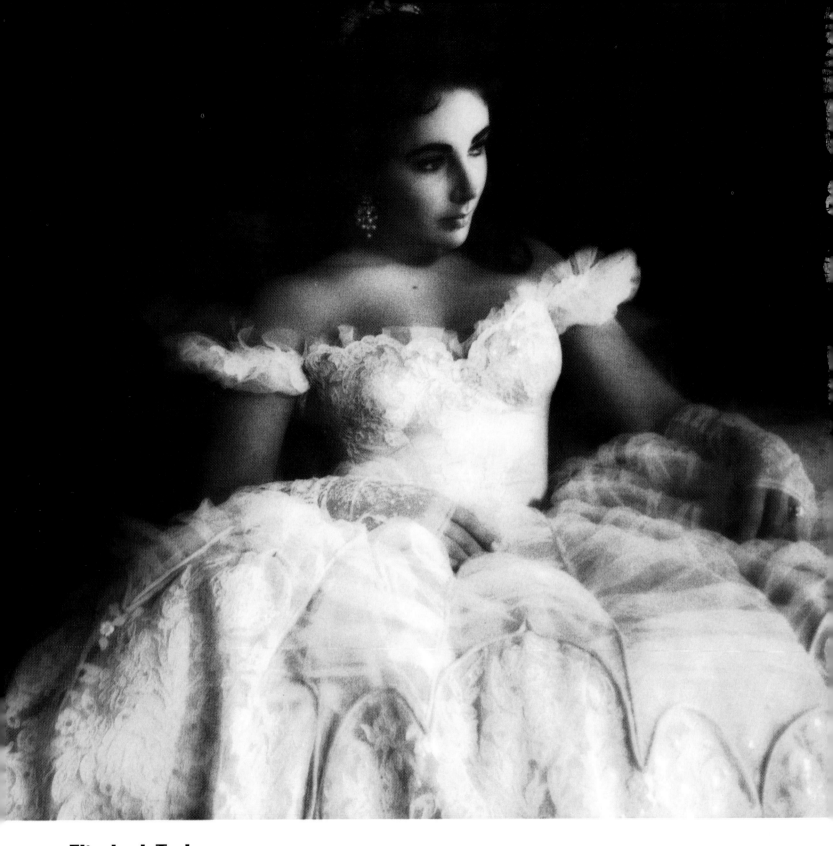

Elizabeth Taylor *Photograph by Bob Willoughby*

It's a fool's game to name Hollywood's greatest-ever beauty, but risk-free to call Taylor a contender. Her appeal has always been more than skin-deep, however. When 1944's *National Velvet* made her a star, she was at age 12 preternaturally lovely—and also good. Delightful in *Father of the Bride,* ferocious as Maggie the Cat, remarkable in *Who's Afraid of Virginia Woolf?,* Taylor could do it all. Her private life, with eight marriages including two Oscar-worthy turns opposite Richard Burton, has been high drama as well.

Grace Kelly *Photograph by Philippe Halsman*

Sandwiched between the Main Line upbringing in Philly and the royal years in Monaco, there was the movie career, barely half a decade in length but sensationally successful. Consider just 1954: *Dial M for Murder, The Bridges at Toko-Ri, Rear Window, Green Fire* and *The Country Girl,* for which she won the Oscar. The next year *To Catch a Thief* came out, but by then Kelly had caught the heart of Prince Rainier of Monaco, and the screen queen turned into a princess. She died after a car crash in 1982.

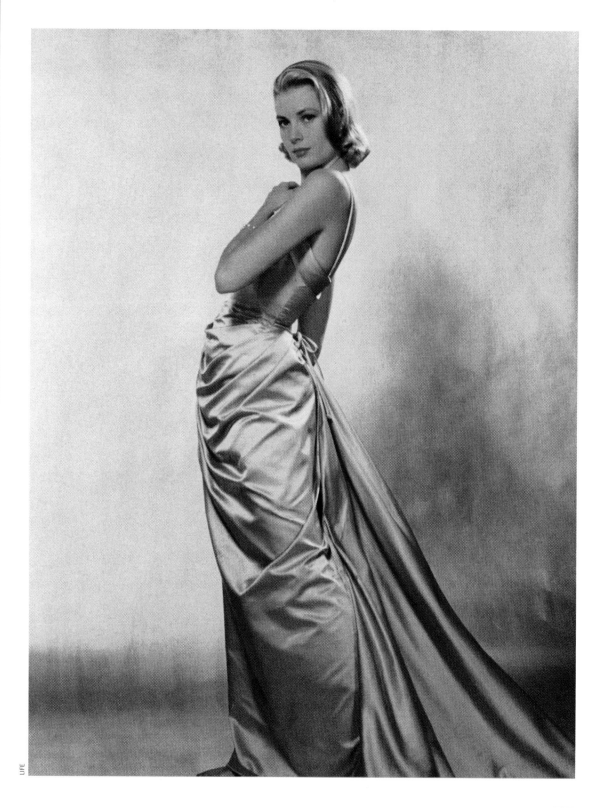

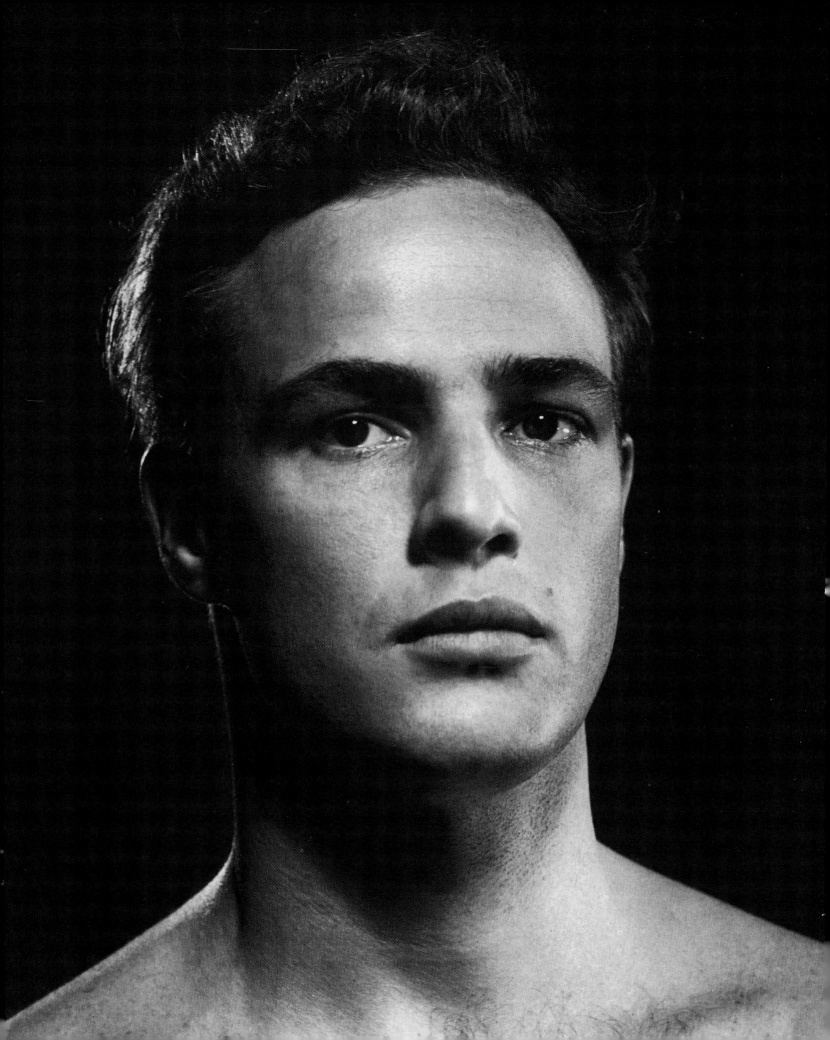

Manfredi, Levine, Eccles & Miller

A Professional Law Corporation
Est. 1981

Sam C. Manfredi
Ronald B. Levine
Matthew R. Eccles
Mark F. Miller*
Kevin P. Carter
Steven G. Rossi
Jeffrey A. White
*also admitted in New York

3262 E. Thousand Oaks Boulevard, Suite 200
Westlake Village, California 91362

PHONE
(805) 379-1919
(818) 907-6100
FAX
(805) 379-3819
www.mlem.com

December 2004

To Our Friends & Clients

The Law Offices of Manfredi, Levine, Eccles & Miller
wish to thank all of our friends and clients
in the Real Estate Industry for
your patronage and referrals over the years.
We have been servicing the Real Estate Industry for over 20 years,
as well as providing legal services to the community
in the areas of business, corporate, landlord/tenant,
personal injury, and other related fields.

Please enjoy this gift as our expression of gratitude to each of you.
We wish you and your families healthy and happy holidays
and a prosperous and joyous New Year.

Thank you!
From all of us at

Manfredi, Levine, Eccles & Miller

Marlon Brando

Photograph by
Philippe Halsman

If ever an actor came to Hollywood from another world, it was Brando. Not the theater, mind you, but *another world.* Is it possibly true that he was raised in Nebraska and Illinois, rather than some alien land hitherto uncharted? There was nothing to compare him to, as the madness in his method revolutionized cinema in *The Men, Streetcar, The Wild One* and *On the Waterfront.* Of course he played Fletcher Christian and of course he then stayed in Tahiti. Of course he did nothing of note for a decade, then in the '70s hit grand slams in *The Godfather, Last Tango in Paris* and *Apocalypse Now.* Simply put, movies and movie actors have never been the same since Brando.

James Dean *Photograph by Dennis Stock*

His middle name was Byron, for the poet, and it was all too suitable. In his Indiana high school he was an achiever with attitude, winning poetry contests, buzzing folks on his motorbike. With three films—*Rebel Without a Cause, East of Eden* and *Giant*—he influenced a generation before dying at age 24 when, in 1955, his Porsche smashed into another car on a California highway. "Dream as if you'll live forever," James Dean once said Byronically. "Live as if you'll die today."

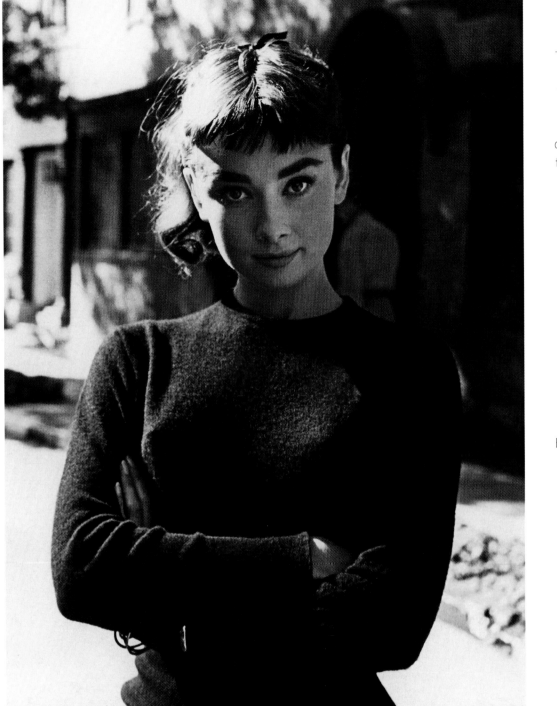

Gary Cooper

Photograph by
Peter Stackpole

For years—even to this day, for some—the image of the American man both here and abroad derived from Gary Cooper: tall, honest, strong, brave, a man of few words but deep convictions. He was called the "indestructible, incorruptible Galahad of moviedom." Men understood when he said in 1929's *The Virginian*, "When you call me that, *smile*." And as Ingrid Bergman noted, "Every woman who knew him fell in love with Gary." Coop was Sergeant York, Mr. Deeds, Lou Gehrig, Beau Geste, Billy Mitchell, John Doe. In *Friendly Persuasion, For Whom the Bell Tolls, Ball of Fire, High Noon* . . . we believed in him, and were glad he was on our side.

Audrey Hepburn *Photograph by Mark Shaw*

Let's get it out of the way quickly: gamine. Good, now let's move on. A Belgian-born beauty—"a Modigliani on which the paint has hardly dried," said photographer Cecil Beaton—hers was the picture next to the definition of *grace* and *charm* and *romance*. (And, yes, *gamine*.) She captured our hearts in 1953's *Roman Holiday* and the following year's *Sabrina;* she was Astaire's Funny Face and Capote's Holly Golightly. She was so much more than just a gamine.

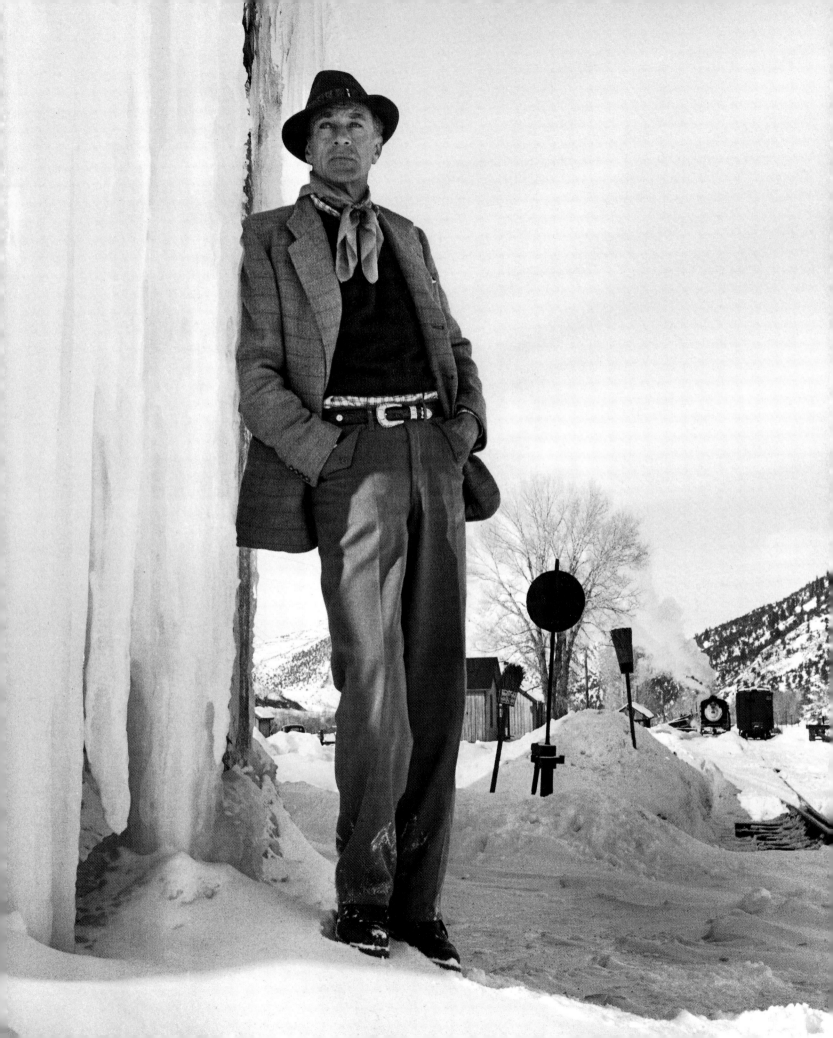

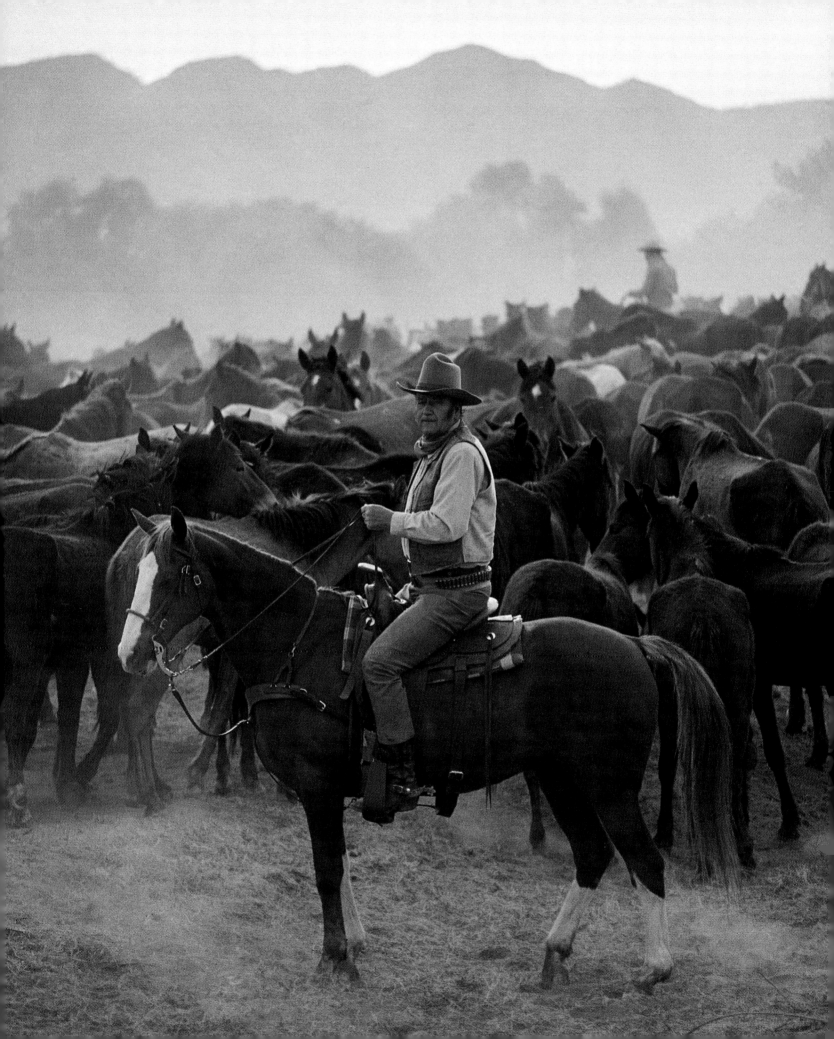

Clint Eastwood *Photograph by Bill Eppridge*

For one so often thought of as the quintessential tough guy, his breadth, when the résumé is consulted, proves remarkable. Yes, he created the indelible Man With No Name and Dirty Harry. But he has starred in and directed winning thrillers (*Play Misty for Me*) and romances (*The Bridges of Madison County*). He has done comedy and even, in a stretch, a musical (*Paint Your Wagon*). His *Unforgiven* is a movie for the ages and he, at 72, has become a monument.

John Wayne

Photograph by John Dominis

He wasn't really an actor, he was a code of honor lugged forward from some earlier time into a present in which some scoffed at him, but most idolized him. He might have ridden quietly off into a desert of inferior oaters if director John Ford hadn't rescued him in 1939 with *Stagecoach;* that duo produced a dozen gems. Duke would continue to ride the range, but he also found time to save the Allies in WWII (at least onscreen) and later to bust a few Commies' and criminals' heads. To his critics he replied, "People like my pictures and that's all that counts." Indeed. From 1949 to '74, he was a Top 10 box office draw every year but one.

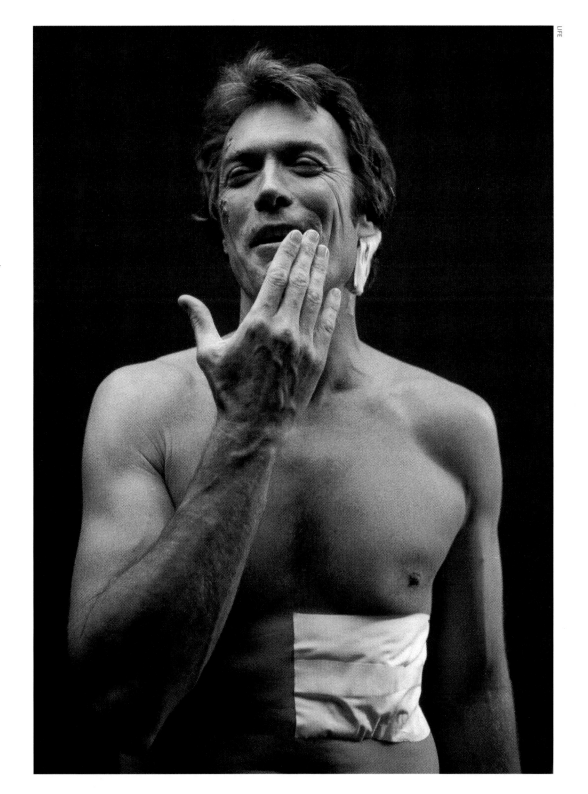

Meryl Streep
Photograph by
Snowdon

The consummate actress of the latter half of the 20th century, she brings to every part a dazzling virtuosity, an unequaled commitment and a vivid intelligence. Americans rarely have the facility with accents that Europeans seem to come by easily; Streep is a profound exception. She also somehow contrives to look different in many roles without requiring elaborate makeup. From 1977's *Julia* through 2002's *Adaptation,* she has made the motion picture a magical event.

Jack Nicholson *Photograph by Douglas Kirkland*

Brando and Dean had already changed the rules when along came Smilin' Jack, another regular-if-difficult guy, but from a new generation, one that had been weaned on movies and imbued with irony and counterculturalism. He cut his teeth in 1958's *The Cry Baby Killer,* the first of several Roger Corman cheapies before *Easy Rider* got him rolling in '69. From then on he nailed role after role, in wildly entertaining performances that were wonders of technique.

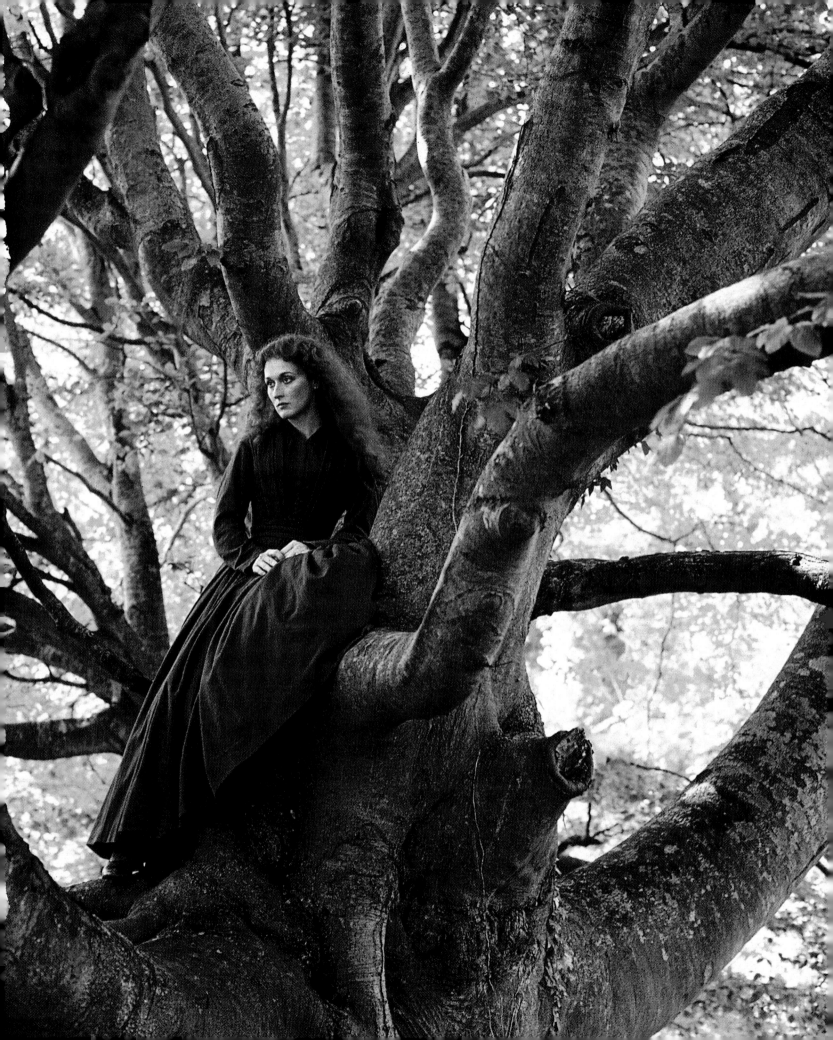

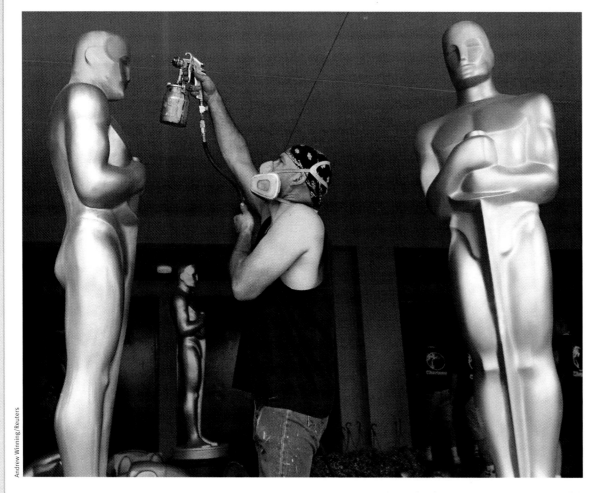

Andrew Winning/Reuters

Mark Roberts touches up a tribe of huge Oscars at the Shrine Auditorium in Los Angeles in 2001. Below: The trophies originally were cast in bronze, then covered with gold plate. Today, they are made of an alloy of tin, copper and antimony called britannium, which is plated with three metals before getting its final coat of 24-karat gold. The work is executed at R.S. Owens in Chicago.

Putting It Together

Standing 13½ inches tall, and tipping the scales at 8½ pounds, this statuette is, atom for atom, the most hungered-after hunk of metal that man has ever devised.

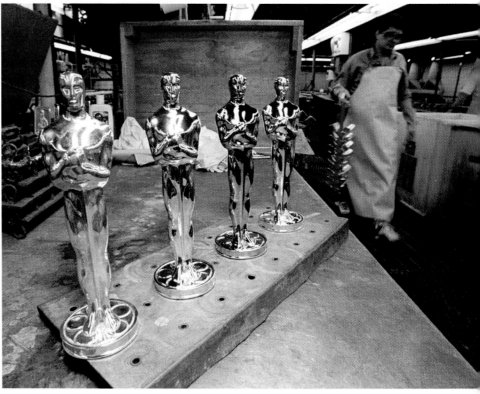

Reuters

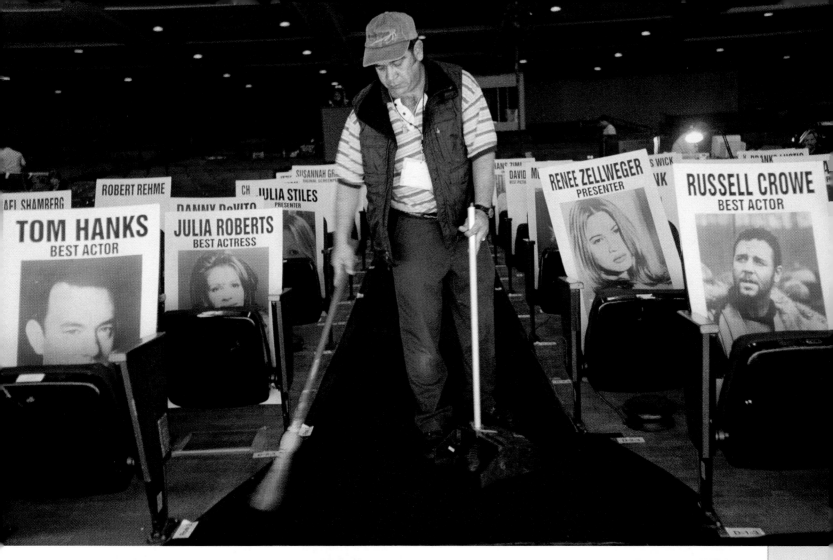

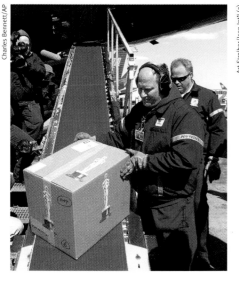

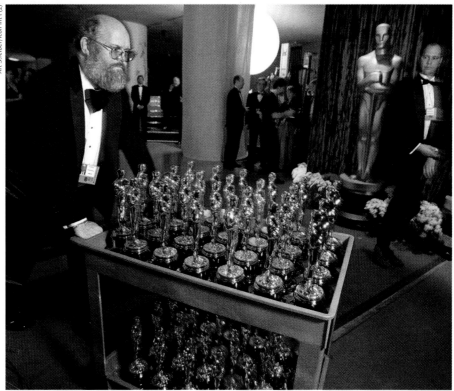

The prizes are packed individually in Styrofoam, eight to a box, then shipped from O'Hare in Chicago (above) to L.A. Seats are marked for nominees and other bigwigs, as the glistening guys are ready to roll to their new homes.

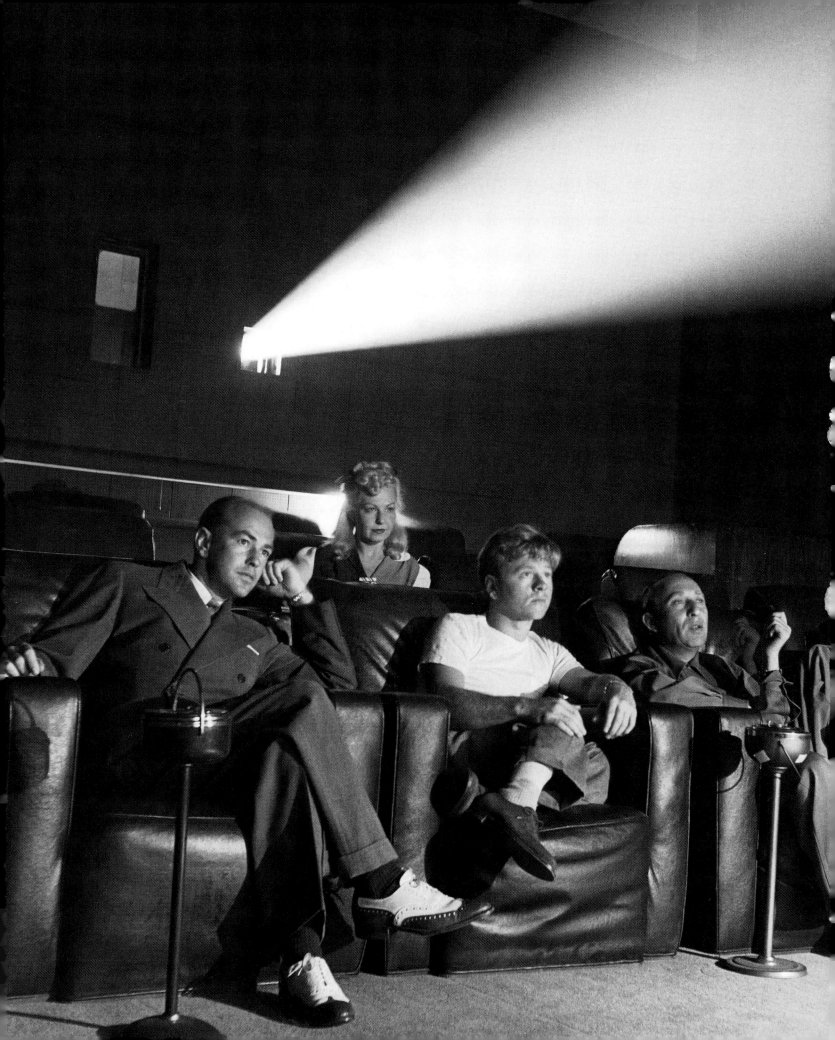

In Hollywood

The Bard was right, of course, when he said, "The play's the thing." But how can one not be fascinated by what goes on before and after curtains rise or cameras roll? That's when you glimpse the "mortals" who inhabit the realm where dreams are made.

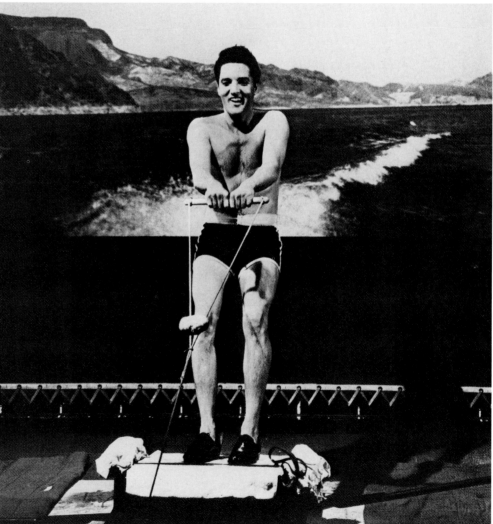

Phototeque

Walter Sanders

In an MGM projection room in 1943, Mickey Rooney takes in rushes of his cameo appearance in *Thousands Cheer* with his publicity manager, Leslie Peterson, director George Sidney and producer Joe Pasternak. Behind them is Mr. Pasternak's "secretary." Above, Elvis has *Fun in Acapulco* and proves that even he prefers comfortable shoes when he walks on water.

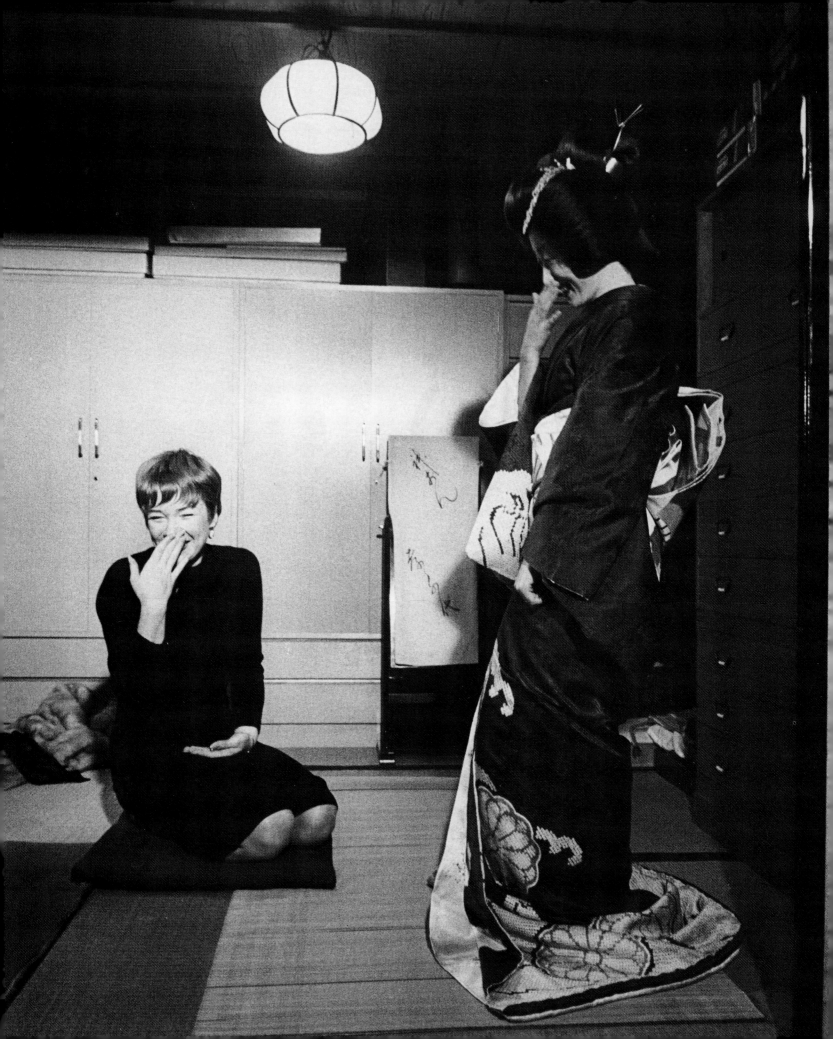

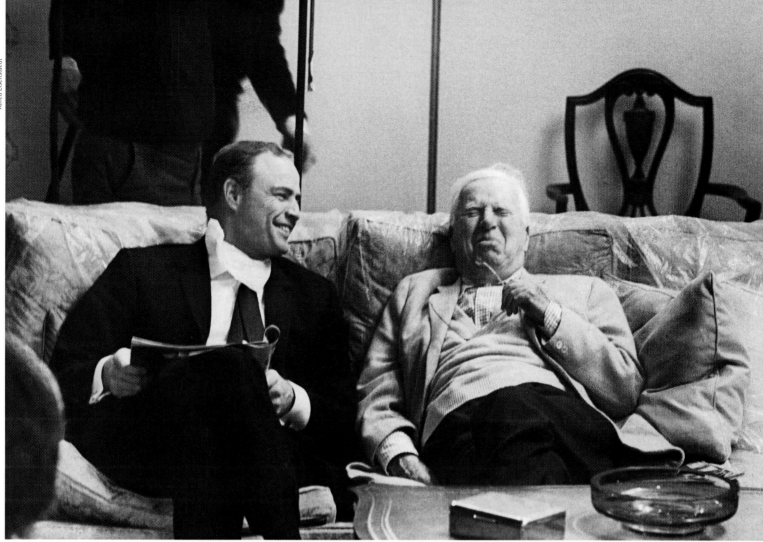

Alfred Eisenstaedt

Here, some of the screen's true iconoclasts are beaming, but for very different reasons. Clockwise from right: Betty Hutton is thrilled just to be alive after swinging on a trapeze for *The Greatest Show on Earth*. She had been scared witless, but director C.B. DeMille tells her, "See? I knew you could do it." Later, many are stunned when the film beats out *High Noon* as 1952's Best Picture. Opposite: Shirley MacLaine always has a ready laugh, but she learns the proper way to do it for 1962's *My Geisha*. As for Brando and Chaplin, on the set of *A Countess from Hong Kong* in 1966, well, they're in clover simply to bask for a bit in the glow of each other's radiance.

Howard Modavis

John Launois

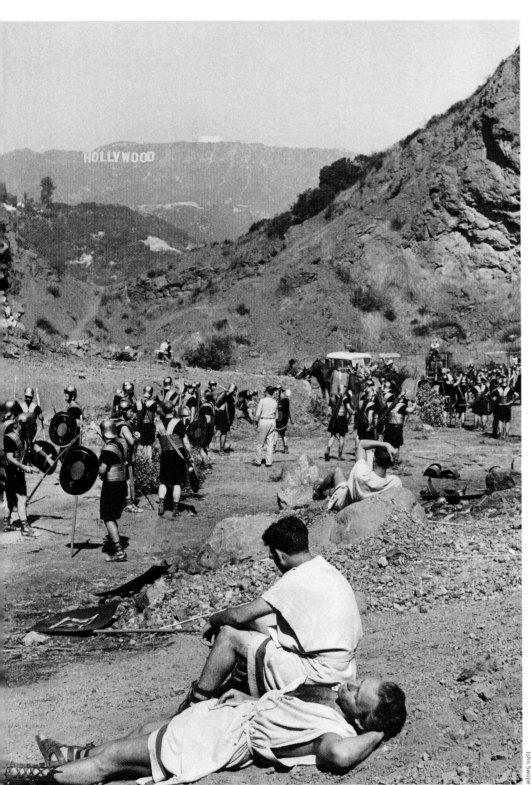

Extras cop some rays on the set of 1952's *Julius Caesar*. (Surely director Joseph Mankiewicz was careful not to let the HOLLYWOOD sign loom behind Cassius's lean and hungry look.) Producer Sam Goldwyn began every day with a two-to-five-mile walk. He was one of the founding fathers of movies, but was so irascible that he was booted out of his own firm, which would later be part of Metro-Goldwyn-Mayer. For decades, Goldwyn produced artistic and commercial successes. His credo? "Pictures are for entertainment, messages should be delivered by Western Union."

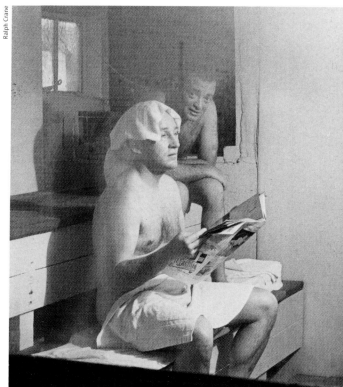

Bing Crosby and Peter Lorre sweat it out in 1944 at the Finlandia Baths on the Sunset Strip. Below, Audrey Hepburn shops in 1958 with a costar from *Green Mansions*. One has to wonder if either of them has ever been in a supermarket before.

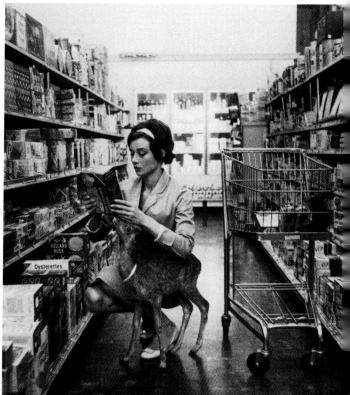

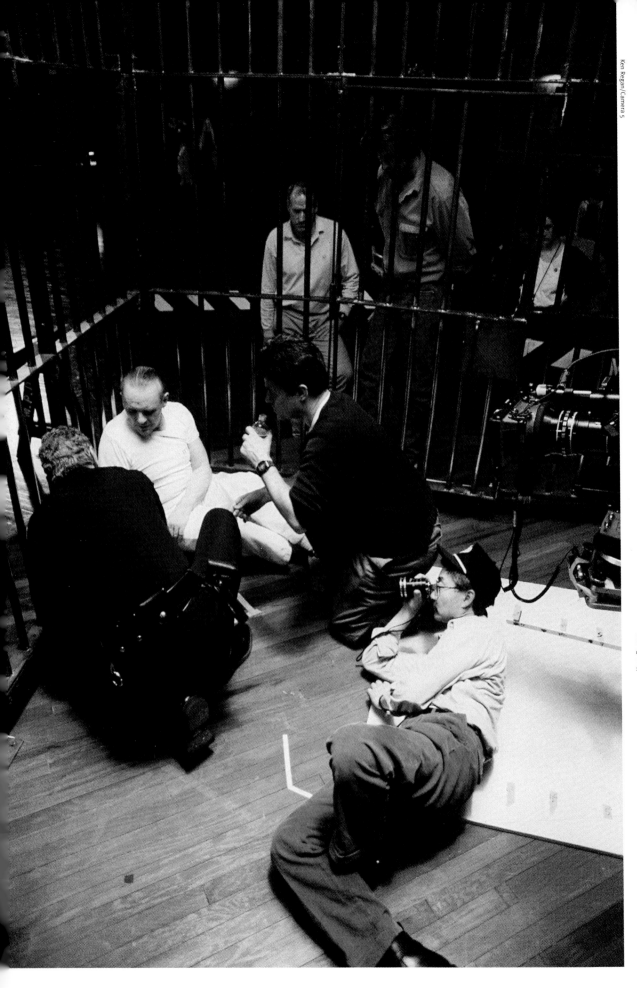

Anthony Hopkins, between takes as Hannibal Lecter in the 1991 shocker *The Silence of the Lambs,* mulls the intricacies of a scene with director Jonathan Demme (holding bottle). Meanwhile, the cinematographer, Tak Fujimoto, gets down and dirty to find the best way to frame the shot.

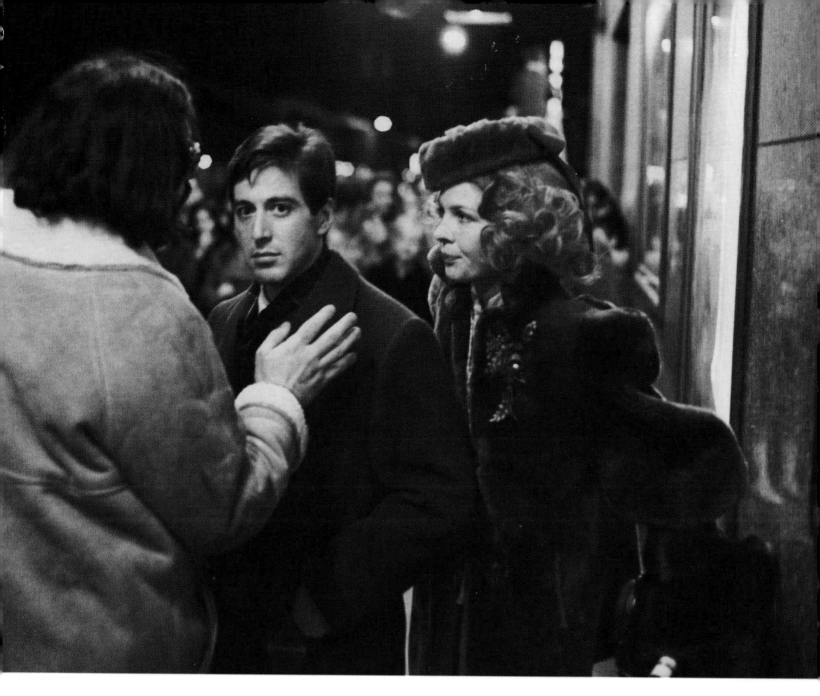

Godfather director Francis Ford Coppola shares his ideas with Diane Keaton and Al Pacino in 1972. A decade later, Steven Spielberg, at the helm of *E.T.,* listens to seven-year-old Drew Barrymore. On one occasion, he yelled because she kept forgetting her lines. But when he learned that she was ill, "I went over to a corner and hugged her for 10 minutes." Then he sent her home with a note from her director.

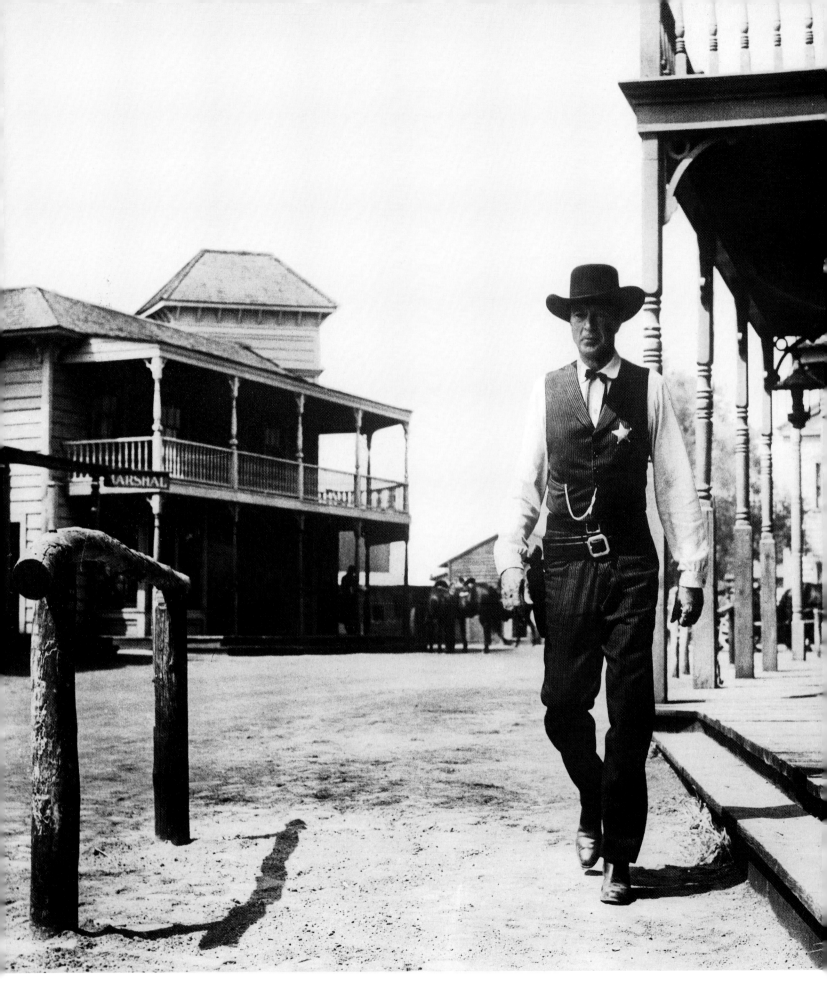

Behind the Scenes ★ High Noon

by Maria Cooper Janis

In December 2002 in New York City there was a 50th-anniversary party for the quintessential film in America's quintessential film genre, the genre being westerns and the film *High Noon*. Some say that the 1952 feature was the first "adult" western. It was a different, daring film, with characters of depth, experimental narrative techniques—and a certain ambivalence about what constitutes heroism.

Today, *High Noon* is rightly regarded as a classic, and this lends it a certain austerity. But it is perhaps more accurate to think of the movie as an early indie. It had a bare-bones budget of under a million dollars and a shooting schedule of one month. The legendary Gary Cooper was on the waning side of a career that needed a boost, and he worked for next to nothing. (Gregory Peck had already turned down the role.) Legend-to-be Grace Kelly was just starting out and was glad for the job. Lloyd Bridges wasn't deemed A-movie material, and Lee Van Cleef hadn't yet established a reputation as a sure-shot western villain. During production on Burbank soundstages and in the Sonoran Desert, none of the principals knew they were onto anything special. "They just hoped they were making a nice little better-than-average western," remembers Maria Cooper Janis.

She was there. The daughter of Coop and his wife, Veronica, Maria grew up happy in the L.A. suburbs, the sole child of devoted parents. Accompanied by her mother, she would visit the studios from time to time, particularly her father's sets. She was attendant during two of *High Noon*'s 31 days of shooting, and drank in the atmosphere of an intense, sometimes troubled production. Subsequently, she learned more about the emotions that were at play during the making of the movie.

Maria Cooper Janis, an accomplished painter and wife of the celebrated concert pianist/composer Byron Janis, now resides in New York City. At the *High Noon* birthday party in Manhattan, she talked about her Hollywood upbringing. Here, she revisits those memories, and expands on them for LIFE's Hollywood commemorative.

Paul Harris (Maria Cooper Janis); Photofest

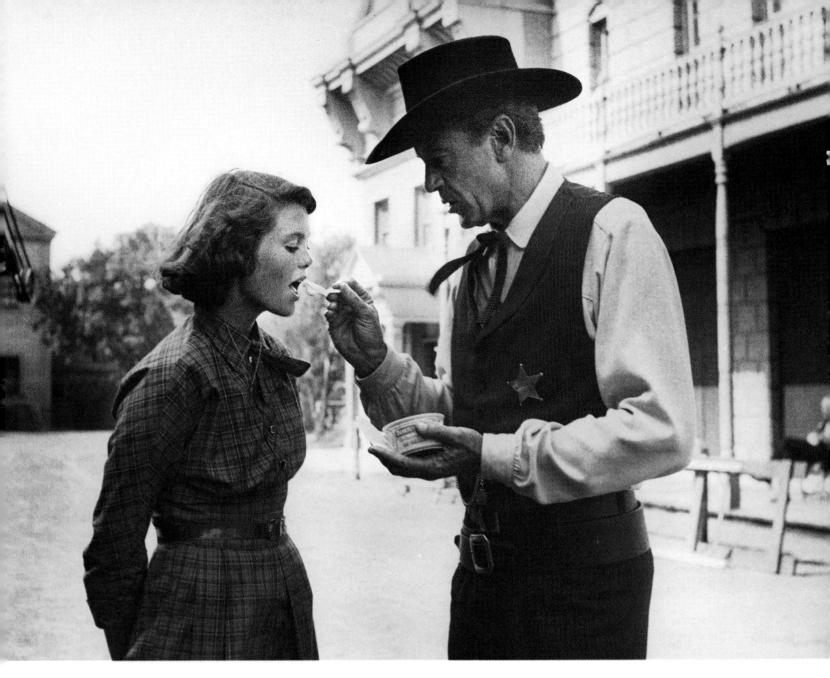

My girlhood was spent with one foot in Oz and one in the real world. Hollywood was a fantasyland, and I loved it all. My parents, however, were very grounded, very down-to-earth, and they made sure that I wasn't swept away by all the magic and, well, the hype and the nonsense. Especially when I was a little girl, our private time was protected by my parents. Our house in Brentwood was on the Movie Star Home Bus Tour, but my mother and father knew when to lie low to avoid pulling out of the driveway into a caravan of strangers. Momma and Poppa were a Hollywood couple, but never the stereotypical Hollywood couple; we didn't have the

"The ice cream was appreciated, I can promise you that," remembers Janis. "It was the hottest set I ever visited." The heat extended beyond the climatic to fights over Hollywood's vicious blacklisting crusade.

lavish birthday parties that you read about. They were just themselves. My father felt firmly that everybody was important, nobody was a "little guy." In those days, when the hills and beaches were still accessible, my parents would "get out of Dodge" to the quiet—riding horses in the surf or picnicking in the virgin hills above Malibu.

I loved to go to the studios. I recall the wardrobe room at MGM distinctly, and the makeup room with this funny sign hanging on the wall: WHAT GOD'S FORGOTTEN, WE FILL IN WITH COTTON. My delight was to go with my mother to the workshop of the designer Irene, my great aunt: miles of sewing machines, hordes of women working away with tulle, silk, satin, making all these costumes. I'd collect the remnants in a big bundle and my mother

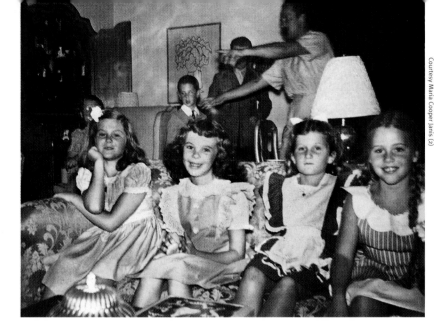

Courtesy Maria Cooper Janis (2)

would say, "What are you going to do with that?" "Oh, something." Poppa had started out as an artist, you know, and I think I was already beginning to think in terms of collages and putting shapes and colors together.

I had my friends, and they were a mix of "Hollywood" and "nonindustry" children. There was a group, we all knew each other. I have pictures from my ninth birthday party. I remember we had run *The Plainsman* at home. We didn't have a projection room—my father just ran it through a 16mm projector, as any dad might. In these pictures, sitting on the couch, there's myself and then Lucille Capra, Frank's daughter; Susan MacMurray, Fred's daughter; Henry Fonda's daughter Jane; Ingrid Bergman's daughter Pia Lindstrom; Ned Wynn, Keenan's son; Joan Crawford's daughter Christina . . .

When my father was making a film, I would of course love to go along—but it was only an occasional thing. He was very serious during production. He was working, and sometimes nervous. He hated it when he messed up a line. He'd have a fit and then out would come the cigarette—unfortunately. [Cooper died of cancer in 1961 at age 60.]

If Mother and I were on the set, he'd always have time during breaks and at lunch for us. The ice cream photo wasn't staged. Poppa was just helping me with the ice cream on a very hot day.

I do remember that about the *High Noon* set: It was very, very hot in Burbank every day. Other than that, it was much like other sets—only more so. The work was more intense because of the short shooting schedule, and there were more than the usual tensions in the air.

Friends gather in the Cooper living room to celebrate Maria's ninth birthday. In the foreground are Maria, Deanne Withers, Susan MacMurray and Jane Fonda. Rear: Ned Wynn looks on as dad Keenan gets to direct.

During a break in filming, Cooper seeks relief from the sun with the nearest available headwear, which happens to be a lovely chapeau from Kelly's wardrobe. Rarely a cutup on the set himself, Cooper approved of his costar's precocious professionalism.

It was the time of the blacklistings, and this was front and center on *High Noon.* Carl Foreman, who wrote the wonderful script, had been linked to a communist group years earlier and was being hounded. Stanley Kramer, the producer, wanted to can Foreman right off the bat, but my father and Fred Zinnemann, the director and a dear friend of my father's, said, "If he goes, we go." They were working for so little, and things were so far along that Kramer backed down. But if you ask me how my father felt about Kramer in this case, I think he was appalled, disgusted, very angry. And remember, my father was an anticommunist. But he knew what was fair and right in dealing with people, and he believed in free speech. This was America.

I wasn't aware of the witch-hunt at the time; I was 14-ish, and it hadn't seeped in. I learned of it, and what was going on with *High Noon,* in later years through reading histories and talking with my parents. In fact, when I was on the set, I was more concerned about my father's health. His ulcer was bleeding, and he had terrible back trouble. At one point, I gained a new respect for his acting talent. It was the wedding scene, and after the parson said "I now pronounce you man and wife," Poppa had to lift Grace Kelly up and put her on this tall piece of furniture. Now, Grace wasn't small, and she was no ballerina—she didn't know how to help. So Poppa was lifting dead weight. Then there was retake,

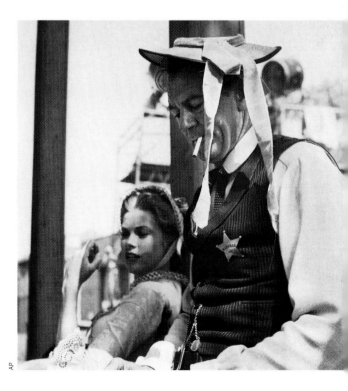

AP

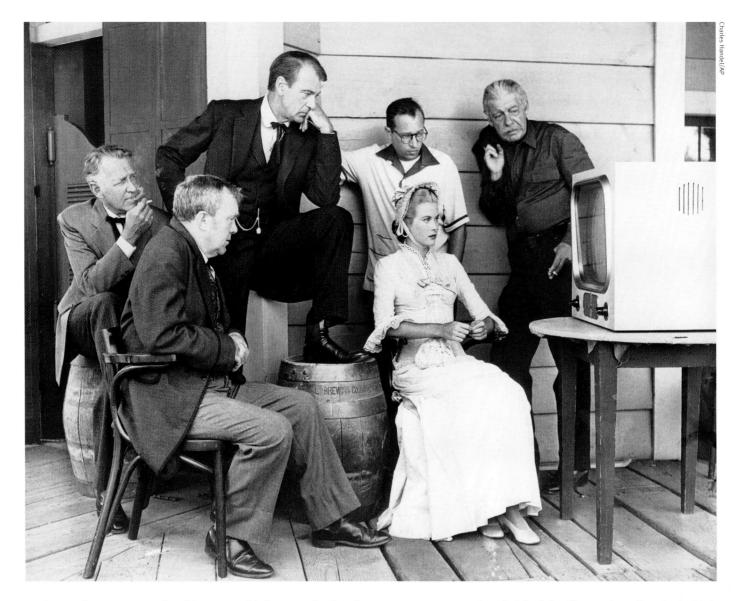

retake, retake. I saw sweat breaking out on his fore-head as his back went out, but was very impressed at how he hid his pain from the camera.

I think he liked Grace Kelly, though, and appreciated her professionalism at such a young age. He was very no-nonsense on the set. During breaks, he would sleep, as often as not, or he'd smoke. So he approved of a no-nonsense, strong-willed young woman who wasn't just prancing around trying to be a movie star.

I'm glad I wasn't there the day they did the fight scene in the barn. My father didn't use a double. I don't think I could have taken that. I heard later that Beau Bridges, who was nine or 10 at the time, was on the set and blew the take. He had been hiding in the barn when his father and mine were fighting, and Zinnemann and others heard Beau laughing behind the bale of hay.

On October 4, 1951, cast members of what would become an American classic enjoy an inning of baseball's Fall Classic between the New York Yankees and the New York Giants. From left: Otto Kruger, Thomas Mitchell, Cooper, a member of the crew, Kelly and Lon Chaney Jr.

They finished the film, and, really, I don't think anyone knew what they had. The aftermath says a lot about that movie. One of the stupidities of Kramer's blustering after the fact—that he made the picture, that it was all his idea to focus on the clocks and do "real time"—is that when he did some editing on an early cut, they had a first preview that was so bad, they had to put it back to the way it was in Carl Foreman's script. The clocks were in the original script. All of it was.

One of the things I heard when the film came out was all the negative stuff about Foreman, who had to leave the country. "He's obviously a Commie! When the marshal takes off his badge and grinds it into the dirt, it's a Commie talking." Well, that's not in the script and Marshal Kane doesn't grind the badge into the dirt. But people were leaping on anything then. Paranoia was everywhere.

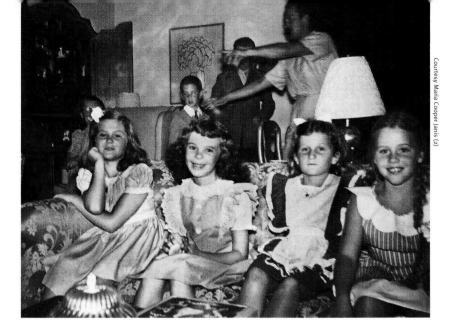

would say, "What are you going to do with that?" "Oh, something." Poppa had started out as an artist, you know, and I think I was already beginning to think in terms of collages and putting shapes and colors together.

I had my friends, and they were a mix of "Hollywood" and "nonindustry" children. There was a group, we all knew each other. I have pictures from my ninth birthday party. I remember we had run *The Plainsman* at home. We didn't have a projection room—my father just ran it through a 16mm projector, as any dad might. In these pictures, sitting on the couch, there's myself and then Lucille Capra, Frank's daughter; Susan MacMurray, Fred's daughter; Henry Fonda's daughter Jane; Ingrid Bergman's daughter Pia Lindstrom; Ned Wynn, Keenan's son; Joan Crawford's daughter Christina . . .

When my father was making a film, I would of course love to go along—but it was only an occasional thing. He was very serious during production. He was working, and sometimes nervous. He hated it when he messed up a line. He'd have a fit and then out would come the cigarette—unfortunately. [Cooper died of cancer in 1961 at age 60.]

If Mother and I were on the set, he'd always have time during breaks and at lunch for us. The ice cream photo wasn't staged. Poppa was just helping me with the ice cream on a very hot day.

I do remember that about the *High Noon* set: It was very, very hot in Burbank every day. Other than that, it was much like other sets—only more so. The work was more intense because of the short shooting schedule, and there were more than the usual tensions in the air.

Friends gather in the Cooper living room to celebrate Maria's ninth birthday. In the foreground are Maria, Deanne Withers, Susan MacMurray and Jane Fonda. Rear: Ned Wynn looks on as dad Keenan gets to direct.

During a break in filming, Cooper seeks relief from the sun with the nearest available headwear, which happens to be a lovely chapeau from Kelly's wardrobe. Rarely a cutup on the set himself, Cooper approved of his costar's precocious professionalism.

It was the time of the blacklistings, and this was front and center on *High Noon*. Carl Foreman, who wrote the wonderful script, had been linked to a communist group years earlier and was being hounded. Stanley Kramer, the producer, wanted to can Foreman right off the bat, but my father and Fred Zinnemann, the director and a dear friend of my father's, said, "If he goes, we go." They were working for so little, and things were so far along that Kramer backed down. But if you ask me how my father felt about Kramer in this case, I think he was appalled, disgusted, very angry. And remember, my father was an anticommunist. But he knew what was fair and right in dealing with people, and he believed in free speech. This was America.

I wasn't aware of the witch-hunt at the time; I was 14-ish, and it hadn't seeped in. I learned of it, and what was going on with *High Noon,* in later years through reading histories and talking with my parents. In fact, when I was on the set, I was more concerned about my father's health. His ulcer was bleeding, and he had terrible back trouble. At one point, I gained a new respect for his acting talent. It was the wedding scene, and after the parson said "I now pronounce you man and wife," Poppa had to lift Grace Kelly up and put her on this tall piece of furniture. Now, Grace wasn't small, and she was no ballerina—she didn't know how to help. So Poppa was lifting dead weight. Then there was retake,

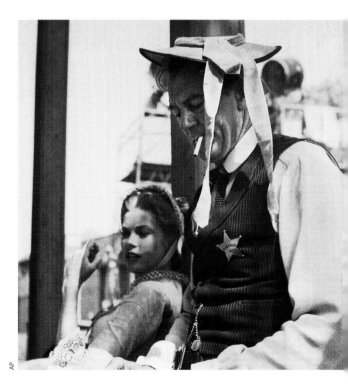

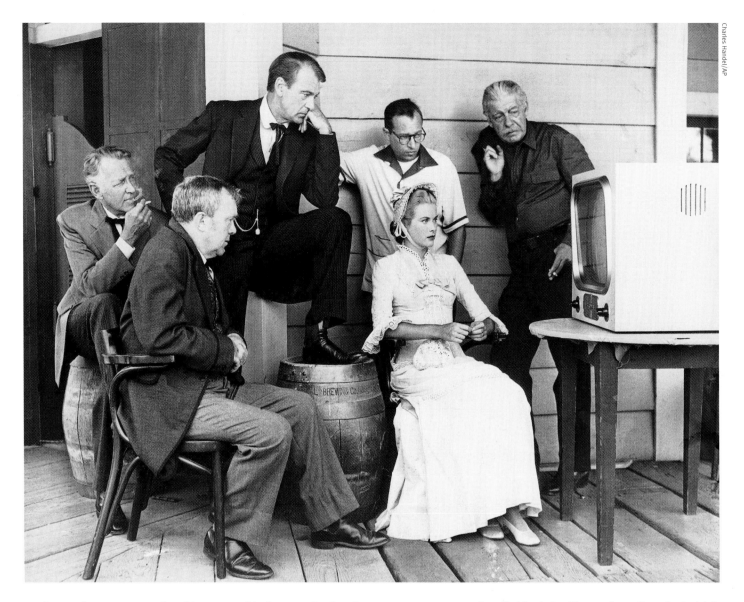

On October 4, 1951, cast members of what would become an American classic enjoy an inning of baseball's Fall Classic between the New York Yankees and the New York Giants. From left: Otto Kruger, Thomas Mitchell, Cooper, a member of the crew, Kelly and Lon Chaney Jr.

retake, retake. I saw sweat breaking out on his forehead as his back went out, but was very impressed at how he hid his pain from the camera.

I think he liked Grace Kelly, though, and appreciated her professionalism at such a young age. He was very no-nonsense on the set. During breaks, he would sleep, as often as not, or he'd smoke. So he approved of a no-nonsense, strong-willed young woman who wasn't just prancing around trying to be a movie star.

I'm glad I wasn't there the day they did the fight scene in the barn. My father didn't use a double. I don't think I could have taken that. I heard later that Beau Bridges, who was nine or 10 at the time, was on the set and blew the take. He had been hiding in the barn when his father and mine were fighting, and Zinnemann and others heard Beau laughing behind the bale of hay.

They finished the film, and, really, I don't think anyone knew what they had. The aftermath says a lot about that movie. One of the stupidities of Kramer's blustering after the fact—that he made the picture, that it was all his idea to focus on the clocks and do "real time"—is that when he did some editing on an early cut, they had a first preview that was so bad, they had to put it back to the way it was in Carl Foreman's script. The clocks were in the original script. All of it was.

One of the things I heard when the film came out was all the negative stuff about Foreman, who had to leave the country. "He's obviously a Commie! When the marshal takes off his badge and grinds it into the dirt, it's a Commie talking." Well, that's not in the script and Marshal Kane doesn't grind the badge into the dirt. But people were leaping on anything then. Paranoia was everywhere.

I can tell you, I never heard those things from my father, and I know he always thought well of Carl Foreman. You can be sure, my father always disliked the mentality of crowds.

Fred Zinnemann did feel that although it was a great movie yarn, there also were deeper undertones: There is a man who must make a decision according to his conscience, and the town was a symbol of democracy gone soft—to use his words. Was it an allegory for what was going on in Hollywood and the whole country? Probably. In any case, one of the people who was speaking out loudest about the film and against Carl Foreman was John Wayne. He was very vociferous, castigating everyone, and kind of accusing my father of being easy on Commies. They say he later made *Rio Bravo* as a response to *High Noon.*

So, cut to 1953, and Poppa is doing a movie, *Blowing Wild,* with Tony Quinn in Mexico. It's the night of the Academy Awards ceremony, and they learn that my father has just won Best Actor for *High Noon* and Tony Quinn has won Best Supporting Actor for *Viva Zapata!* They're out celebrating— Quinn, Poppa and Barbara Stanwyck, who was really just one of the boys—and my father starts giggling devilishly.

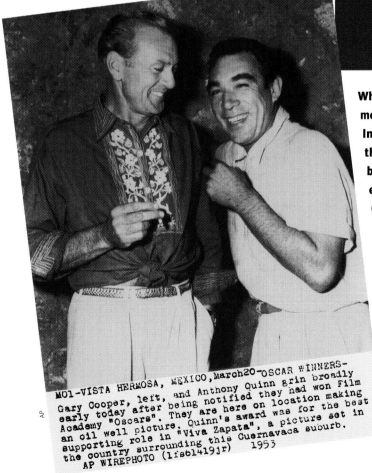

MO1-VISTA HERMOSA, MEXICO, March20-OSCAR WINNERS- Gary Cooper, left, and Anthony Quinn grin broadly early today after being notified they had won Film Academy "Oscars". They are here on location making an oil well picture. Quinn's award was for the best supporting role in "Viva Zapata", a picture set in the country surrounding this Cuernavaca suburb. AP WIREPHOTO (1fsb1419jr) 1953

AP

Why are these men smiling? In part because they've just been told they each won an Oscar, and also because Coop's prank on the Duke has worked so brilliantly.

Quinn says, "What?" and my father says, "Well, you know, a few weeks ago I bumped into Wayne, and, since I needed someone to stand in for me anyway, I said, 'Duke, if I win, would you pick up the Oscar for me? I'll be on location.'" What could he say? That must have been quite a moment for Duke.

Me, I was at home watching on my bed with a girlfriend who had come for a sleepover. It wasn't Pia, I've forgotten who it was. When they said "Gary Cooper," it was quite a moment for me as well as for Wayne and Poppa. I screamed and threw my arms out wide. I whacked her in the mouth and she bled all over my bed.

My father was always a little bit surprised that *High Noon* took off the way it did. Was he prouder of it than his other movies? I think so. As time went on, I think he came to realize what a special picture they had made.

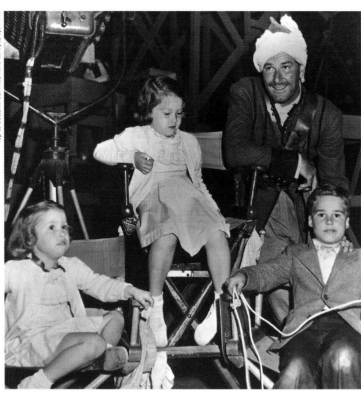

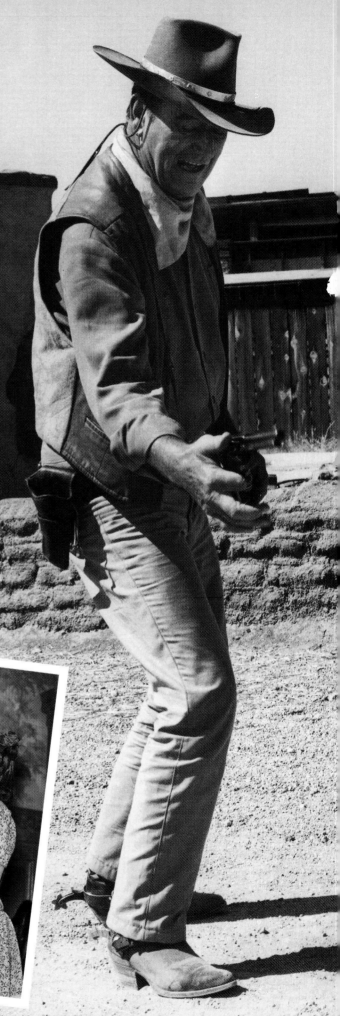

Errol Flynn, taking a break from his role as Mahbub Ali in 1950's *Kim,* and his overarching role as an incorrigible wild man, plays Dad to Deirdre, Rory and Sean. The son, who became a photojournalist, was lost in Cambodia in 1970.

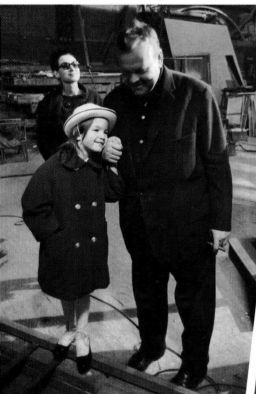

Big directors and their little girls: Orson Welles greets Beatrice on 1962's *The Trial.* Alfred Hitchcock bumps into Patricia while making his favorite film, 1942's *Shadow of a Doubt.*

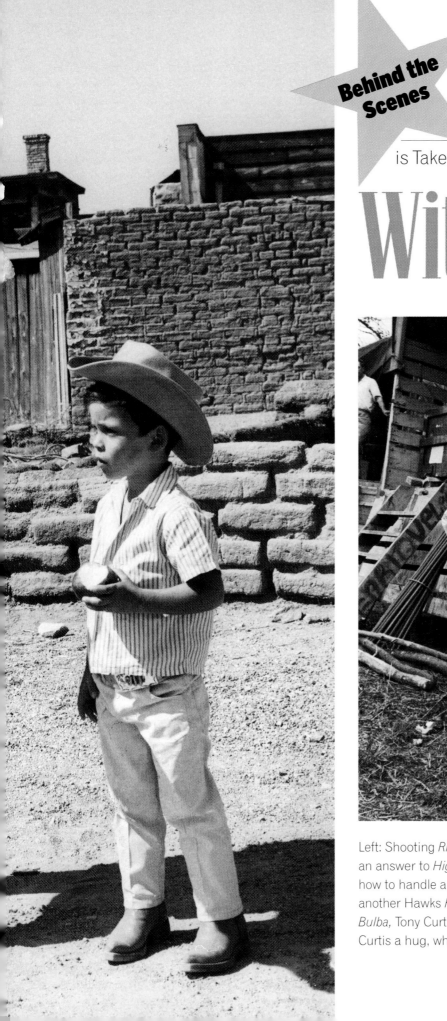

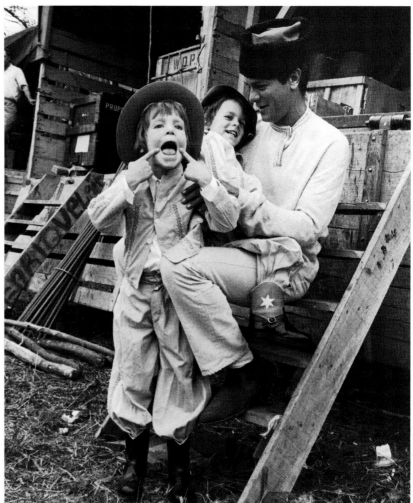
Maria Cooper wasn't the only offspring of a Hollywood icon to be enchanted by a visit to the set. In what other profession is Take Your Child to Work Day such a big deal?

With the Kids

Jerry Ohlinger's Movie Material

Left: Shooting *Rio Bravo,* the movie he and Howard Hawks intended as an answer to *High Noon,* John Wayne shows his son, John Ethan Wayne, how to handle a six-shooter. Ethan will later play alongside his dad in another Hawks *Rio* film, 1970's *Rio Lobo.* Above: While making 1962's *Taras Bulba,* Tony Curtis gives his daughter and future movie star Jamie Lee Curtis a hug, while her sister, Kelly, mugs. The girls' mother is Janet Leigh.

At the Oscars

Some folks in the movie business pooh-pooh the Academy Awards as a silly or even unfortunate competition. But for the vast majority, the idea of being forever linked to Oscar, of hearing "And the winner is . . ." and then their own name, is a dream beyond compare.

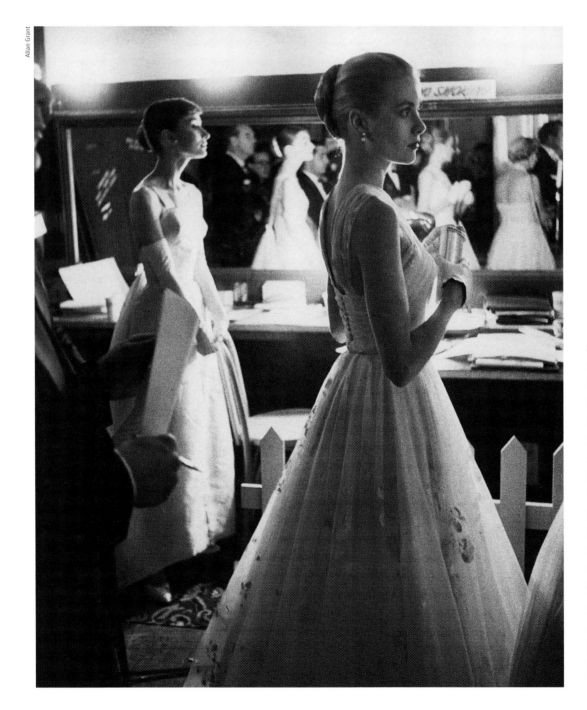

Allan Grant

Audrey Hepburn and Grace Kelly wait eagerly backstage for their turns as Oscar presenters, Hepburn for Best Picture (*Marty*) and Kelly for Best Actor (*Marty*'s star, Ernest Borgnine). It is March 21, 1956. In less than a month, Kelly will wed Prince Rainier III of Monaco, and never again will her beauty adorn the silver screen. Two years later (opposite), Joanne Woodward tries to compose herself after taking the honors for *The Three Faces of Eve.*

Ralph Crane

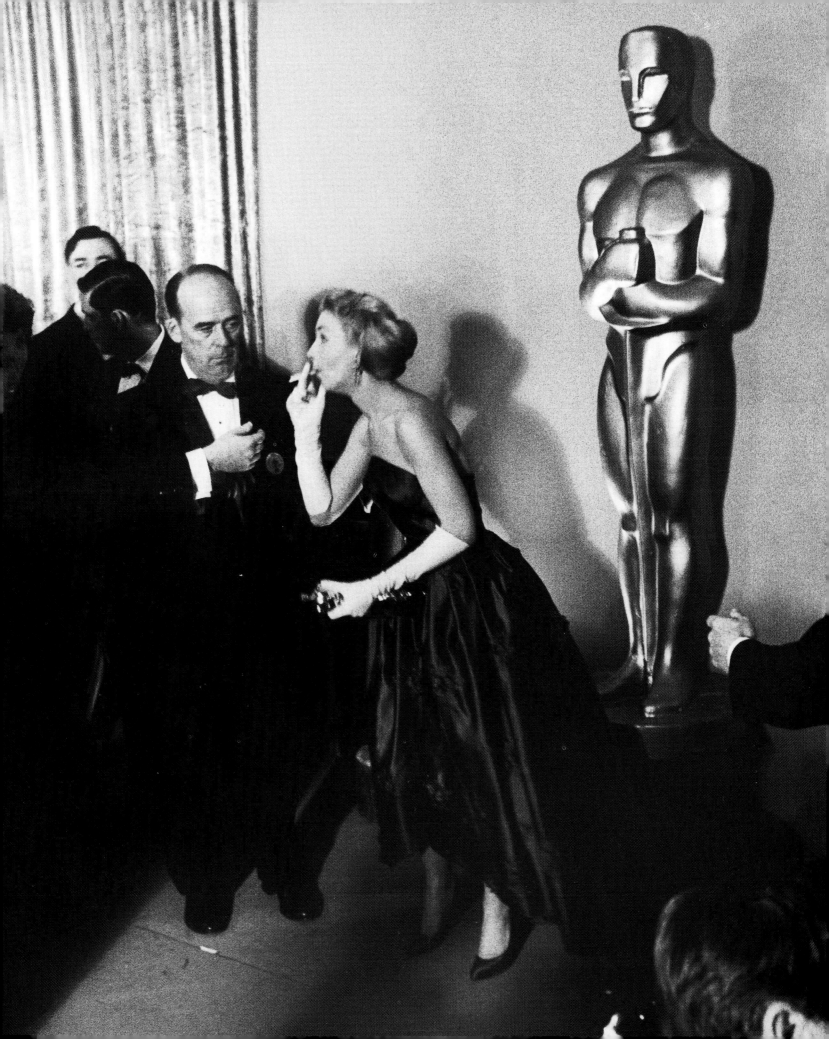

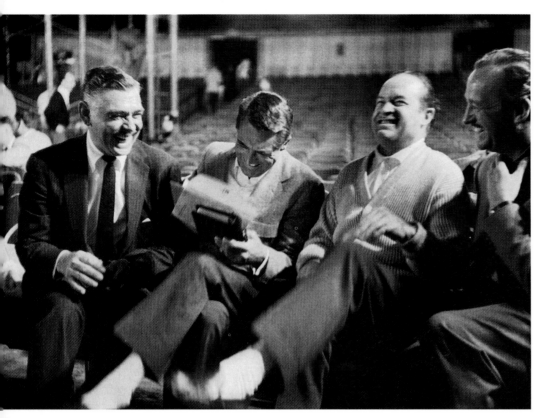

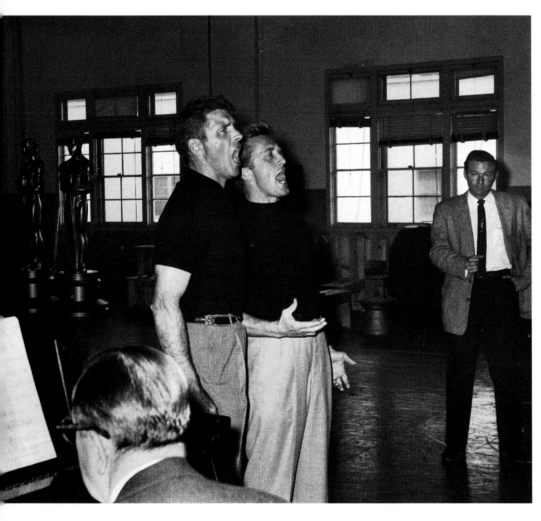

For Oscar's 30th anniversary, in 1958, Hollywood went all out. This soiree required five hosts: Bob Hope, David Niven, James Stewart, Rosalind Russell and Jack Lemmon ("I haven't opened my mouth, but I've already

gotten a speed-up signal"). At top left, Hope, recently returned from Russia, has Clark Gable, Cary Grant and Niven in stitches: "They didn't recognize me there, either." Left, Burt Lancaster and Kirk Douglas rehearse a Sammy Cahn–

Jimmy Van Heusen sour-grapes ditty, "It's Great Not to Be Nominated." The number had a real showbiz coda, as Lancaster gleefully danced off the stage while holding Douglas aloft in a handstand. Above, a bouquet of

celebs preparing for the big show. Front: Janet Leigh, Debbie Reynolds, Bob Hope and Shirley MacLaine. Rear: Shirley Jones, Van Johnson, and Mae West and Rock Hudson, who teamed up for a steamy "Baby, It's Cold Outside."

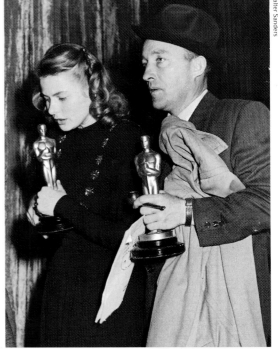

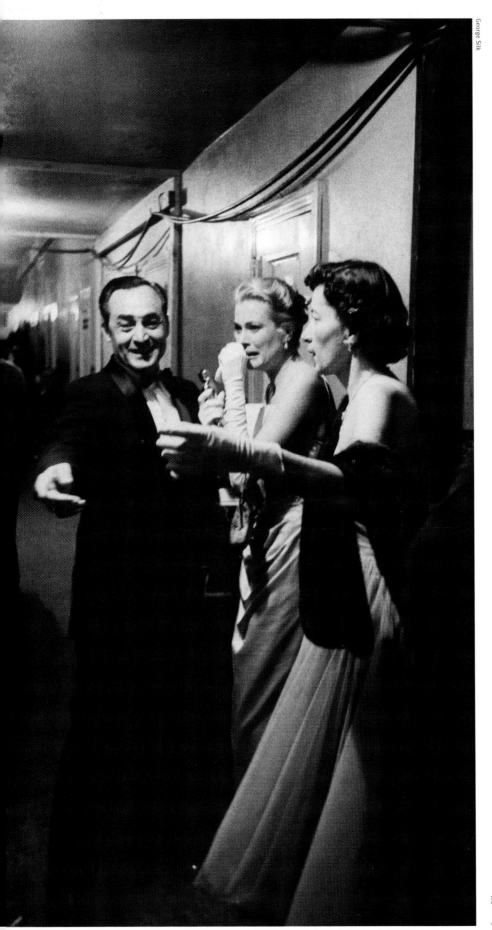

Above, Bing Crosby (with pipe and prize for *Going My Way*) escorts Ingrid Bergman (Oscar only—*Gaslight*) in 1945. Left: Happy Paramount flacks with Grace Kelly, winner for 1954's *The Country Girl*. Walt Disney fixes one of his four awards from that year. Opposite: Joan Fontaine contemplates her Oscar for 1941's *Suspicion*.

gotten a speed-up signal"). At top left, Hope, recently returned from Russia, has Clark Gable, Cary Grant and Niven in stitches: "They didn't recognize me there, either." Left, Burt Lancaster and Kirk Douglas rehearse a Sammy Cahn–

Jimmy Van Heusen sour-grapes ditty, "It's Great Not to Be Nominated." The number had a real showbiz coda, as Lancaster gleefully danced off the stage while holding Douglas aloft in a handstand. Above, a bouquet of

celebs preparing for the big show. Front: Janet Leigh, Debbie Reynolds, Bob Hope and Shirley MacLaine. Rear: Shirley Jones, Van Johnson, and Mae West and Rock Hudson, who teamed up for a steamy "Baby, It's Cold Outside."

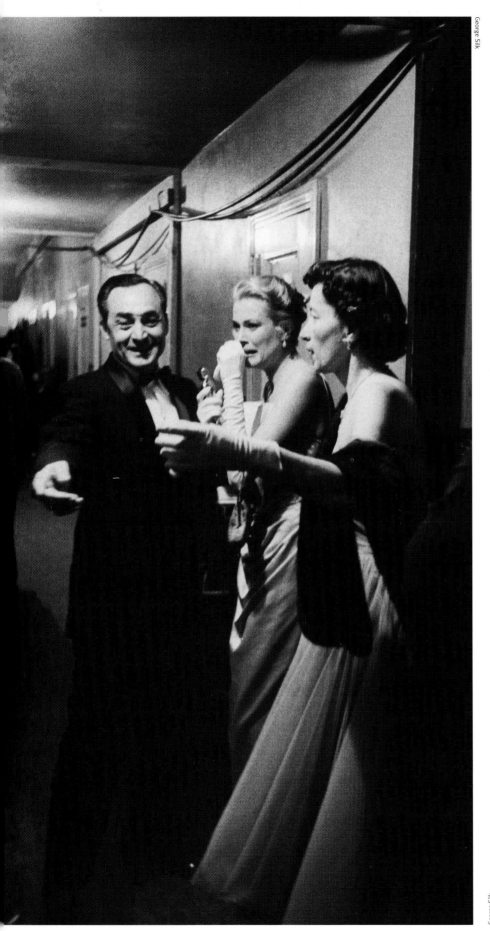

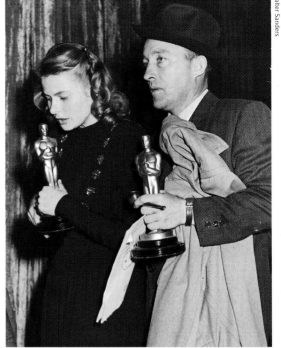

Above, Bing Crosby (with pipe and prize for *Going My Way*) escorts Ingrid Bergman (Oscar only—*Gaslight*) in 1945. Left: Happy Paramount flacks with Grace Kelly, winner for 1954's *The Country Girl.* Walt Disney fixes one of his four awards from that year. Opposite: Joan Fontaine contemplates her Oscar for 1941's *Suspicion*.

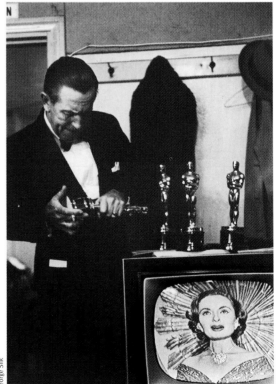

George Silk

Walter Sanders

George Silk

Peter Stackpole

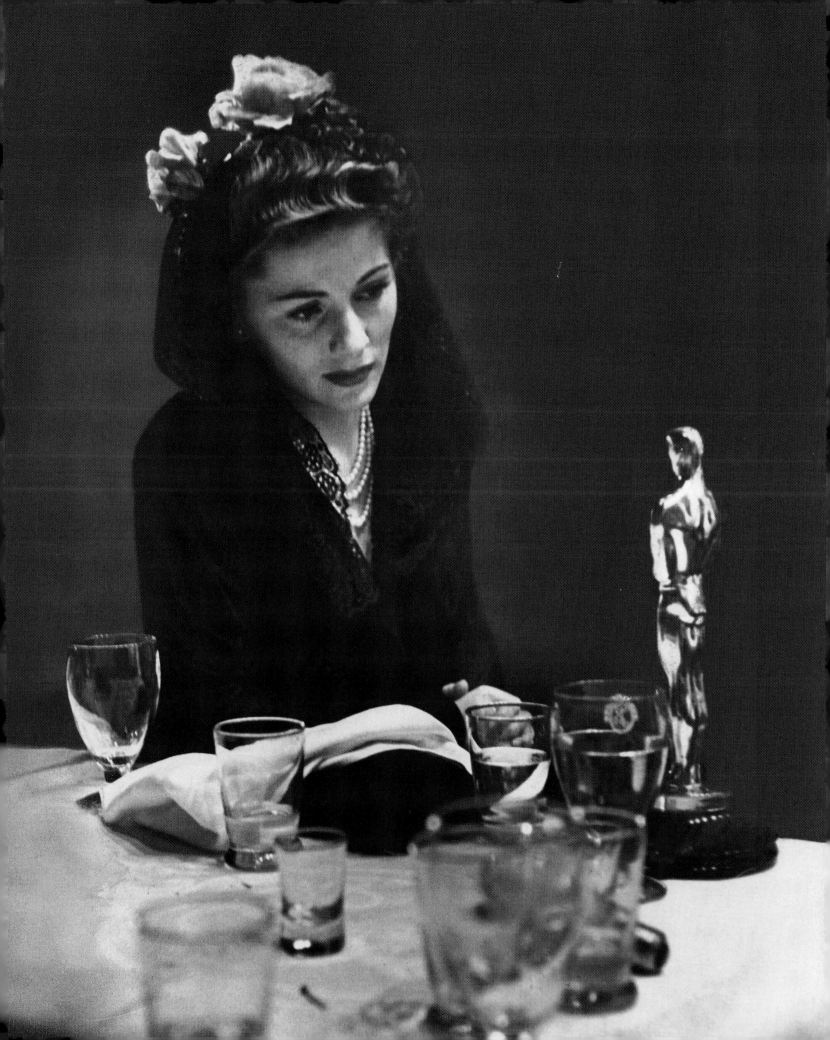

Julia Roberts, in vintage velvet Valentino, totes her Oscar for 2000's *Erin Brockovich.* In her giddy acceptance speech she exulted, "I love the world!" Below, the first African American woman to win Best Actress, Halle Berry (*Monster's Ball*) and hubby Eric Benét watch as Denzel Washington offers thanks for *Training Day.* That 2002 show was a memorable one, capped off by Sidney Poitier's stirring oration. At right, on the morning after in 1977, Faye Dunaway considers her reward for *Network.*

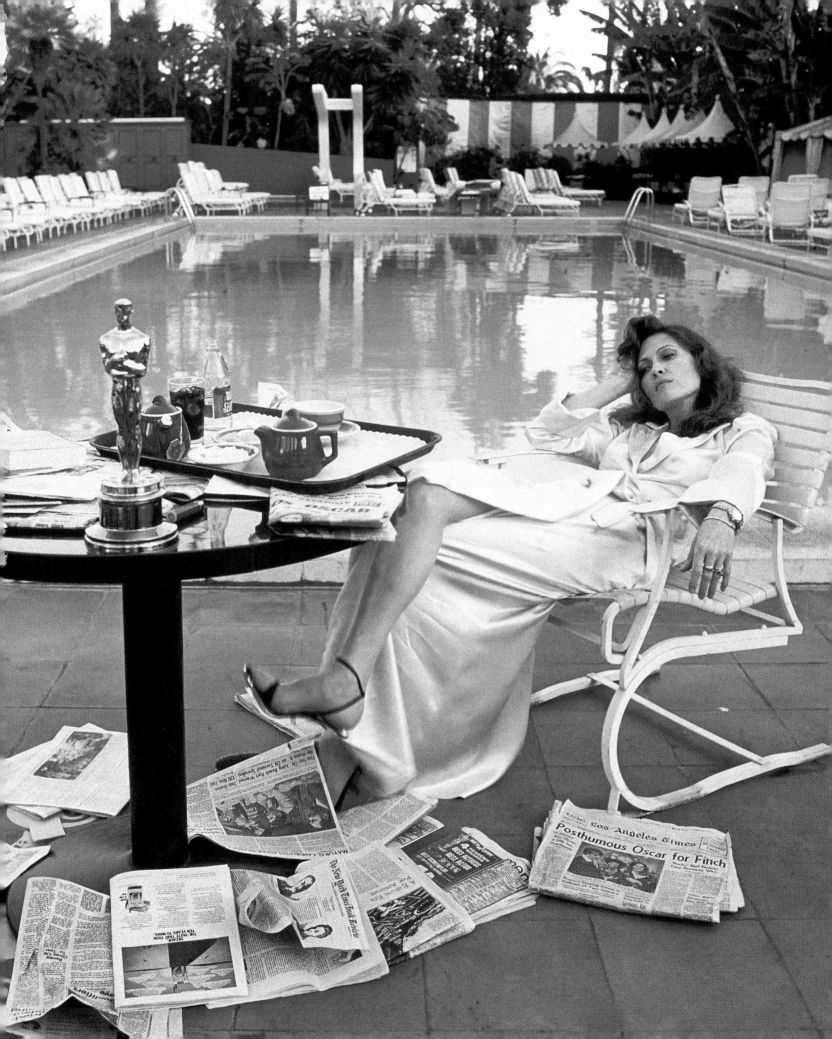

Masters of Ceremony

As with any get-together, the host of the Academy Awards dictates to a large degree the success of the event. Some were born to the role. Others might better have declined.

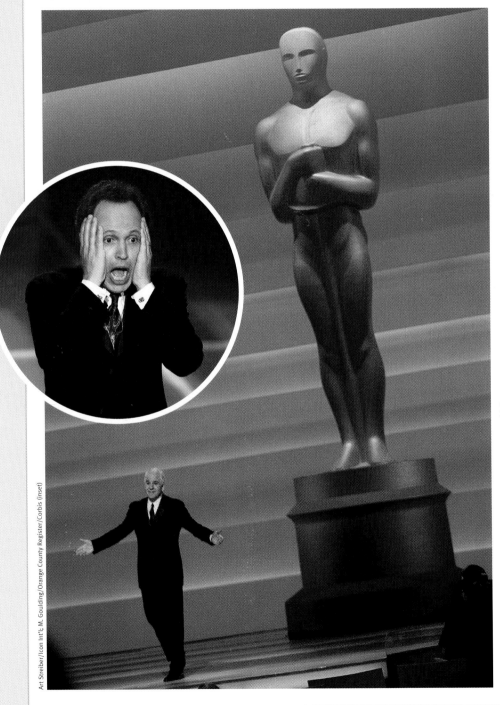

The Oscars show attracts a vast television audience. And as much as anything, these broadcasts are remembered for their hosts. Counterclockwise from left: Billy Crystal has made his opening number a must-see seven times; Steve Martin was typically droll, though he drew a menacing stare from Russell Crowe; David Letterman proved a dog in '95 and dragged poor Tom Hanks onstage; Johnny Carson fared well, with or without Miss Piggy; the incomparable Bob Hope was The Man for 18 shows.

J.R. Eyerman

Art Streiber/Icon Int'l; M. Goulding/Orange County Register/Corbis (inset)

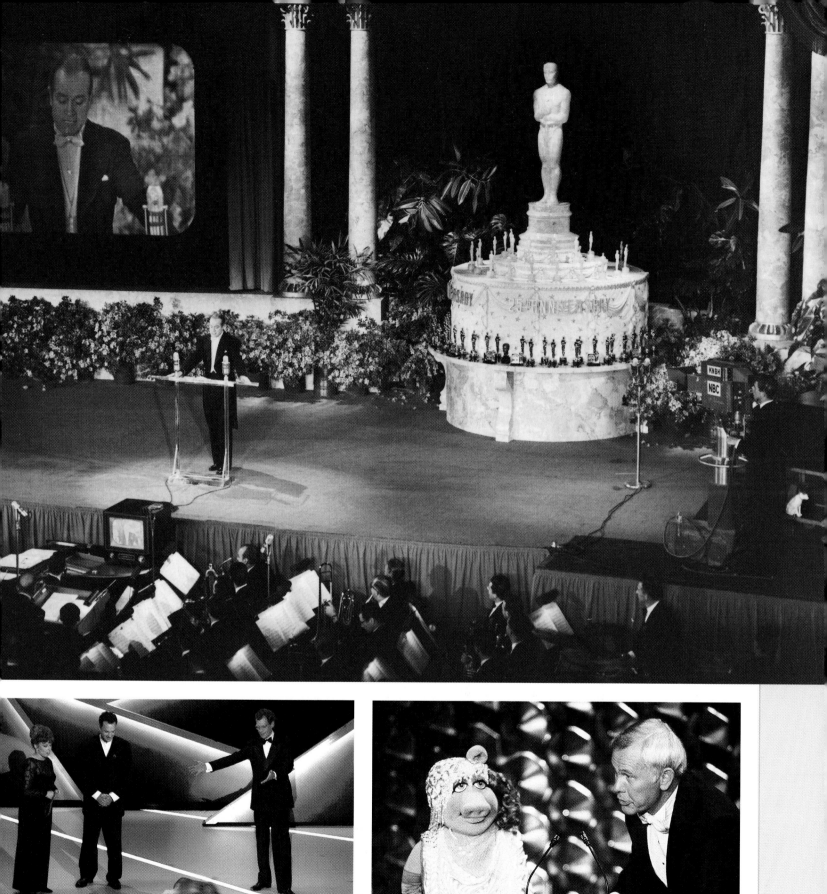

Michael Caulfield/AP

Gunther/MPTV

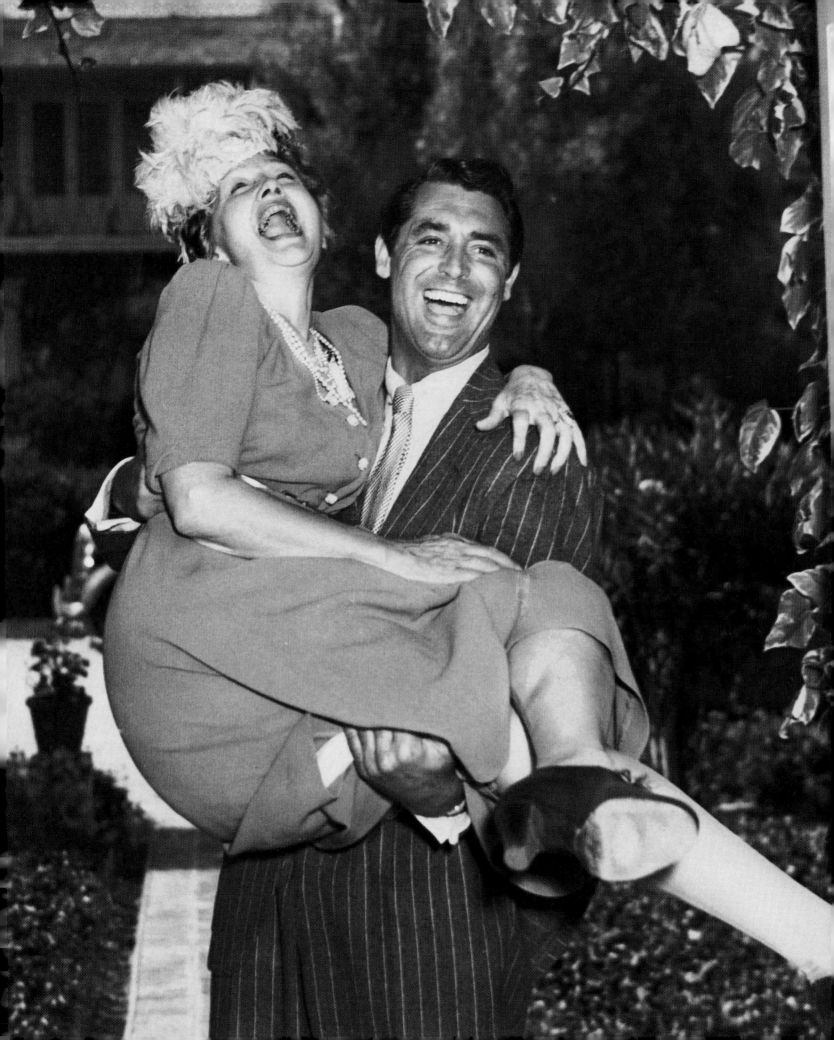

Hedda Hopper's Moving Day

When one of the country's top gossipmonger–power brokers moved into her new Beverly Hills digs, she got help with the heavy lifting from some true Hollywood heavyweights.

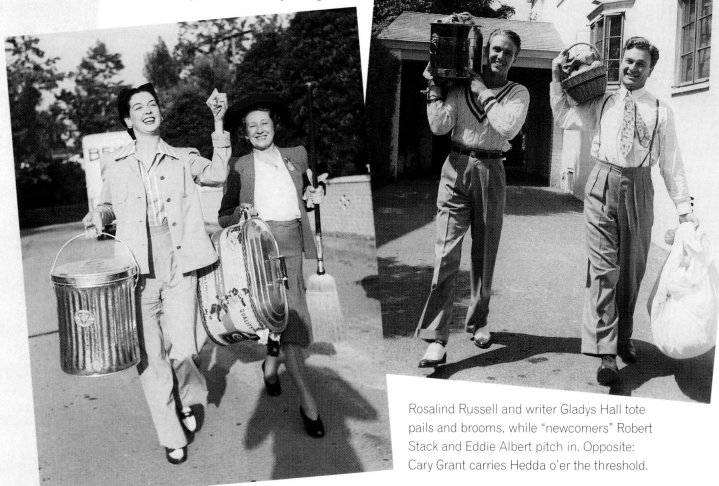

Rosalind Russell and writer Gladys Hall tote pails and brooms, while "newcomers" Robert Stack and Eddie Albert pitch in. Opposite: Cary Grant carries Hedda o'er the threshold.

Jerome Zerbe (3)

"Hedda Hopper is a gay, boisterous, impulsive woman in her 50s who knows more gossip than any person alive," LIFE reported in 1941. "Daily in 22 newspapers and three times a week over CBS she tattles her tidbits in burbling, pell-mell style to a vast, devoted following." In those days, Hopper and other gossips of similar reach and renown—Louella Parsons, Walter Winchell—had real power. They could boost or bust a star with a well-timed rumor, be it nice or nasty. In comparing Hopper with Parsons, LIFE showed a clear bias:

"Prettier, wittier, more kindly by instinct, Hedda is infinitely more liked by the movie colony than her ruthless rival." Maybe the magazine truly felt that way. Or maybe this opinion was a quid pro quo for inviting a LIFE photog along for some setups on moving day. And maybe all these stars showed up because they liked Ms. Hopper in such an infinite way. But maybe, just maybe, the famous folks on these four pages knew upon which side their bread was buttered, and how fickle film fans could be. Maybe, just maybe, they figured that stooping to manual labor for a day—helping dear Hedda— might in the end prove a fairly sound career move.

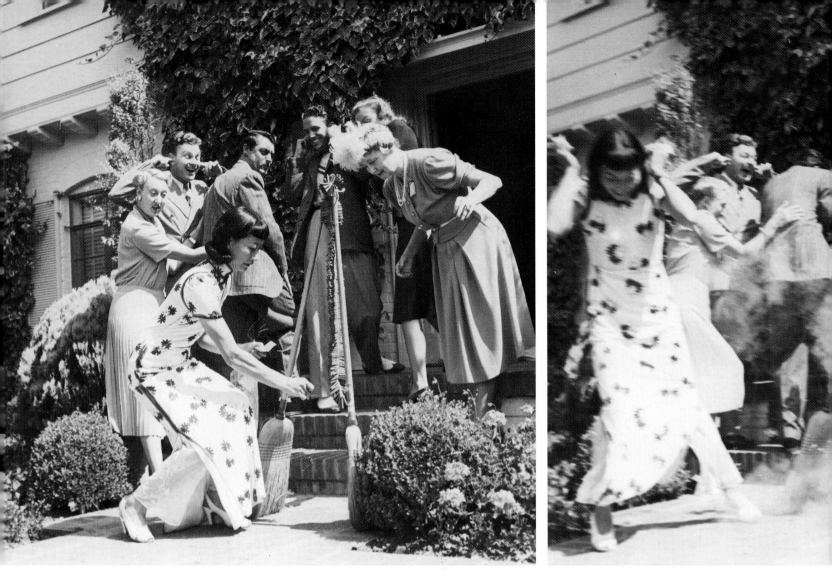

It's pointless to tinker with the original LIFE caption describing the sequence above: "Anna May Wong brings Hedda good luck by exploding a string of Chinese firecrackers to drive away evil spirits. Resultant debris has to be swept up." Wong, a native of Los Angeles, was a respected actress in silents and talkies but was denied many lead roles because of her ethnicity.

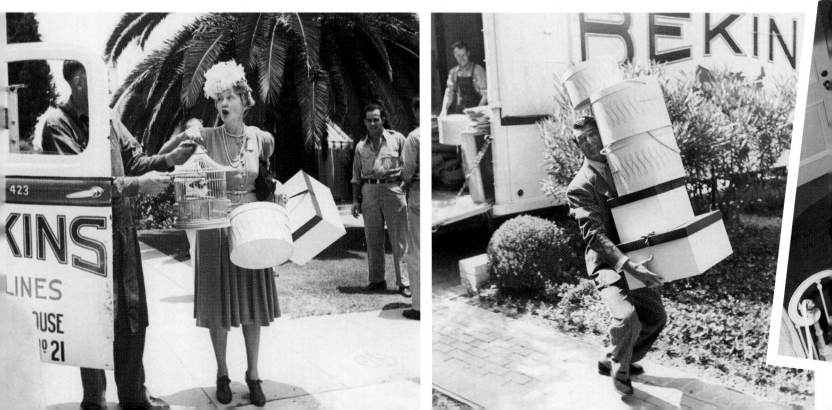

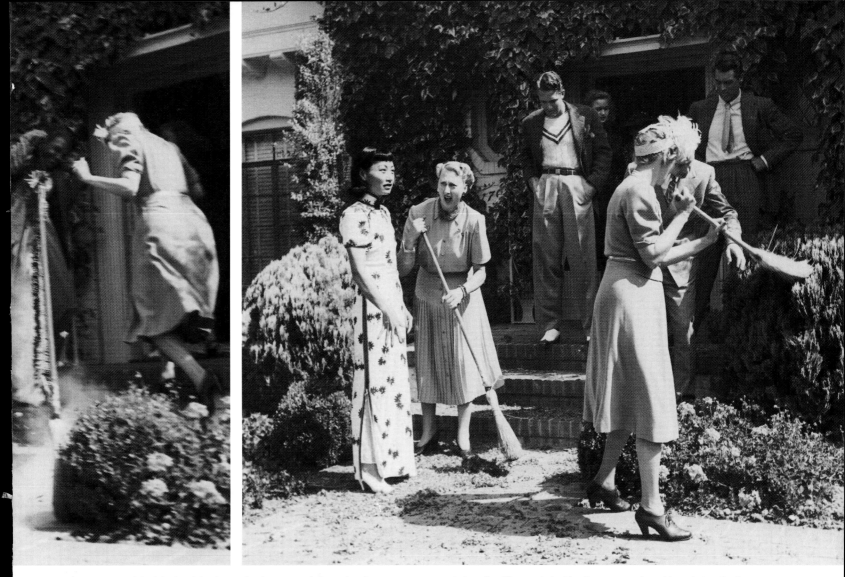

Hedda hadda thing for hats, and Cary hadta carry a mountain of millinery into the house and up the stairs. In the bedroom, he inspects the goods and wonders if his exertions were worthwhile. Hedda herself must have done her part, for at day's end she claims tired tootsies and chills at the fridge.

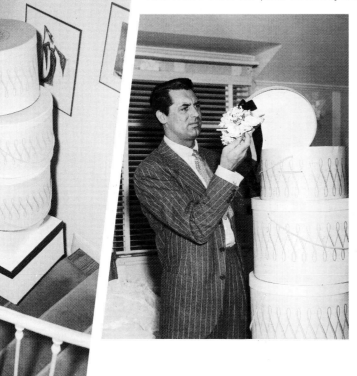

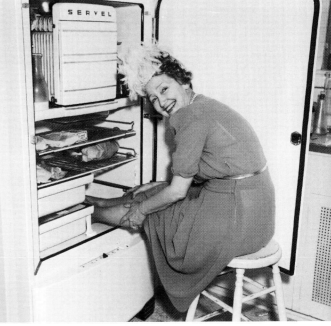

Jerome Zerbe (8)

Golden Couples

It's all about chemistry. They might really be in love (Bogie and Bacall; Liz and Dick, on good days) or they might be just congenial (Fred and Ginger), but if there isn't that certain something onscreen, then the whole merely equals the parts.

Tracy & Hepburn

Before they were cast in 1942's *Woman of the Year,* Tracy was often regarded as a talented, intelligent actor and Hepburn a talented, cold one. But together, in nine films made before Tracy's death in 1967, they sizzled— they really sizzled. In a series of smart romantic comedies grounded in the battle of the sexes (*State of the Union, Adam's Rib, Pat and Mike, Desk Set*), they were able to translate their offscreen love affair into big-screen passion. Tracy, a devout Catholic, could not divorce his wife to marry Hepburn. Still, their union is eternal.

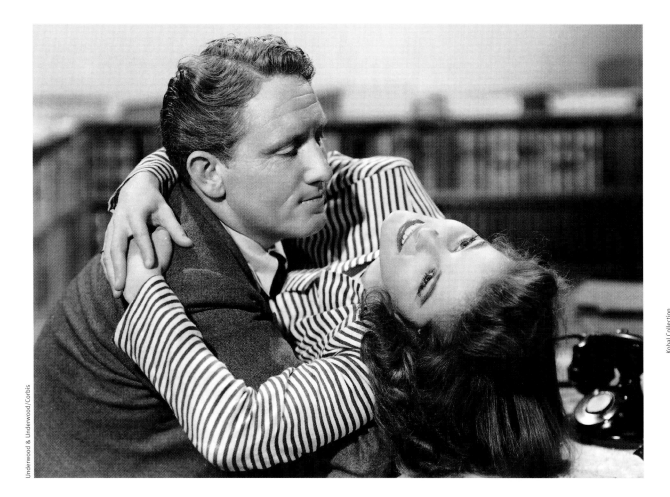

Underwood & Underwood/Corbis

Kobal Collection

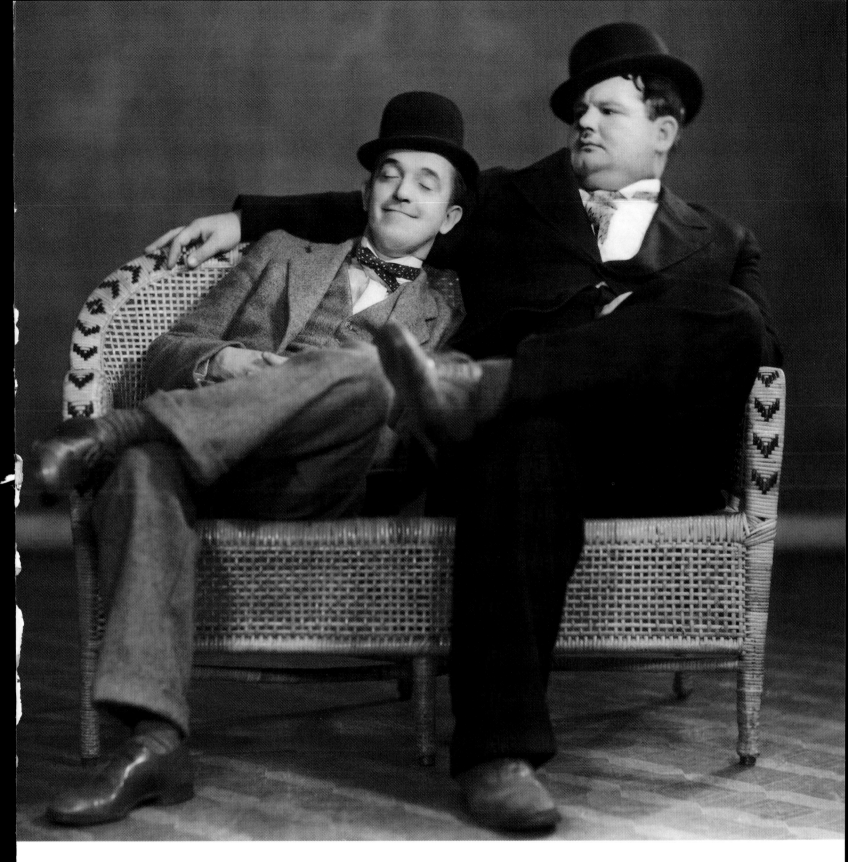

Laurel & Hardy

The most beloved comedy duo of all time, Stan Laurel of Lancashire, England, and Georgia's own Oliver Hardy teamed up in a 1926 two-reeler called *Forty-five Minutes from Hollywood,* and for the next two decades, Stanley whimpered splendidly and Ollie gifted the camera with his saintly slow burn as the boys slipped inexorably into yet another fine mess. And still, through all the mayhem that perforce surrounded them, the skinny one and the fat one brought naught but merriment and goodwill.

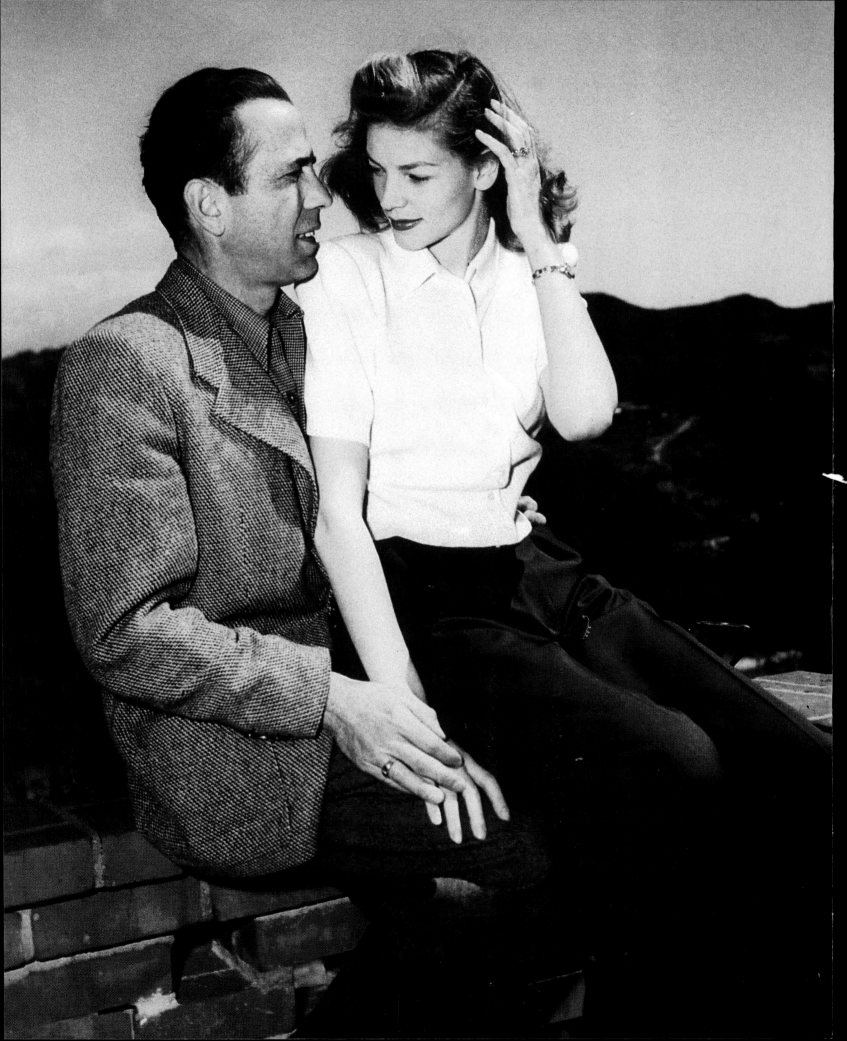

Bogart & Bacall

Their movie career together was short but bulletproof, their marriage strong and lasting. When 19-year-old ingenue Bacall brought her upward-glancing gaze—The Look—to Howard Hawks's *To Have and Have Not* in 1944, she stole the show from the 44-year-old veteran. He hardly minded, and the unlikely couple wed in 1945. During the next three years they made *The Big Sleep, Dark Passage* and *Key Largo*—classics all— then Bacall went on to prove herself a solo star, while Bogie, too, enjoyed success until his death in 1957.

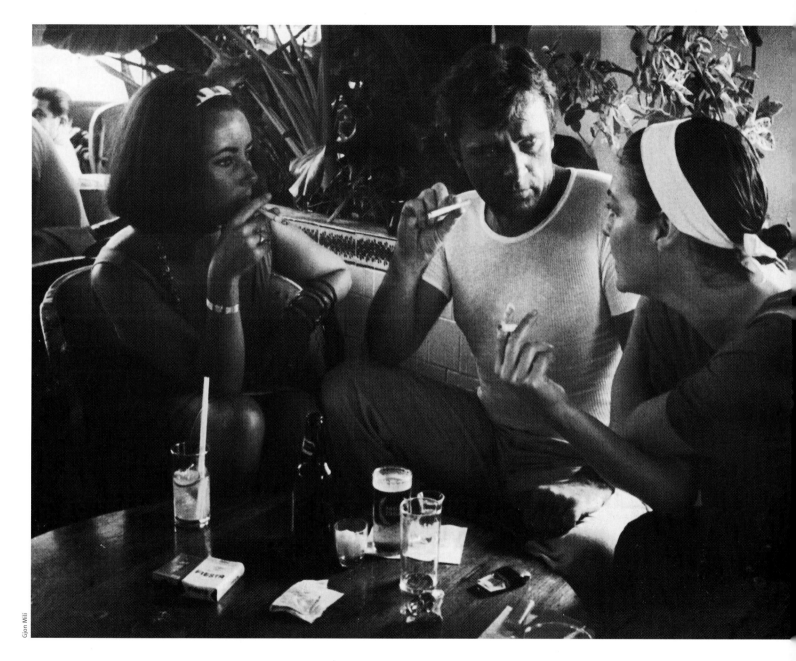

Gjon Mili

MPTV

Taylor & Burton

Some partners send off sparks, others throw flames. Elizabeth Taylor and Welsh miner's son Richard Burton (above, with Ava Gardner) were ever a fiery concoction. Their romance, which rocked the set of 1963's *Cleopatra* and left Taylor's marriage to Eddie Fisher in the desert dust, lasted off and on for 14 years and 10 films. Some of the years and films (*Who's Afraid of Virginia Woolf?, The Taming of the Shrew*) were incendiary, others were duds. Regardless, among Hollywood couples, no legend rivals Taylor and Burton's.

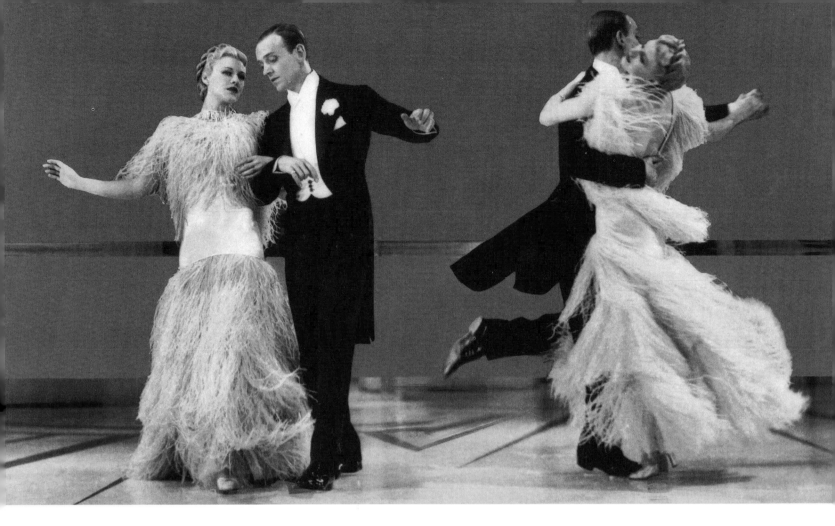

Rogers & Astaire

Katharine Hepburn said famously, "He gives her class and she gives him sex." The equation was certainly more complex than that, for who can delineate kismet? Consider: They appeared in nine films together in the 1930s before splitting up (they had a brief reunion in 1949's *The Barkleys of Broadway*); almost all their plotlines were flimsy at best; of approximately 100 minutes in each movie, perhaps 10 were spent dancing—yet those fleeting, flying moments transport us still. 'S Wonderful.

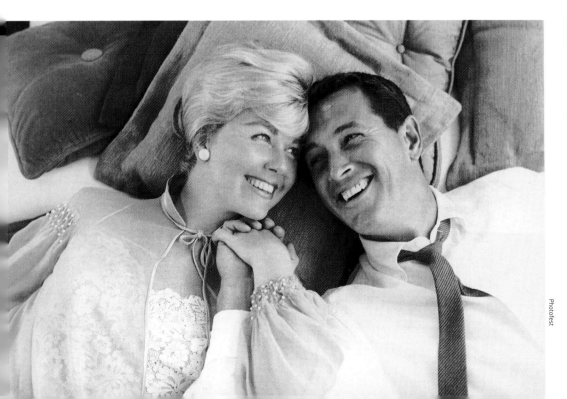

Day & Hudson

Because a Doris Day–Rock Hudson movie is such a familiar notion, it's hard to believe they made only three films together. They were two of Hollywood's biggest stars when they teamed for one of the 1950s' brightest romps, *Pillow Talk*, which gave Doris a chance to bounce around town in diveen designer wear, while Rock got to show that this was one hunk endowed with sure comic timing. As in the later *Lover Come Back* and *Send Me No Flowers*, they were marvelous foils in sparkling, very funny comedies.

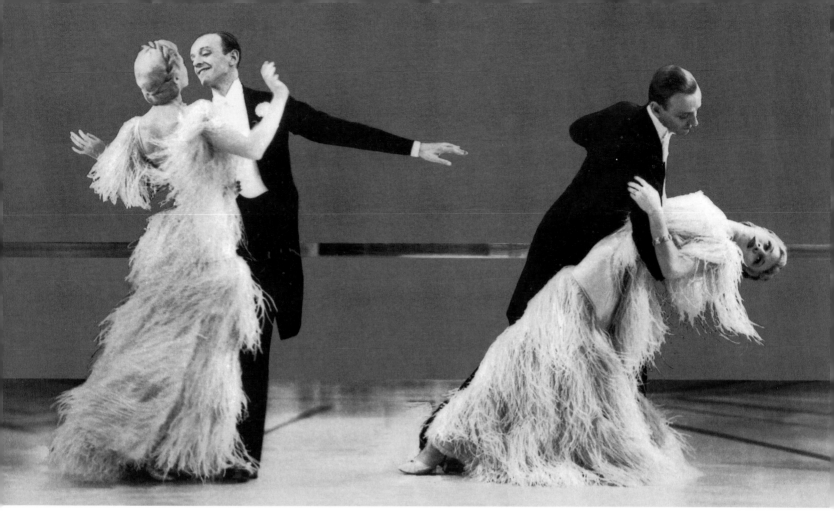

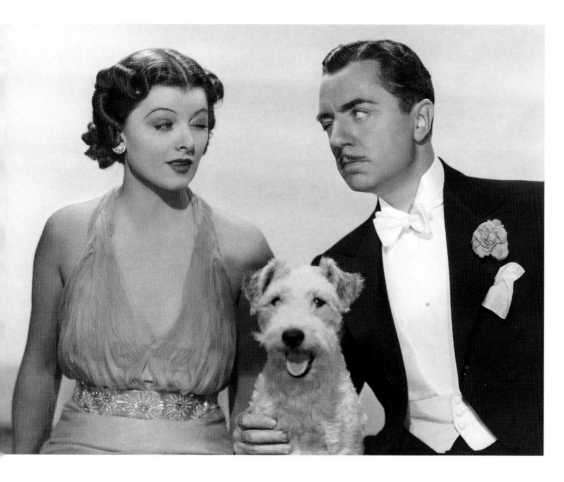

Loy & Powell

He was Hollywood's embodiment of such terms as "suave" and "debonair." She was the Queen of Hollywood, a.k.a. the Perfect Wife. And heaven knows they were terrific on their own, in scores of movies, but without the 14 films they made together, William Powell and Myrna Loy would not have attained such superlatives. They were a delicious blend—especially as Nick and Nora Charles in their six *Thin Man* flicks. And to keep the gin joint jumpin', there was Asta, their wily wirehaired terrier.

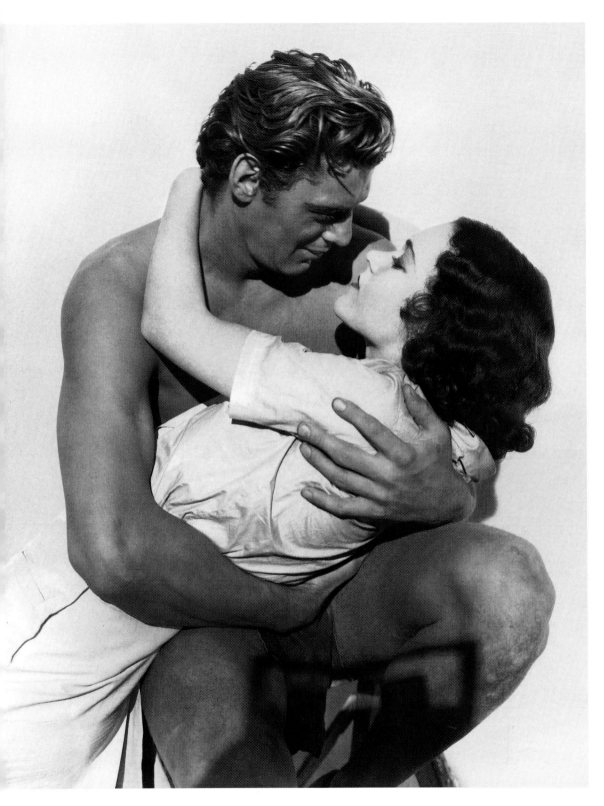

Karloff & Lugosi

Boris Karloff did *Frankenstein* and *The Mummy.* Bela Lugosi was *Dracula.* Were it only for these classics, which they made on their own, these actors would have known undying fame. Fortunately, though, they joined forces for eight other fright films, including the tremendous *Son of Frankenstein, The Body Snatcher* and (seen here) the art deco stunner *The Black Cat.* Such gentle souls they were . . . offscreen. But when the lights went down, these chums became monsters.

Weissmuller & O'Sullivan

Seven decades after Olympic swimming star Johnny Weissmuller and Irish-born, convent-raised Maureen O'Sullivan took to the treetops in *Tarzan the Ape Man,* a beautifully realized saga of a man raised among the animals who meets his match, this famous love story still resonates. These were, of course, two lovely creatures, and O'Sullivan's delicate, worldly charm mingled delightfully with Weissmuller's gruff, honest simplicity in six timeless adventure tales.

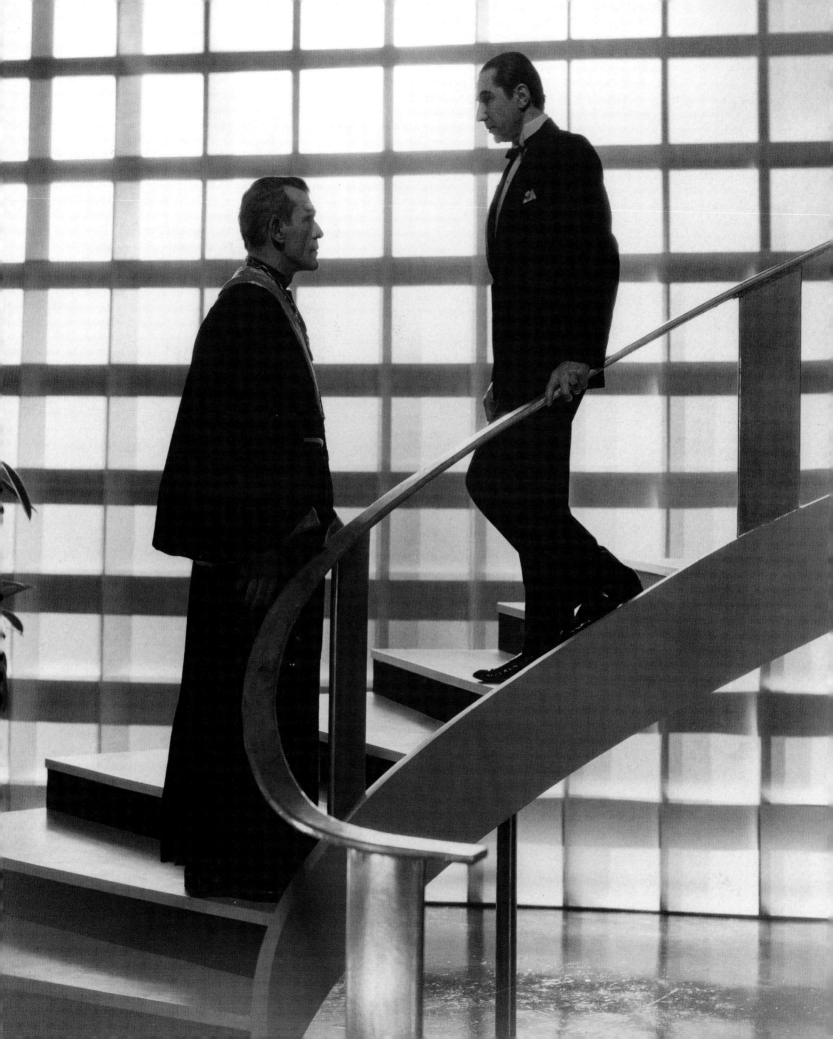

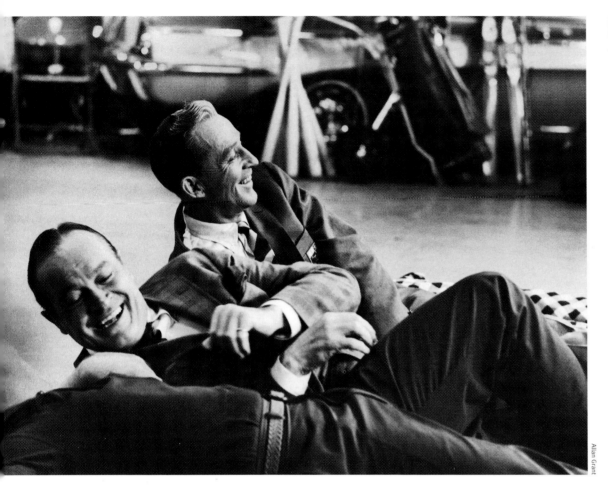

Hope & Crosby

There was a relaxed, genuine interplay between Bob Hope and Bing Crosby that made the audience feel good too. And these fellas knew how to entertain: Bing was a singer's singer, and Hope was no slouch himself; both could dance enough to have fun with it; and slinging wisecracks was Hope's day job, while der Bingle had a deft way with a riposte. Add it all up and you've got seven very special *Road* movies (with plenty of room to spare for Dorothy Lamour's sarong).

Allan Grant

Corbis

Lemmon & Matthau

Nearly all the grand screen partners have quite a lot in common, a shared sensibility. Laurel and Hardy were twinkly stumblebums, Hope and Crosby were in cahoots one step ahead of the girl's father. But Jack Lemmon and Walter Matthau were the bona fide clash of oil and water. One has the feeling they didn't really need a script: Simply place the two of them in any given situation—then lights, camera, action! Two heavyweight actors with a clear decision after seven bouts: a knockout combo.

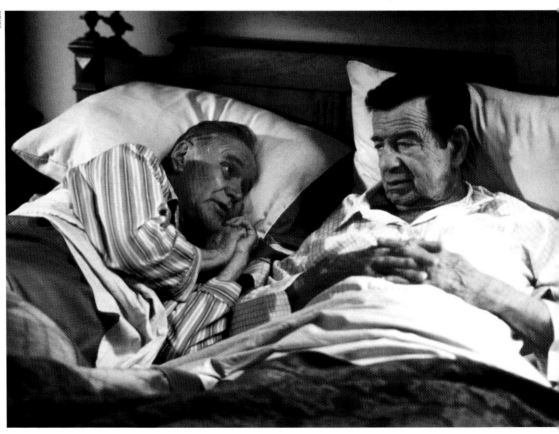

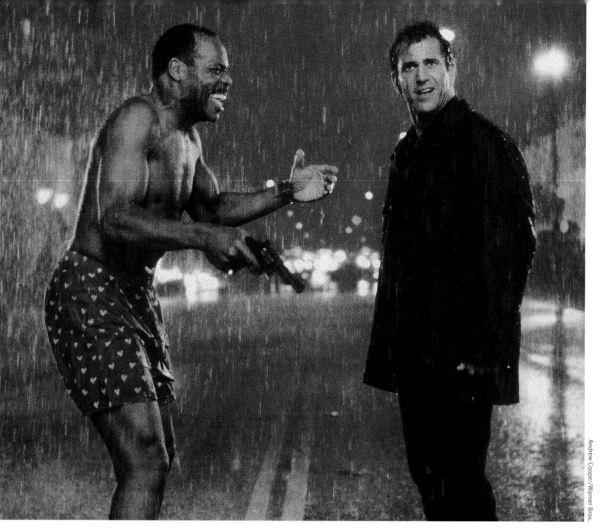

Glover & Gibson

The modern era has seen more than a few odd-couple associations in buddy movies; Robert De Niro and Charles Grodin leap to mind. It might not have seemed apparent in 1987 that the bringing together of esteemed stage and screen actor Danny Glover (*The Color Purple, Places in the Heart*) and heartthrob Mel Gibson (*Mad Max*) was the wisest thing, but after four smooth and funny *Lethal Weapon* movies, Glover and Gibson fit as comfortably as hand in glove.

Andrew Cooper/Warner Bros.

Culver Pictures

Lancaster & Douglas

The screen has hosted legions of he-men, but never has there been a powerhouse pairing to equal that of Burt Lancaster and Kirk Douglas. These gents packed plenty of testosterone, along with two world-class chins topped, if called for, by grins of frightening brilliance. They also had an athleticism and courage that left most stuntmen redundant. Most important, they shared a depth of intelligence, and curiosity, and the need to express their feelings, which this dynamic duo did in six fine films.

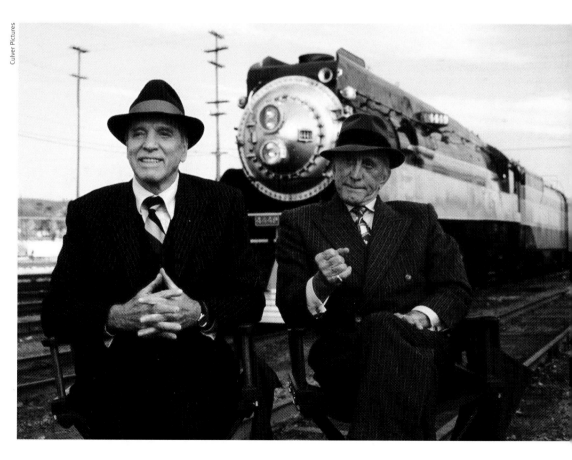

And the Winner Is...

Then they hear their names, then they have their trophies, then all pretense—sometimes, all self-control—is lost, and the actor is laid bare. And so, we forgive just about anything.

AMPAS

Leigh Wiener

AP

The pj'ed Miss Crawford accepts her award and the eager entreaties of paparazzi. Left: Field accepts our love while Brando, by proxy, tells Roger Moore and Liv Ullmann that he chooses not to accept (right). Above: Signoret, only too willing to accept, gets hold of herself in preparation for an overjoyed dash to the stage.

Roberto Benigni's gymnastics, Cuba Gooding Jr.'s elation, Halle Berry's tears . . . Sally Field! Swept away as she wins for *Places in the Heart* in 1985, she injects a phrase into the public lexicon: "I can't deny the fact you like me." Joan Crawford, up for *Mildred Pierce* in 1945, feigns illness and remains abed to escape the public glare, then courts it with an all-time photo op. Just before Simone Signoret wins Best Actress for *Room at the Top* in 1960, she is embarrassingly gripped by tension. She explains from the podium, "I wanted to be dignified, but I can't." Ah, yes, and then there is the "dignity" of "Sacheen Littlefeather," the "Native American" sent by Marlon Brando to refuse his 1973 Oscar for *The Godfather* as a protest of U.S. treatment of Indians. As it turns out, Littlefeather is an actress named Maria Cruz. Even this we forgive. It is, after all, Hollywood.

Maria Sermolina

Gordon Parks in Hollywood

It was, to a young LIFE photojournalist, "that golden, forbidden city." But then he entered its gates and, to his surprise as much as anyone's, changed the city forever. This is that story, in the words of Gordon Parks.

Hollywood will always be there. And multitudes of dreamers will keep entering its crepuscular light, whether it be at high noon, twilight or dawn. Time never seems to matter in Hollywood, and time spent there treats different people in different ways. Like languishing roses, some who visit Hollywood will stay on and bloom. Others will hit bottom and then, like rotting leaves, stay too long, get blown about—wondering, finally, why they had come to this city in the first place.

To millions, Hollywood has meant a million different things. For some wizened magazine photographers I've known, it meant extravagant power to capture images that would make beautiful pages. Then there were others who, like me, felt the lure of Hollywood itself slowly seeping into their pores.

I know I don't speak only for myself when I confess to being weary of stories about blacks doing something first that other blacks had longed to do. But these things happened—back in the time when no Hollywood studio would have hired a black to pen a major film, let alone direct or score one. Back in the time

when I never thought much of my chances. Back in the time when, for the moment, I accepted my success with *Vogue* and LIFE in peace.

What I remember of finding my way to Hollywood comes rolling in, sometimes blanketed with nostalgia. I was on the Sicilian Island of Stromboli, covering the love story between Ingrid Bergman and Roberto Rossellini. They were shooting a film there, and the production was

Parks, photographer: In 1949, Parks (left) shot Rossellini and Bergman leaving Stromboli to ask Bergman's husband for a divorce. Below: A more standard shoot in Marilyn Monroe's backyard in 1956.

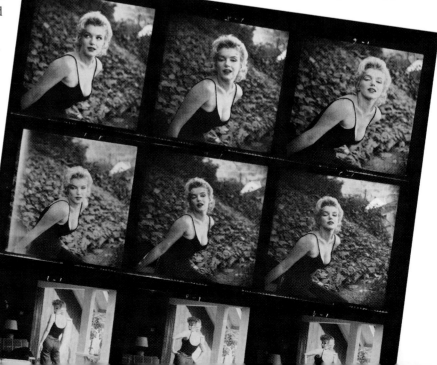

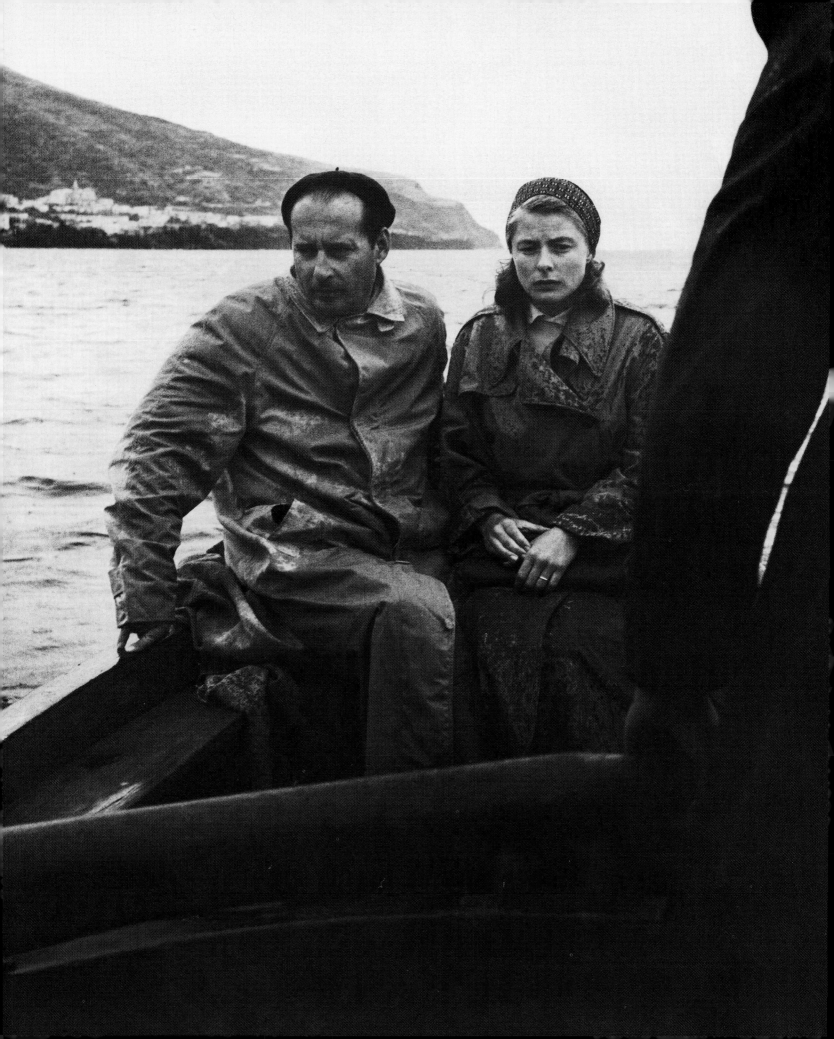

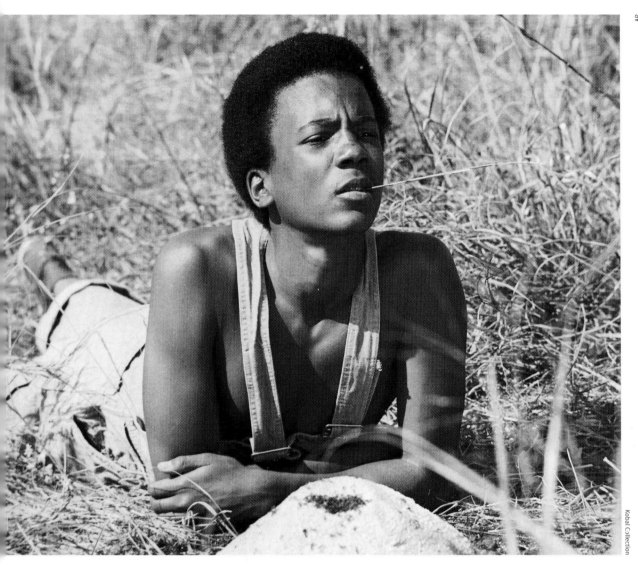

failing miserably. Having adored the locations in which I had chosen to photograph her, Ingrid asked me to stay on and assist Roberto on his film.

"I'm surprised and pleased, Ingrid, but he would never agree to your suggestion."

"Would you allow me to ask him?"

"Yes, but he will say no."

Her request to Roberto was, as I had predicted, time wasted. He said no.

But Ingrid awakened a germ that had been asleep inside me. And I began thinking about that golden, forbidden city. Ingrid Bergman had laid Hollywood's fingers on my waistcoat.

Assignments to Hollywood during the years to follow proved to be the bulwark of my existence. While watching films unfold, I found myself directing without actually directing. Within bright and soft lights, I was subconsciously placing actors where I alone wanted to see them. *Two lovers*

waltzed without moving. An elm tree took on wings and flew through a cyclone. Each assignment provided new challenges.

I was like a key without a lock when the LIFE photographer Carl Mydans suggested that I write a novel about my rugged childhood years in Kansas. A best-seller, *The Learning Tree* found its way to the actor John Cassavetes in Hollywood, then to [producer] Kenny Hyman's desk at Warner Bros. Like a cup of stars, Cassavetes's call came to me in New York at midnight. "Just read *The Learning Tree.* It must be made into a film and you have to direct it."

"But you know Hollywood, John. There are no black directors on the payrolls."

"I know. I know. But come to Kenny Hyman's office in Burbank two days from now. I'll introduce you and leave. Kenny and I are not speaking."

Drowning in dreams, I landed in Hyman's office. John introduced us and left. Hollywood was about

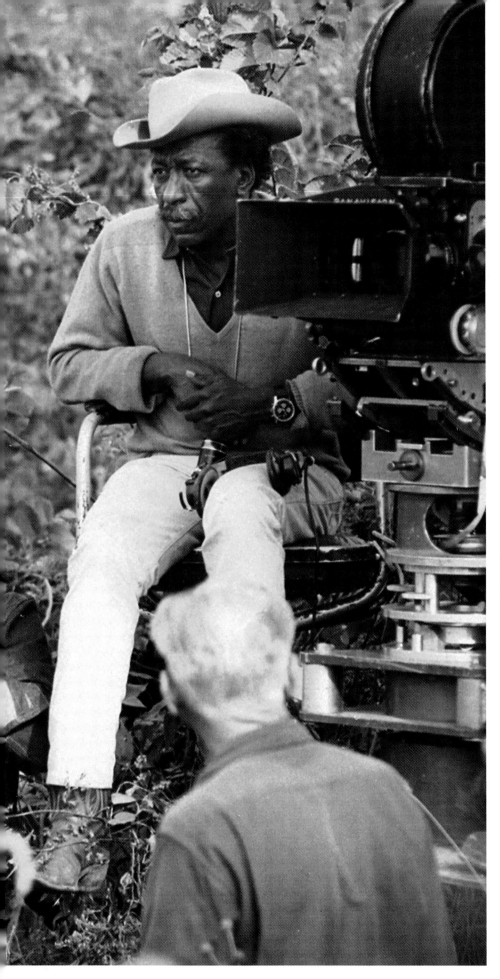

Everett Collection

Parks, filmmaker: In December 1968, Parks is in the chair for _The Learning Tree,_ a look back at his hard boyhood. Kyle Johnson (opposite) embodies young Gordon, while Gordon Parks Jr. (wearing shades), who will later direct _Superfly,_ assists his dad. Below: Richard Roundtree _is_ Shaft.

to be reborn; at last, Hollywood could start shaking out its dirty gloves. Not only was I assigned to direct, but the screenplay and musical score were also made my sole responsibility. "You'll be the first black director out here," Hyman said to me as I walked out the door. "Seems to me that you should also produce your film for the studio." Luck had struck. And I was ready for it. I stroked my chin and said, "Well—why not?"

California's sun smiled down on me when I left. Now I would turn to my roots, and I would get down to work.

On October 29, 1969, _Variety_ placed _The Learning Tree_ at the top of its chart. Not long after, I awoke to find _Shaft,_ my second film, in the same place. Later came _The Odyssey of Solomon Northup,_ then _Leadbelly._ For other hopeful black directors, Hollywood's hurtful past had started to crumble. Today, it seems to be flying away like wastepaper.

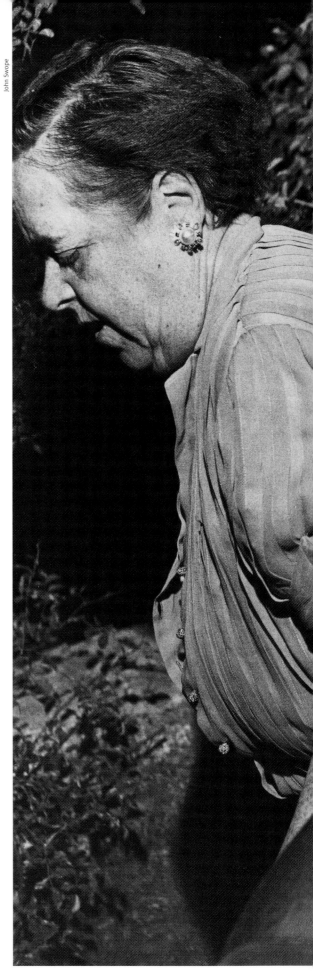

Steppin' Out

Even civilians know that making a movie is hard work, with long hours and one take after another. So when the day's a wrap, Hollywoodians whoop it up wherever they are.

Above, in December 1933, Rudy Vallee, Alice Faye and Gary Cooper toast the end of Prohibition. Right: Royals from Hollywood and elsewhere enjoy the French Riviera in '48. Here, Elsa Maxwell, Tyrone Power and the Duke of Windsor. At left, in '59, another Duke helps Toots Shor forget that his joint is closing that night.

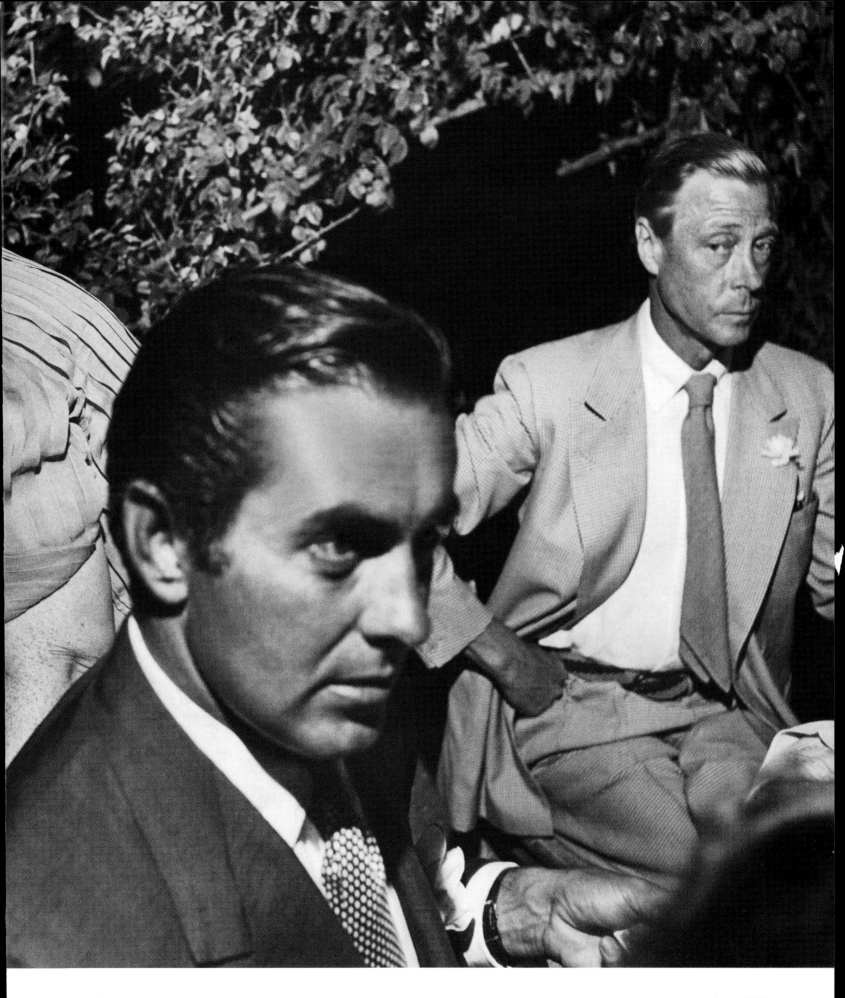

Larry Schiller

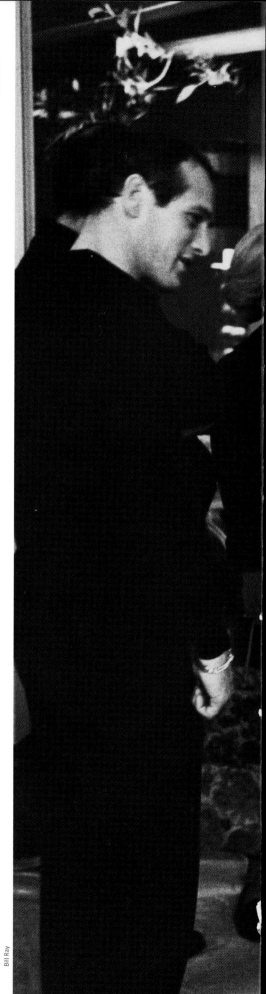

Rex Hardy Jr.

Above: Producer Carlo Ponti and wife Sophia Loren at an Oscars bash in 1962. Left, at a Beverly Hills Tailwagger's benefit for stray dogs in 1938, hostess Bette Davis (in white) is about to lose at musical chairs. At right, Natalie Wood test-drives her fiancé, producer Arthur M. Loew Jr., in 1963. Paul Newman is trying to persuade them to try Go Kart racing.

Bill Ray

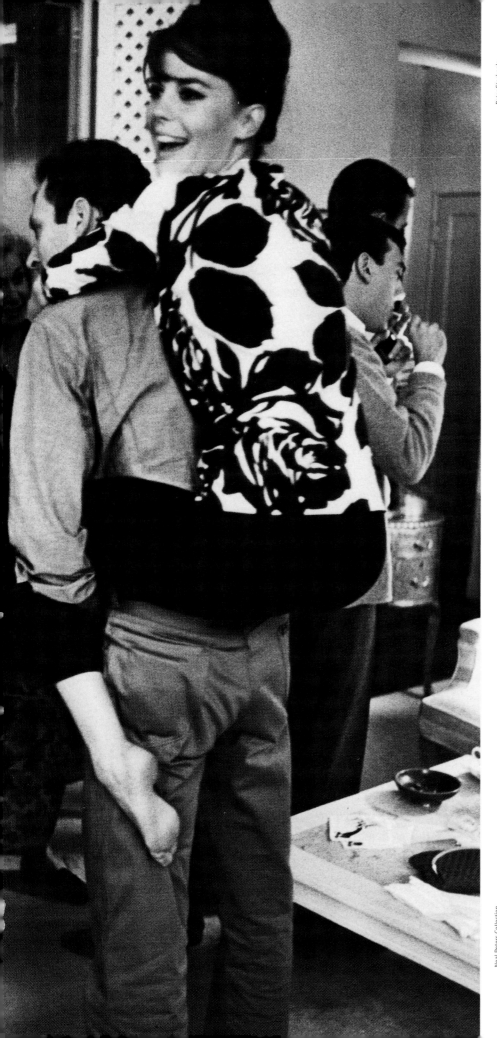

At Sam Spiegel's 1948 New Year's Eve party in
Beverly Hills, director Robert Siodmak (above,
left) chats up Judy Garland and her husband,
Vincente Minnelli. Below, Sammy Davis Jr. has
James Dean feeling bubbly in L.A. in 1955.

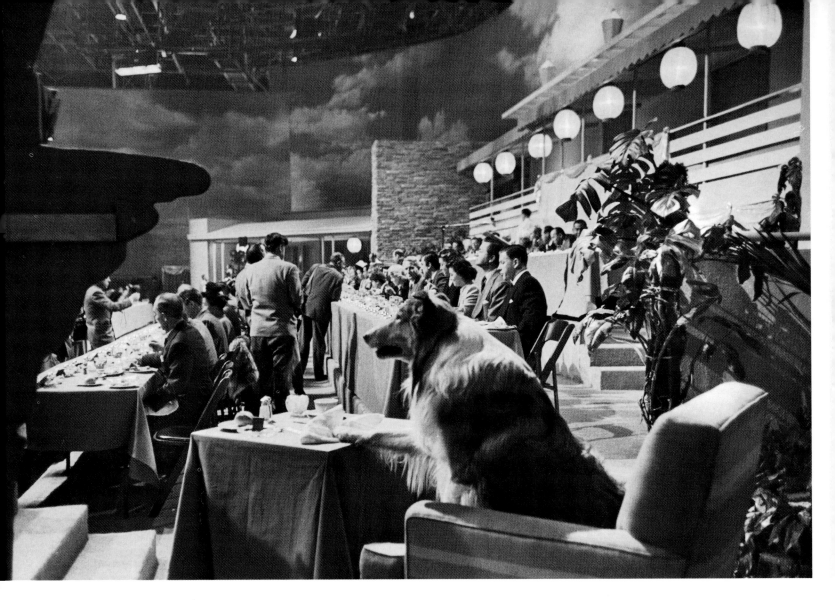

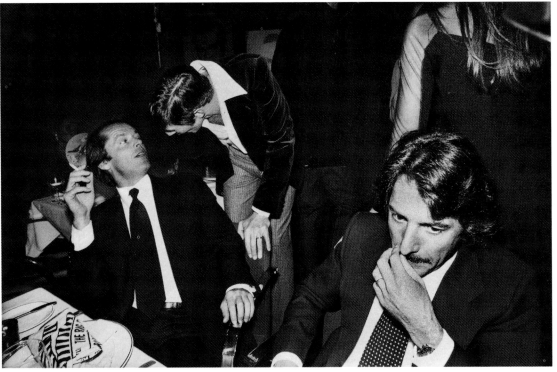

In 1949, at a dinner party to celebrate the 25th anniversary of MGM, one of the studio's most dependable stars gets a table to himself (Lassie was always played by a male). At left, in 1976, Dustin Hoffman ponders the universe while Leonard Nimoy and Jack Nicholson recall the old days.

Dafydd Jones (top); Alex Berliner/BEImages

At an Oscars blowout in Los Angeles in '94, Sharon Stone puts the horns on Leonardo DiCaprio, much to the delight of Ellen Barkin. The following year, at an L.A. eatery, Goldie Hawn gestures as soulmate Kurt Russell chuckles and Tom Hanks says, "Yes, *exactly!*" Dig the table awash with awards.

Peter Stackpole

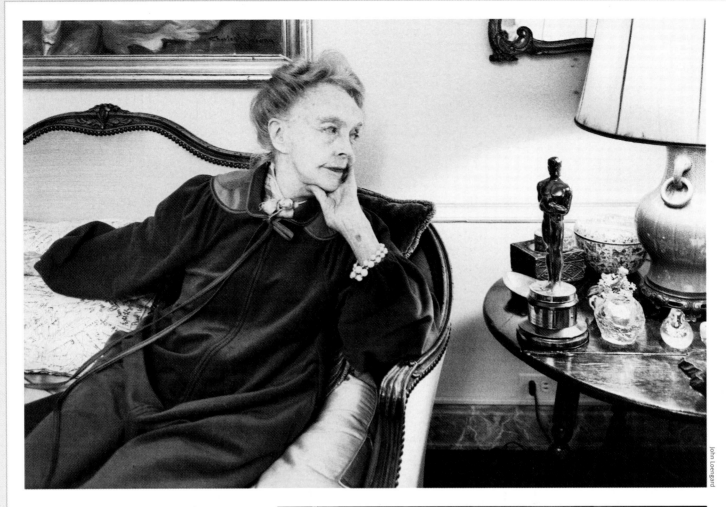

John Loengard

At Home With Oscar

When the big day is done and the statuette won, one question remains: Where to keep it? Some find an unassuming place—and then there's Kevin.

Art Streiber/Icon Int'l

"They're not to be hidden," producer Richard Zanuck told *In Style,* and he should know: His father, studio chieftain Darryl F. Zanuck, won three Oscars and three Thalberg Memorial career achievement awards, and Richard, too, has both an Oscar and a Thalberg. Sophia Loren, who has an Oscar and an honorary, was of the opinion that they should be "in the center of everything." Michael Douglas, who has one Oscar for producing and one for acting, didn't disagree but added, "I don't want a gauche presentation, where they're set up on some revolving platform in the living room, and as soon as you open the door, a key light comes on." Old-school superstars like James Stewart, James Cagney and Lillian Gish certainly subscribed to the sound thinking of Kirk's bright young boy, but new schoolers like Kevin Costner might think him nuts.

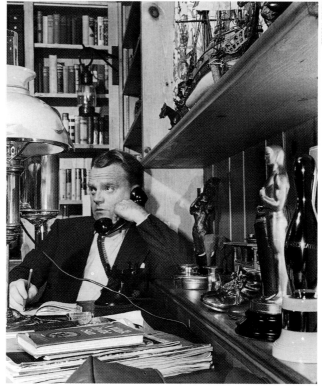

Harold Trudeau

Gish admires her honorary in New York City in 1987. In 1945, Colonel Stewart talks with an employee at his family's Indiana, Pa., hardware store. Also in '45, Cagney talks business next to his film and bowling hardware. Costner's display, made from jewelry cases that were once in the Empire State Building, is outside his screening room.

Just One More

Photograph by Ed Clark

Before the Oscars in 1954, *From Here to Eternity* producer
Buddy Adler was shaking: "I don't know what I'm doing."
Afterward, he was calmer, checking his Best Picture
Oscar at Romanoff's before heading in to the party.
By the by, Buddy's epitaph reads, FROM HERE TO ETERNITY.